Bodies
of Knowledge

'Bodies of Knowledge: Knowledge of Bodies'

A STRUCTURALIST'S INVERSION OR CHIASMUS

'The greatest thing a human soul ever does in this world is to *see* something, and tell what it *saw* in a plain way. Hundreds of people can talk for one who can think, but thousands can think for one who can see. To see clearly is poetry, prophecy, and religion, – all in one.'

JOHN RUSKIN

The Works of John Ruskin, edited by Cook and Wedderburn, volume 5, page 333

Liam Hudson

Bodies of Knowledge

The Psychological Significance of the Nude in Art

Weidenfeld & Nicolson London

George Weidenfeld & Nicolson Limited
91 Clapham High Street, London SW4 7TA
1982

ISBN 0 297 78117 0

Printed in Great Britain by Butler & Tanner Ltd,
Frome and London

Contents

Notes are grouped at the end of each chapter

List of Plates and Figures

FIGURES

Acknowledgements

This book first took shape seven years ago, in the course of a sabbatical year spent at the Institute for Advanced Study in Princeton. No thanks can be sufficient for the time, space and self-confidence that the Institute provides. In such places one can rid the mind of familiar thoughts and come to grips, initially, with new ones. Since then, the text has been nudged forward in ways that may seem capricious. In particular, I am indebted to John Gross who, as Editor of the *Times Literary Supplement*, sent me several books to review that I would not otherwise have read, and that nonetheless have exerted a formative influence. The structuralist's inversion implicit in the title, 'Bodies of Knowledge: Knowledge of Bodies', is one that I borrowed, at first unwittingly, from Paul Atkinson, then a research student in my department in Edinburgh. (He used it in the context of medical education, but it has seemed to suit my needs just as well as his.) The most fertile of the text's sources, though, have been conversations with my wife, Bernadine Jacot.

Introduction

The pleasures and excitements of art, like the pleasure and excitement that certain people stir in us, are ones laced with danger: unresolved and perhaps unresolvable tensions that visual images are ideally suited to explore and exploit. Accordingly, there exist intimate parallels between paintings, sculptures and photographs and what goes on in the privacy of our own lives and heads. Here, I shall concentrate on one parallel in particular: the use we make of images of the body as a means of articulating our desires and fears about it.

In what follows, the early chapters set up a framework of ideas that are, in essence, psychological. There then follow, chapter by chapter, several detailed examples: instances which examine the relation of these ideas to the lives of particular people and the images by which their imaginations were seized. Finally, in the last two chapters, the argument returns towards its point of departure: the web of perceptions from which memorable images of the body spring, and the bearing of this web on our attempts to make systematic sense of the lives we lead. Despite the proliferation of its detail and its many loose ends, the argument is, at heart, formal and simple. It amounts to a conjecture about the way in which the imagination works, and the scrutiny of this conjecture in the light of certain rather carefully selected 'texts'.

This movement to and fro between psychology and the visual arts is in no sense capricious; nor does it express a desire to poach on the provinces of the art historian or critic. On the contrary, it flows from a view about how psychologists ought sensibly to set about their work. As Clifford Geertz, the Princeton sociologist,

1

has recently remarked, something is happening to the way we think about the way we think. We are losing the impulse to explain our processes of thought in terms of the analogies and metaphors of technology and physical science, and are beginning to exploit the models, metaphors and analogies that lie all around us in the form of 'theatre, painting, grammar, literature, law, play'.[1] For me, paintings, sculptures and photographs are not just metaphors or analogies, though; they provide the psychologist with a parallel 'text' with which to make sense of the imaginative processes of those who create and enjoy them. They are intriguing in themselves, but they also constitute evidence about the mind's workings, embracing areas of the psychic life often assumed to lie beyond our reach except in terms of hunch.

Chapter 1, 'The Body Itself', stresses the extent to which our bodies, though beautifully poised mechanisms, are nonetheless ones which we are *bound* to perceive ambivalently; and the extent to which these ambivalences, excitement counterbalancing dismay, are *bound* in their turn to shape our imaginative lives. I also suggest, tentatively, that the minds of men and women may be seized in subtly different ways.

Chapter 2, 'What We See in Each Other', is schematic in the quite literal sense that it is taken over by diagrams. These, I hope, illuminate an important puzzle: how it is that a simple-seeming opposition, that between maleness and femaleness, can generate widely differing patterns of identity and desire: at one point on the spectrum of possibilities, the effeminate but heterosexual male, at another the brusquely masculine lesbian. Elusive when one is trying to define them, and at least as much a matter of imagination as of physiology, these patterns hold each of us in an iron grip, governing who we see ourselves to be and how we present ourselves socially, whom we find desirable and whom we view with indifference or distaste.

Chapter 3, 'In Two Minds', the last of the conventionally psychological ones, offers, in effect, a model of creativeness. In it, I try to be less imprecise than psychologists usually are both about the state of being in two minds, and about the generative part that such ambiguities can play in our imaginative lives.

The next two chapters shift the argument from the schematic to the illuminatively particular. The step is a delicate one but vital,

for explanation in psychology turns on a movement in the mind between generalized models and highly specific evidence about what people actually do and think. Just as theory earns its keep by sharpening our eye for tell-tale detail, so tell-tale detail, in its turn, earns its keep by placing theory under logical strain. The notion that we should study cases that are 'representative' or 'typical' strikes me as specious; rather, they should be eloquent, in that (like Darwin's finches) they can in principle force the investigator to change his mind. Our examples, in other words, must have room in which to answer our theories back.

My first examples are drawn from the Renaissance. Though nearly half a millennium old, they retain their potency. I have chosen them because the artists in question, Conrat Meit and Titian, one German and the other Italian, pose the ambiguities of knowledge and desire with an exceptional felicity of touch. Their chapter, 'Containers of Consciousness', forms the book's hinge. It takes William Gass's notion of a sentence as a 'container', and extends it to include visual images. Works of art are seen as sites or venues within which we explore the nature of our own ambivalence. These exercises of the imagination are performed not as a war of opposites – Life against Death, Male against Female – as the earlier 'psychological' chapters might be seen to suggest, but as feats of subtlety or nuance.

The next chapter, 'What Ruskin Saw in What Turner Saw', introduces a newcomer to the argument, the spectator; and it does so in the form not of a passive receiver of visual signals, but of an active and often quirky agent, who has pressing needs that certain visual images satisfy. It examines the critic John Ruskin's passionate advocacy of Turner's paintings, and discusses a significant mystery – why it was that Ruskin should have been so deeply committed to paintings that seem to violate his own precepts about art. My claim will be that carefully wrought visual images often carry freights of meaning only partially understood by artist and spectator alike; that they allow both to prise up the edges of common sense, without forcing either to acknowledge to themselves that this is what they are doing.

The 'image-making machine' of Chapter 6 is of course the camera. Until recently, there has been a tendency to despise this device, seeing it as an intrusion of technology into the fragile

worlds of art and personal intimacy. I dwell on it because, as Ruskin was quick to realize, it transformed the business of image-making for artist and public alike; and it did so both in obvious and in more subterranean ways. It removed literal representation from the sphere of high art to that of a man who pushed a button and then crouched over baths of chemicals. It also changed irreversibly the stock of visual ideas on which sophisticated painters like Degas and Manet were at liberty to draw. It was precisely through his use of photographic conventions and references that Manet sparked off the nineteenth century's most virulent row about art; not just a wrangle among experts, but an explosion of popular indignation.

The last two chapters, 'Artist and Model' and 'The Still Image', move back in the direction of psychology, and of the schematic. 'Artist and Model' looks with some care at the relationship on which the whole enterprise of figurative art turns – that between the depictor and the depicted – and stresses its risks and apparent perversities as well as its gratifications. 'The Still Image' seeks to explain our strange need to transform the living and desirable into images that are immutable, an explanation that draws, again, on William Gass and also on certain insights of Roland Barthes's.

To the expert, the prospect of a psychologist marauding in this way across the meadows of art historical scholarship must be reminiscent of an enthusiast with his metal detector vandalizing an archaeological site. The comfort that Geertz offers – and in such matters, his is an authoritative voice – is that, willy-nilly, the various 'genres' of academic life are blurring into one another, and that, accordingly, the territory of the psychologist is now merging back into those of the historian, the biographer, the physiologist, the sociologist, the critic, the philosopher. The moral, I think, is that the familiar academic boundaries have often been drawn arbitrarily; and that any inquiry following a rational path rather than a conventional one is bound to violate lines of academic demarcation continually. Certainly, the excitements of psychology seem to lie not so much in the heartland of the discipline but around its edges, either at the points where the psychologist meets his academic neighbours, or where he confronts the needs of people who are not academic at all.

Nonetheless, some may feel indignation at what they see as the

conceptual impropriety of the whole venture. There is a tradition among critics that the 'Life' should not be allowed to obtrude upon the 'Work'; and an equally strong tradition among Anglo-Saxon sociologists and historians that psychology has no place in the discussion of culture or of history. The psychologist should be cautious, I think, but not cowed. He can write about Life and Work in the sure knowledge that both are elements of the same biography. Whether or not, in any one case, the Life illuminates the Work, both are grist to the psychologist's mill: he is as interested in the mind's capacity for segregation, paradox and contradiction as he is in its capacity to be consistent.

As an indication of where, on the map of disciplines, the psychologist might properly pitch his tent, let me offer the touching instance of Bishop Berkeley, the great eighteenth-century Irish philosopher, a man whose perceptions of his own body seem to have influenced his public utterances in an unusually transparent way. He stands at the point where public utterance and more hidden systems of imaginative fantasy meet and breed. Our self-appointed task as psychologists is not to explain away the one in terms of the other; still less to play the tiresome game of spot the pathological symptom – a game which, in retrospect, has disfigured so many attempts to move between psychology and the arts, Freud's study of Leonardo da Vinci not least.[2] Rather than making simple-minded causal assumptions about the dependence of the Work on the Life, or vice versa, our task is to map the two systems of thought, the public and the private, and offer some sensible account of how they come to coexist, like two prisoners in a cell, within a single head.

Berkeley's intellectual life was dominated by two passions. The first was to purify metaphysics of 'matter': to refute the arguments put forward by Locke in support of a material world of tables and chairs that exist independently of whether we perceive them or not. The second, to promote the use of 'tar-water', an emetic brew, as a panacea for all our physical ills: smallpox, eruptions, ulcers, distempers, ulceration of the bowels, consumptive cough, pleurisy, erysipelas, indigestion, asthma, piles. In his book *The Unconscious Origin of Berkeley's Philosophy*, John Wisdom argues that 'matter' was dangerous to Berkeley, poisonous even; that he equated it at the back of his mind with excrement; and that

accordingly, his two passions were analogous. In each, he sets himself to cleanse a system: in one, the body of our knowledge; in the other, the body itself.[3]

It is true that Berkeley wrote most of his metaphysics in his twenties, and that he did not launch the vogue for tar-water until he was approaching sixty. Accordingly, one is tempted to write off his zeal for tar-water as evidence of a fine mind in decline. On the other hand, the place of tar-water in his thought is in some ways close to Isaac Newton's mature preoccupations with alchemy and the Trinity; not so much an aberration as one element in a complex pattern of imaginative activity, some of which looks recognizably modern and some of which does not. And while Berkeley's metaphysics can be made to seem quaint, they are congruent with some at least of the metaphysics being done today. If the eighteenth-century categories of 'idea' and 'matter' are translated into the twentieth century's 'signifier' and 'signified', there is more than an echo of Berkeley in currently fashionable thought: for instance, Jacques Lacan's insistence that the signified can never be retrieved. Many present-day psychologists and sociologists seem to me Berkeleian in a wider sense too. Like Berkeley, they find objectionable the idea that the processes of the body can exert a causal influence over the processes of the mind. Few of them, however, share Berkeley's command of prose, in itself a form of cleansing.

Before launching myself around this dangerous course, from psychology through the visual arts and back again, I have two apologies to make. The first concerns the text's loose ends. These may be distracting, especially to readers who like a book to have a message: a handful of summarizing propositions that they can carry away in a nutshell. In fact, inquiry is an untidy business, especially in those interstices where established disciplines meet. A popular solution, in such circumstances, is to take a 'line'. In the present case, one might offer, let us say, a Marxist (or a Freudian or a Feminist) reading of the nude. I have been eager to avoid anything so high-handed; an imperialism of the mind, it seems to me, that recreates all the comforts of home in a new and exotic setting, but removes from its subject-matter the chance to take us by surprise. I have, I hope, allowed the elements of my material breathing space; and although my text is informed by a

thesis of sorts – that the nude can sensibly be viewed as a vehicle or venue for the exploration of ambivalence – it is in the nature of a reconnoitre.

My other comment is less an apology than a distinction. It concerns the question of prejudice. Here and there, the sound of ideological warfare will be heard off-stage: the battle women continue to fight for the freedom to think of their own bodies as they see fit. Theirs is a cause I support. But such sympathies are tangential to the book I have produced. While no more immune to false-consciousness than my neighbour, I do claim to have written not about the equality of the sexes, but about the body's relation to the imagination it houses. My text contains more female bodies than male bodies. This results not from leering chauvinism, but from a historical fact. Almost without exception, visual artists of the highest rank have in the past been men; and, perhaps for this reason, ours is a culture in which it is predominantly women's bodies that have been used as a symbolic means of expressing desire. It follows that the raw material for any inquiry like mine is bound, very largely, to be the work of men who have wanted to depict women. This imbalance between the sexes may redress itself in the future; it may even reverse. But, meanwhile, it would be pandering, even dishonest, to pretend that this asymmetry between men and women does not exist, or to strive artificially for a numerical parity between the two.[4]

At points I assume, too, that the spectator is male rather than female. There are several reasons for doing this. The first I have already alluded to: the fact that many images are produced by men with an audience in view that is predominantly male. The pin-up is an obvious instance. The second is that it is for women, not men, to say what women's reactions are; not least, to images of other women's bodies. The spectacle of men telling women how women think is rarely edifying. Not only may the reactions of most female spectators to a given image differ from those of most males, but the reconciliation of these 'male' and 'female' constructions may itself become a source of insight to men and women alike. These biases of perception cannot be short-circuited or prejudged. There is no easy way out. Such reconciliations are the stuff, though, of any inquiry which removes from the inquirer his (or her) God-like authority to read other people's minds. They

arise around each cultural division; even, within psychology and the social sciences, between one school of thought and another. The inquirer has no special authority: he points to his evidence, his text, and challenges his audience to produce a more accurate construction of it.

There is also a difficulty at the level of personal pronouns. Many English sentences force us to identify the person spoken of as male or female, as a 'him' or a 'her'. Here and there, where I have treated artist and spectator as male, and model as female, it has been for reasons of verbal convenience. No sinister intention lurks behind this usage; no hint, certainly, of historical inevitability. We seem to be moving towards an era in which women are as likely as men to take photographs or paint from life, and in which the model is as likely to be male as female. In the course of this change, we may well evolve a system of androgynous pronouns; ones that make no reference to gender. But until such times arrive, I see no alternative to writing as I have.

Notes

1 Geertz (1980).

2 Freud (1963).

3 Wisdom (1953).

4 My text is neutral with regard to sexual politics, not because it seeks a position in the mid-ground between opposed political camps, but because it addresses other issues. To judge what I have said in political terms is, I would want to claim, to offer it an arbitrary bludgeoning, equivalent to dismissing a book about the transistor because it says nothing about popular music, an essay about bee-keeping because it ignores health foods, a treatise about planetary motion because it seems theologically unsound.

1 *The Body Itself*

I want to begin with the body as a physical entity, because it is the body which gives us the alphabet of images in terms of which most of our imagining occurs. It provides the format within which our imaginative lives are contained. In this chapter, some of my claims concern men and women alike, and are, I think, fairly straightforward. Others focus on differences between men and women; and in as much as they touch on questions of sexual equality, they demand special care.

Intentionally, I say nothing here about the Oedipus Complex: the profound ambivalences of love and hate that Freud postulated in the relation of the infant to its mother's and father's bodies. I omit this, not because I disbelieve it, but because I am eager to establish a fabric of argument at a different and, in a sense, more humdrum level. To step straight from the world of the everyday into psychoanalytic theory seems to me strategically ill-advised.

My basic assertion is this. Given ordinary candour, the body is something we are bound to perceive in ambivalent terms. Far from being an arbitrary physical lump onto which we project culturally determined values, it positively demands of us responses that are contradictory, fissured.

Three of the body's properties seem to me especially eloquent in this respect. The body, in the first place, has an excretory function. It takes in food, but it also expels waste; and does so, unless elaborate precautions are taken, in ways that are socially inconvenient and a danger to health. As anthropologists like Mary Douglas have observed, the symbolic lives of both primitive and more sophisticated societies are organized to a remarkable degree

9

around the oppositions of purity and dirt. This intimate relation of opposites is made all the more poignant by the comical confusion that exists, anatomically, between our excretory and reproductive functions. In the male, the organ which is the seat of sexual desire doubles as the one that passes liquid waste; in the female, the vagina is poised between two excretory orifices, and is closely connected to each. Anatomically, we are like some extraordinary surrealistic pun. A major commitment of our culture, consequently, is the maintenance of 'politeness': the discreet management of our body's excretory functions, and the separation of these from its amatory ones, a skill that must often exercise the psychic mechanism of denial.

The body, then, is inherently 'dangerous'; we run the risk of confusing desire with disgust. But the body does not just excrete; it suffers disease and dilapidation. The prospect of a healthy body corrupted by illness or old age is alarming, at least to those still healthy and young. As a result, many of us are preternaturally sensitive to the least sign of their erosive effect. Socially, we have evolved subtle devices for managing these facts of life: the skills of *tact*. We are tactful with one another; and tactful, too, with ourselves – to the extent that many of us live not in terms of what our body demonstrably is, when confronted in a mirror, but in terms of what it could be at its best, when caught in a sympathetic light.

Beyond this second, entirely obvious but still potent component of our ambivalence about the body lies a third, slightly more elusive one. The body has an outside, but also an *inside*. We accept as a matter of fact that the outside acts as an envelope for a job-lot of internal organs: heart, lungs, intestine, liver, kidneys, and so on. But while we acknowledge their hidden presence, we can make no connection between them and the person, the sensibility, they serve. This incongruity between outward semblance and innards is conceptually uncomfortable, especially as our everyday knowledge about our own insides comes, predominantly, from eating the insides of animals that somewhat resemble us. Most of us would fail to distinguish our hearts from our bladders if they were presented to us on a dish. None of us would recognize the people we love if they appeared before us without their skins. None could distinguish the heart of someone he loved from the heart of someone he abhorred.

Unless we are doctors, our preconceptions about our internal organs – our livers say – are based, if on any evidence at all, on what we see in the butcher's shop, or on the dinner plate. A consequence is that we probably have a clearer idea of how our livers would taste than of how they would appear. Even if we are doctors, we have probably conditioned ourselves to think, fictitiously, in terms of the 'normal' liver, whereas, in truth, no such standardized entity exists. Human livers, like other internal organs, differ remarkably not only in shape and size but also in position: in some people, the liver is hidden behind the ribs on the right-hand side of the body; in others, it lies almost wholly below the level of the ribs and further to the left.

It is worth noting too that not only does sexual intercourse represent a fusion of inside with out, but the organs of reproduction themselves represent something of a halfway house between the two. They look incongruous, the male especially, and suggest parts of the body's inside that have been extruded. The female organs are also associated with parts of the body's inside that, at special moments, come out: the new-born baby in childbirth, and also the placenta, which, visually, is grossly at odds with the body's outer surface.

Despite these transitions, there is a sharp discontinuity in most people's minds between the body's outside and its inside; between the knowable and the hidden. We acknowledge the existence of this discontinuity when we speak of 'squeamishness', violations of squeamishness forming a routine part of our culture's toughening procedures. (As a raw recruit to the British Army, I was not only required to kneel on all fours and scrape encrustations from an old urinal with a razor blade; I was confronted, for my first breakfast, with a sheep's heart, gently puffing steam from its aorta.)

The fantasy that, inside, we are all more or less alike, is, I suspect, a powerful and pervasive one. Williams's old but still excellent book *Biochemical Individuality* shows how far it is from the truth. We differ anatomically; and, probably of greater significance for the psychologist, we also differ biochemically. Five-fold differences in the chemical composition of the blood are commonplace; and massive differences are found, individual to individual, in levels of hormonal excretion. Williams mentions a study of twenty normal males in which the excretion of male sex hormones

differed *thirty-five-fold*. This level drops with age; nonetheless one man of seventy-two was found to excrete more than twice as much male sex hormone as another of twenty-one. Behaviourally, such differences remain hard to interpret, of course. Hormone assays give us only an indirect indication of how much hormone is reaching the pertinent receptors at any one time; and they tell us nothing about the sensitivity of that receptor. Logically, it is possible that one man may have thirty-five times as much sex hormone in his bloodstream as another, and yet, because his internal receptors are particularly insensitive, display lower levels of sexual activity. The fact remains, even so, that, inside, we may differ just as radically as we do in terms of our outwardly visible characteristics and skills.[1]

As the natural focus of ambivalences and discontinuities, the body is well suited to serve as a symbol or public image. It allows us to play with potent and conflicting emotions; and, in the form of paintings, sculptures and photographs, to do so at one remove. In the humbler exercises of these arts, the body's more complex connotations are ignored. It is idealized, or made to seem absurdly alarming. Only simple boundary-games are played, in the spirit of a striptease. But the centuries have seen a patient accumulation of knowledge about the more eloquent of the body's ambiguities; and in works of quality, we confront the body laden with messages that are characteristically two-edged: the shades of doubt and nuance that make it the ideal vehicle for sustained imaginative exploration.

In such exploration, there is one part of the body that plays a crucial part, and that I have not so far mentioned: the face. It may seem premature to dwell on any one element in the visual artist's armoury at this stage, but the face raises an issue of interpretative principle best voiced early on: for it is the part of the body which expresses not only individuality and intelligence, but also intention. It is by looking at the other's face that we decide whether we are dealing with someone whom we can subsume to our own needs; or who, at the other extreme, is intent on subsuming us to theirs. At the crudest level, facial expression signals sexual availability or refusal. More subtly, it indicates, often misleadingly, capriciously, the extent to which we can hope to gain access to the other's experience, and the terms on which that access is likely to be achieved. The face serves at these moments not just as a gateway to the mind but as a metaphor for it.

In art, the face also determines whether the body portrayed is perceived in universal terms, or as that of a specific individual. If the treatment of the face is stylized, or if, as in much classical sculpture, it is missing, the image will command a sense of universality; it will be perceived not as *a* body, but as *the* body. If the face is shown in detail, the image's universality evaporates. Charis Wilson, the photographer Edward Weston's model, makes the point with characteristic clarity: 'If the full face appears, the picture is inevitably the portrait of a particular individual and the expression of the face will dictate the viewer's response to the body. If a photographer wants to make a nude, rather than a nude portrait, he has only three possible options: the face must be averted, minimized by distance, or excluded.'[2]

Ordinary observation suggests, then, that we have a lively appetite for images of one another's bodies, and that the needs which this looking expresses may be more complex than they seem. That said, our bodies remain our destinies in ways that demand more expository caution. Creeping into the last page or two, there has been the acknowledgement that, in the matter of looking, the sexes are asymmetrical. Men look at images of women's bodies, often with deep absorption; but women do not usually show a similar concern with nude images of men. The point has been made by John Berger: 'Men look at women. Women watch themselves being looked at. This determines not only most relations between men and women but also the relation of women to themselves. The surveyor of woman in herself is male: the surveyed female. Thus she turns herself into an object – and most particularly an object of vision ...'[3] Rather than striking an attitude about the rights and wrongs of this dissimilarity, the psychologist is under some compulsion to say how such an asymmetry between men and women might arise.

Predictably enough, popular psychology has explanations to hand: two in fact, each of which contradicts the other. The first holds that, where they arise, psychological differences between men and women are by-products of centuries of oppression. The second, that men and women differ for genetic reasons, their dissimilarities being 'wired in' from the moment of their conception. At this level, the ideological conflict between these two camps, the political and the biological, seems to me devoid of

intellectual interest, and is one I am eager to avoid. The crude opposition of hereditary and environmental determinants is an irrelevance – in the analysis of sex differences, as in the analysis of differences in intelligence or mental health. Demonstrably, hereditary and environmental factors interact; and work in human physiology suggests that the nature of such interactions will eventually prove to be of bewildering convolution. In his recent book *Foetus into Man*, Tanner makes it plain, for example, that the action of hormones in determining physical growth is exceptionally complex, being characterized by threshold effects, triggering effects, even reversals. If this is true in the case of physique, a relatively straightforward human attribute, it will be true a hundred times over in the realms of sex and gender, intelligence and mental stability.[4]

Rather than entering this morass, I want to concentrate instead on what the body might mean to the person inside it: on the body's imaginative construction. Where men and women have bodily characteristics in common, the impact of the body on their imaginative lives, I want to suggest, will be similar – unless of course some dissimilarity in their perceptual systems intervenes. But where bodies differ, the impact of the body on the imagination is one that should itself differ; and there is solid evidence to suggest that this is so.

Before I say what that evidence is, let me elaborate momentarily on the question of prejudice. The territory, clearly, is one in which the shrewd are careful with their metaphors. Research and common sense combine to suggest that human beings do not act on one another imperviously, like billiard balls; nor, it seems, are we wholly malleable like putty. Rather, we present one another with surprising mixtures of malleability and recalcitrance. Where psychological differences between men and women occur, they usually do so, in any case, not over questions of ability but over those of personal preference, taste and natural inclination.

Faced with phenomena such as these, the mind moves away from the extremes of billiard ball and putty, and towards those of natural tendency: the image, for example, of grain in wood.[5] In terms of evidence, such an image commits us to expect nothing more threatening than the recurrence, from biography to biography, and from culture to culture, of certain preoccupying themes.

Domestic intimacy is the plainest instance. Couples are now free to lead childless, egalitarian and role-sharing lives together should they see fit. The physical differences between them are ones they can view as trivial. Or, on the other hand, they may see precisely the same differences as of the utmost significance, a focus of mutual dependence and fascination. At one extreme, men and women can seek to liberate themselves from their bodies by ignoring them. At the other, they can see liberation as lying in the recognition of necessity – in this case, those necessary differences of anatomy and physiology on which the survival of the species depends.

With these reservations in mind, there are four properties of the body I want to mention particularly:

Sexual anatomy
The onset of puberty
Pregnancy
Sexual potency

Very sensibly, psychoanalysts insist that small children are more alert to the sexual aspects of their own bodies than unsuspecting parents might imagine. Once alert, boys and girls certainly have very different bodies to be curious about. Males discover that their genitals are external: females, that theirs are internal. Girls, on the other hand, learn that they are to have breasts. The sense that children make of these commonplaces is still unclear, but certain implications are hard to escape. The most obvious are not those stressed by Freud, whose preoccupations with oral, anal and genital phases, and with penis envy, strike me as unhelpful. (What a misfortune it is that so profoundly influential a theorist should have spent so little time observing his own children, and should have had so slight a sexual interest in his own wife!) Rather, one notes that the organ emblematic of maleness, the penis, serves an excretory function, whereas the organs publicly emblematic of femaleness, the breasts, do not. Breasts are a locus of comfort and nurture. In other words, the organ that males have and females lack has connotations of dirt, the expulsion of urine; whereas the organs females have and males lack have connotations that are life-giving, the giving of milk.

Girls may also be alert, at quite an early age, to the fact that the vagina will eventually become the source of a mysterious bleeding.

As Shuttle and Redgrove stress, the vagina may be perceived as a special kind of wound, a permanent gap or tear in the body's fabric.[6] Boys, in contrast, are more likely to perceive their genitals as hose-like attachments to the body's surface; even, when erect, as a kind of implement.

Already, there exist two different imaginative schemata for making sense of sex: in the boy, an expulsive and instrumental frame of reference; in the girl, a more inclusive and nurturative one. Erik Erikson's experiment in *Childhood and Society* is neatly illustrative of this: the one in which little boys used building blocks to construct towers, the little girls to create enclosures.[7] As soon as puberty sets in, the experience of the male and female will differ in at least one new respect. Typically, the onset of sexual excitement is more abrupt and more dissociated in boys than in girls. While adolescent girls may certainly experience sexual yearnings, boys frequently suffer gross physical embarrassment: they have to learn to cope with an erectile organ that asserts itself, often at awkward moments, in ways unrelated to personal feelings or attachments of any sort at all. Sex for the adolescent boy can seem a purely physical attribute, a behavioural manifestation that does not properly belong to him; whereas for the adolescent girl, the dislocation of such sensations from her more ordinary processes of thought, her affections and daydreams, will usually be less sharp.

Although heavily overlaid with cultural expectations, the source of this difference between male and female adolescents is probably hormonal. Endocrinology is an inexact science; but the indications are that it is the male sex hormones, the androgens, that play a central part in the mediation of desire, for men and women alike. These androgens are secreted by the testicles in the male, and by the adrenal cortex, a part of the kidney, in both sexes alike. The levels of testosterone, the most active of the androgens, leap up as boys reach adolescence: between the ages of ten and sixteen or seventeen, the amount of testosterone in the blood plasma increases on average some twenty-fold. The pattern in girls is quite different, showing a steady drift upwards that begins at the age of seven or eight. Secretions increase until the age of fifteen or sixteen, but level out at concentrations a tenth of those displayed by adolescent boys of the same age. Individuals differ, of course, both

boys and girls; but the data for young adults show testosterone levels for the lowest male to be nearly four times as high as that of the highest female.[8]

Even more potent, imaginatively speaking, must be the prospect of pregnancy. Again, the experience of male and female is sharply dissimilar. Often from an early age, a girl knows, or at least intuits, that a body can grow inside her own body; that she can sustain the growth of a separate life. The sense of a body-within-a-body, of a life-within-a-life, has no male counterpart more realistic than the fantasies of the couvade. Anything 'other' within the male body is either something swallowed – a coin say – or evidence of disease, a cancer to be cut out. When expelled from the womb, babies are a startling mess, admittedly; but they are alive and immediately display needs and wills of their own. While a woman may see her body, in the context of reproduction, as an entity to be penetrated and even perhaps spoilt, the male's contribution is external to himself; a responsibility he is frequently tempted to disown. The dramas of fertilization, pregnancy and parturition occur *out*side his body, *in*side hers.

The last item on my list of four, sexual potency, concerns a discovery made by those already grown up, rather than the sensitivities of children and adolescents. It is congruent, nevertheless, with patterns of expectation already established; and even if it fails to etch new lines on the imagination, it at least deepens those already there.

As Kinsey showed, sexual potency follows one path in men, another in women.[9] In the male, the peak of sexual potency is usually reached in the teens; and does so, characteristically, before he has had a chance to fashion an intimacy within which it can find fully-fledged expression. Often as much a nuisance as a gift, his potency usually declines from this peak, so that, by his forties or early fifties, he is conscious of powers on the wane. In the female, by contrast, potency often reaches a peak only in the late twenties or early thirties; but then remains at a relatively constant level, well through into late middle-age. As a result, many women, were it not for the importuning of the males around them, would find it perfectly feasible to remain chaste until they have formed a relationship which, in their view, deserves their sexuality. Once such a relationship is established, however, they are in a position

to lend sexual meaning to it, and to go on doing so long after their consorts have become aware of a dwindling sexual need. (Impotence, too, is eloquent; sometimes cruelly so. For the male it consists in an external organ that subverts its owner's best intentions: that will not erect itself as it ought; or of orgasms that arrive too soon, too late, in half-baked form, or not at all. His humiliation is heightened by an unkind trick of physiology: for while intercourse can proceed in a harmonious and affectionate manner while the male is excited but the female not, the reverse is an impracticality.)

In each of these four respects – sexual anatomy, the onset of puberty, pregnancy, sexual potency – the female seems to me freer than the male to integrate her sexuality into a coherent sense of who she is. For the male, in contrast, such an integration must always be something of an achievement.

In these four rather specific ways, in other words, the bodies that men and women inhabit really do seem to serve as formats for more than the purely physical. Such dissimilarities suggest that men and women will tend to gravitate of their own accord towards different frames of imaginative reference. They may also help to explain the existence of activities which fascinate most men and bore most women: games of violence, for example, literal and symbolic; enthusiasms that focus specifically on technical apparatus or 'gear'; and altogether more wretchedly, the sexual perversions.

Rather than rehearsing voluminous evidence, out of place here, let me offer illustrative details instead. First, violence. Just as there is not one primitive society in which women wage war while men guard the hearth, nor one, it seems, in which it is women rather than men who manufacture weapons; so, in our own society, it is predominantly men who hunt, shoot, and bellow at football matches.[10] On the banks of the Thames each weekend, it is men and their sons who watch their fishing rods by the hour, absorbed, while their womenfolk either watch them watching, or stay away.

To an extent that differences in academic competence cannot begin to explain, it is the men not women in our society who become engineers. A British survey published in the 1960s showed that one in every five doctors was a woman, whereas there was only one woman for every 1,500 men among mechanical engineers.

18

A more recent American survey suggests that the proportion of female engineers is rising, from less than one per cent in the late 1960s to nearly three per cent in the late 1970s. Consistently, however, science and technology are perceived as 'harder', less feminine and less libidinous than the humanities, by those in the sciences and the arts alike.[11] It is men, too, who still dominate those leisure pursuits – hi-fi, photography, the internal combustion engine – that offer the chance to own and tinker with hardware. The diversity and sophistication of this equipment is such that a man can now have a 'career', for example, as a camera enthusiast, not by taking photographs, but by exploring the Aladdin's Cave of lens and bodies, filters and flashguns that the weekly magazines lay out for his delight. Both the assertive instrumentality of these magazines and their undertow of wistfulness are plainest in their advertisements. Side by side in a recent edition of *Camera*, for instance, you find an advertisement for 'Microflash', a 'twin gun system for close-up photography', and one urging its presumably male readers to 'attract women'. It offers 'androstenone pheromone (as recently demonstrated on BBC TV's Tomorrow's World)' – 'the ultimate male cosmetic spray' and 'a powerful female attractant', available at a special price from an address in Thames Ditton.

And by no means as remote from such enthusiasms as they might seem, there are the sexual perversions. Where the body is used as a sexual object, or objects are put to sexual use, the male monopoly becomes virtually complete. Female fetishists, rapists and voyeurs are rare, and it is men, not women, who haunt the shops and cinemas selling hard porn.

At every turn, in other words, men seem naturally to adopt an 'instrumental' mode of address to the world around them. Wherever a culture offers a choice between activities that are a matter of impersonal manipulation or control and ones of personal relationship and caring, it is men who seem drawn towards the first, women towards the second.

It need not be so, of course. The puzzles of sex and gender might well fade to the status of palimpsests or echoes; dimly discernible traces, almost lost between the lines of scripts altogether easier to follow. To my blinkered eye, the prospect is unappealing. Rather, it seems to me that it is brute nature, in the

form of food and drink, landscape, weather, the properties of our own bodies and the prospect of our mortality, that provides the raw material from which any sane life is built. Far from being obstacles to a life of liberation, self-discovery or self-actualization, the paradoxes of sex and gender are a heaven-sent opportunity to construct signs and lives for ourselves that are other than banal.

As illustration, consider the experience of the renowned French photographer of the nude, Lucien Clergue. Born in the south of France in the 1930s, and brought up in considerable hardship, Clergue is quite explicit about the source of his abiding fascination with the nude as a subject. He begins a brief autobiographical account: 'To understand my interest in photographing the nude, you have to know something about my early life and my parents' relationship.' He was born, he says, by Caesarian section, an operation that 'was not well done'. Thereafter, sexual intimacy between his parents ceased, and they were divorced when he was seven. When he was fourteen, his mother fell seriously ill, and she weakened progressively:

> Often she fell down, and I had to run in terror to get the doctor or a friend ... Eventually, things reached the point where I had to wash her emaciated body in the mornings, and the sight of her poor thin breasts affected me deeply. It was really her body that formed my concept of a woman's body ... Death was part of my life; my mother spoke to me each night about what would happen to me tomorrow if she died before dawn. When she finally did die, I really lost two people: my mother and this invisible presence of death.

Clergue felt responsible, he says, not only for his mother's divorce, but also her illness and death. For her, the sexual relation between men and women was 'something evil, something terrible, something which had ruined her life'. When she died, he was almost nineteen, and poor. In the evenings, he was learning to become a photographer. Before his mother died, he had started to take photographs of the nude, although, initially, this was 'just a pretext to see a woman naked'. Prostitutes demurred, it seems, but his girlfriend obliged. His earliest photographs seem to have been those of dead animals floating in the local river, and of young acrobats, children 'in the shadow of an abandoned city', Arles, who 'never stood in the sun'. But by the age of twenty-two, and

despite the apparent morbidity of his interests, Clergue had taken the first of the many nudes in the sea for which he is now justly famous. In his own words, these 'represent an affirmation of life, a reaching out to beauty and health'. He took the first of this series to the family doctor, to whom he had been talking about his troubles: 'He looked at it and said, "Now you are well. You don't need me any more." ' Clergue also took this first print to Picasso, whom, it seems, he had already met. Picasso's response was altogether more positive: 'You did this? I can hardly believe it. Someone could cut a piece from a Velazquez canvas and place it next to your photograph, and it would not be possible to say, "This is Clergue, this is Velazquez." '[12]

Such complexities and apparent contradictions of motive, and the expression of these in works of art, are the concerns on which this text of mine are based.

Notes

1 Williams (1963).

2 Wilson (1977), p. 115.

3 Berger (1972), p. 47. Berger slides too easily, however, to the conclusion that women in this respect betray their political subservience and passivity. If there were no tension between the lookers and the looked at (whether male or female) the loss would be incalculable, to art and life alike.

4 Tanner (1978).

5 The role of metaphor in formal explanation is discussed with some care by Lakoff and Johnson (1980). In a recent paper of my own, 'The Role of Metaphor in Psychological Research', I examine the problem as it applies to my own discipline. Like others, the metaphor of wood grain is open to considerable elaboration. There may, for example, be good reasons for working across the grain, for using it purely decoratively, or for ignoring it altogether. It remains normal, nonetheless, to find the wood's grain and work along it. (The use of words like 'normal' or 'natural' in such contexts can cause irritation, but seems to me fairly blameless.)

6 Shuttle and Redgrove (1980). Their text about menstruation represents just the sort of blurring between genres (in their case, between

poetry, psychoanalysis and biological science) remarked on by Geertz, and that seems to arise of its own accord whenever a topic is pursued as interesting in its own right.

7 Erikson (1963). This notion of an incorporative cast to the female imagination has been taken up by at least one feminist writer about photography: Spacks (1978).

8 Faiman and White (1974). It is *not* safe to assume that levels of hormonal secretion are immune to cultural influence; nor, of course, does it follow from data like Faiman and White's that levels of desire in young adult males are ten times as high as those in young adult females. Just as the relation of hormones to growth is complex, so too will be their relation to erotic experience.

9 Kinsey *et al.* (1953), Fig. 143.

10 D'Andrade (1967) reviews the anthropological evidence about sex differences in primitive societies, and does so in an accessible fashion.

11 Klein (1966), Lombardo (1979); Hudson (1968), Weinreich-Haste (1979).

12 Clergue, in Kelly (1979), p. 51. Clergue's images were warmly praised by Cocteau, and served as inspiration to the poet Paul Eluard.

2 *What We See in Each Other*

It is not just a matter of what we see when we look at one another, but of what we see *in* one another when we look. As much of the looking we do is conditioned by our sense of maleness and femaleness, categories at the same time imperiously simple and subtly invasive, it is as well to begin by being schematic. While it makes sense, in certain contexts, to subdivide the human race into the male and the female, in others it makes nonsense. As it happens, there are some elementary diagrams which help to explain how this simple-seeming bifurcation can remain simple, yet yield the contradictions of behaviour, perception and self-perception that many men and women actually display. Although artificial, the exercise of tracing out these patterns is salutary. For in matters of maleness and femaleness, inconsistency is the rule rather than the exception; and a source of vitality, too, rather than an error to be cured or explained away.

At barest minimum, the diagrams offered here should prove that there are better things to do with polar categories like male and female than treat them as pigeonholes. Handled correctly, they establish the dimensions in terms of which each individual, often inconsistently, establishes his (or her) habitual mode of response to the world around him. The issue is not whether a certain individual can be assigned an average score or rating on the dimension of masculinity/femininity. Rather, of how the internal consistencies or inconsistencies of his solution influence the life he wants to lead.

In order to construct the sort of diagram I have in mind, one must first identify separate facets of masculinity and femininity;

respects in which it makes sense to describe someone as typically 'male', typically 'female', or as occupying a position that is to some extent indeterminate. I have selected four:

Biology
Gender Identity
'Object-Choice'
Presentation of Self

Taking each in turn, I want now to construct a species of decision tree, one demanding four choices, each of which is in principle separable from the other three.

Beginning with the sixth week of life in the womb, we each retain the female form that all mammals take after conception, or differentiate ourselves into males. Thereafter, the die is cast. Short of radical surgical intervention, we are destined to live out the rest of our lives as men or as women; as possessors either of the male or the female reproductive apparatus and the biological roles that go with them. There are anomalies in this simple binary scheme of course: girls, for example, who have been 'masculinized' by excessive secretions of male hormone late in their mothers' pregnancies, and are born with male sex organs attached to bodies that are otherwise female. Also the hermaphrodites, born with sexual organs that are not properly differentiated either into the male or the female form; and, different again, children who are chromosomally odd – rather than following the normal XX pattern for girls, or XY for boys, some have an extra X chromosome, some an extra Y, and some display 'mosaics', in which different chromosomal patterns exist side by side in the same body.[1]

These cases are the exception, though. Normally, and for reasons that are hormonally regulated, males and females differ markedly, not just in reproductive anatomy but in adult physique. The remarkable hormonal changes of puberty ensure that most men are taller, heavier and hairier than most women. Also that they will develop relatively broad shoulders and relatively narrow hips; a pattern that in most women is reversed. This interesting dissimilarity arises because cartilage cells in the shoulder of both sexes are programmed to respond to male sex hormones, whereas those in the hip are programmed to respond to female sex hormones.[2] As a consequence, most men inhabit typically 'male'

bodies, while most females inhabit typically 'female' ones. These differences between men and women, nevertheless, are statistical rather than clear-cut, the evidence suggesting, in the case of shoulder and hip widths for instance, a ten per cent overlap, one man in ten displaying the 'female' configuration, and one woman in ten the 'male' one.

Even at the level of physique, in other words, there is scope for ambiguity. But in terms of our reproductive function we are usually committed, clearly and irrevocably, to one path or the other. In diagrammatic terms, we branch.

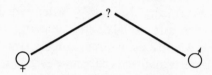

Figure 1 Sex and gender: the first branching –
anatomy and physiology

However, biological males do not necessarily see themselves as unambiguously 'male'; nor do biological females necessarily see themselves as unambiguously 'female'. Some have a weak sense of gender identity; a few none at all; and a tiny minority, the trans-sexuals, display a reversal – they are convinced beyond all persuasion that they are really men trapped inside women's bodies, women trapped inside the bodies of men. Occasionally this dissonance between gender identity and physiology is so distressing that the individual seeks a surgical intervention that will bring body and gender identity more nearly into line.

Those who have studied such cases in detail, notably Robert Stoller, claim that our sense of gender identity is established early in life, and that, once established, it is extraordinarily difficult to shift. Vital to this sense of identity, he claims, is the child's relation to its mother. If, for example, the mother treats her son as belonging to the same category of person as herself, the son will grow up believing that, at heart, he is 'essentially feminine', or at least that there is something essentially feminine about him. Experiences in adolescence no doubt exert an influence too, though. However robust the sense of 'maleness' or 'femaleness', it will be threatened if, in adolescence, the appropriate physical characteristics fail to

develop; or, worse still, as occasionally happens, if the ones that develop are inappropriate.

Experts in this field seem agreed that the developmental path followed by the male is more tortuous than that followed by the female, and, as a result, they stress the male's 'psychosexual frailty'. Stoller sees the establishment of a stable gender identity among males as an 'achievement' (because they must first detach themselves from an identification with their mothers, who feed and comfort them), and links this both to the greater frequency of sexual perversions among men than among women, and to the greater rigidity of the adult male's object-choice.[3]

Gender identity admits doubt, in other words. Our society encourages us to commit ourselves to one camp or the other, but many of us reach adulthood nearer agnosticism than convinced belief. We may entertain shreds of transsexual fantasy, or simply feel at a loss; and may look to our reactions, tastes and accomplishments rather than to our bodies for confirmatory evidence of where our true natures lie.

In diagrammatic terms, we branch for the second time. Again the choice is between the male and the female. We may move in a direction congruent with our first choice; or, on the contrary, react in a way incongruent with it. We not only branch, we may cross over.

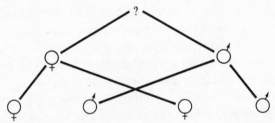

Figure 2 The second branching – gender identity

Reading from the left, this diagram offers four 'solutions': the biological female who sees herself as a female; the biological male who sees himself as a female; the biological female who sees herself as male; and the biological male who sees himself as male. If the criteria for crossing over are stringent, the middle two solutions will contain only *bona fide* transsexuals; if more relaxed, they can encompass all those who entertain some uncertainty – the men

who see something decidedly feminine in themselves, women who see themselves as in some important respect masculine. On this basis, and in the present state of our culture, the four solutions could well attract adherents in roughly equal proportions.

A third component of our sexuality is, for lack of a better phrase, our 'object-choice'. The natural pattern is for men to desire women, and women to desire men; but the exceptions are many and well-advertised. Where such choices originate, no one seems to know. Nor do we know why some people are drawn to people they see as like themselves, others to people they see as dissimilar. Nor why the desires of some are rigidly fixed on one category of 'object', while others are free to move from one category to another – a middle-aged woman, say, who is equally drawn both to other middle-aged women and to much younger men.

Regrettable though our ignorance about causes is, it does not prevent us from adding a third layer to the diagram; one, again, in which the individual makes either a typically masculine or typically feminine response. For the biological male, the typically masculine response is to desire women, the atypical or 'feminine' one is to desire other men. For the biological female, the typically feminine response is to desire men, the 'masculine' one is to desire other women. The diagram now begins to look like an inverted tree.

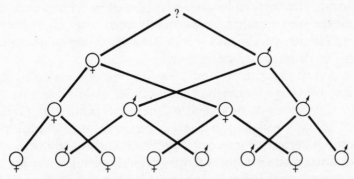

Figure 3 The third branching – object choice

Of the eight solutions in this tree, only two are consistent: on the extreme left, the woman who sees herself as a woman and desires men; and on the extreme right, the man who sees himself as a man and desires women. The other six are all inconsistent. Of

the two nearest the centre of the array, one is a woman who sees herself as masculine but who desires men; the other, a man who sees himself as feminine but desires women.

Although simple, the tree now permits important refinements. The woman on the extreme left and the man on the extreme right are both heterosexual, and are both attracted to people they see as unlike themselves; to people they see as in some sense *strange*. They might well suit one another. The two people nearest the centre are also heterosexual, but they are attracted to people they see as belonging to the *same* gender category as themselves: the woman sees herself as masculine and is attracted to men; the man sees himself as feminine and is attracted to women. There is a sense, in other words, in which this man is a 'lesbian'; in which they could both be said to be 'homosexuals' after all.

The diagram thus separates out two definitions of homosexuality (or, for that matter, heterosexuality): one behavioural, the other experiential. Two men in the tree are homosexual in the public and behavioural sense that concerns the police constable; but only one of them is experientially so: the man, third from the right, who sees himself as a man and desires other men. The man second from the left, in contrast, desires other men, but sees himself as a woman. In fantasy, if not in observable fact, he has more in common with the consistently heterosexual woman at the tree's left-hand extreme than he does with his fellow homosexual. Both he and the consistently heterosexual woman, after all, focus their desires on men who seem to them 'strange'. They might even be rivals for the same attractive man.

We do not just perceive ourselves as typically male or female, though; we *display* ourselves as typically male or female. The diagram needs a fourth layer; one that deals with what Goffman has called our 'presentation of self in everyday life'.[4] Traditionally, society has permitted men to be dominant and aggressive, and has constrained women to be submissive and more gentle. We may move, soon, to a cultural arrangement in which this differentiation no longer applies, or in which it is reversed. For the time being, however, the traditional expectations apply: both socially, and by implication sexually, the male is expected to take the initiative.

Expectations and the public presentations of self they beget may be dissonant, even so, with the gender identities and object-choices

of the men and women concerned. A male may bury himself in rugby scrums and quaff ale because this expresses his sense of who he really is. Alternatively, it may camouflage suspicions about his femininity that he wishes to hide both from others and from himself.[5] However rudimentary, any scheme of maleness and femaleness must take such discontinuities into account; and to do this the tree must have a fourth layer of branches.

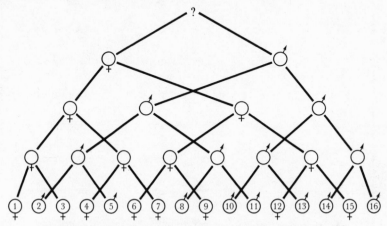

Figure 4 The fourth branching – presentation of self

The tree now becomes awkward to read. Its prime virtue, in the present context, is that it yields sixteen different solutions to the conundrums of sex and gender, each of which constitutes a recognizably human prototype or 'identikit': a format within which the individual's amorous projects are organized, and around which abiding doubts and prevarications are hung. At the extremes – Nos. 1 and 16 – are the man and the woman whom the Victorians would have recognized as 'normal', and whose solutions are internally consistent. No. 1 is a woman, sees herself as a woman, desires men, and presents herself to them as submissive; No. 16 is a man, sees himself as a man, is attracted to women and presents himself to them as dominant. Each of the other fourteen identikits represents a significant equivocation; a pattern containing at least one inconsistency. These are easier to grasp when the sixteen identikits are set out in the form of a table (Figure 5).

No. 12, for instance, is a woman who sees herself as masculine, who is attracted to other women, but is submissive towards them.

	Biology	Gender Identity	'Object-Choice'	Presentation of Self
1	F	F	→ Men	Submissive
2	M	F	→ Men	Submissive
3	F	F	→ Men	Dominant
4	F	F	→ Women	Submissive
5	M	F	→ Men	Dominant
6	F	M	→ Men	Submissive
7	F	F	→ Women	Dominant
8	M	F	→ Women	Submissive
9	F	M	→ Men	Dominant
10	M	M	→ Men	Submissive
11	M	F	→ Women	Dominant
12	F	M	→ Women	Submissive
13	M	M	→ Men	Dominant
14	M	M	→ Women	Submissive
15	F	M	→ Women	Dominant
16	M	M	→ Women	Dominant

Figure 5 The sixteen identikits that the four categories of sex and gender yield

Schematically speaking, her biology is consonant with her presentation of self, but both are at odds with her gender identity and object-choice, a dissonance that would in all probability make her a remarkable person to know.

Dissonance arises from two sorts of source however. The first source is internal to the individual; the second resides in the relation of the individual to other people. At the risk of becoming over-elaborate, I would like to consider each in turn.

I have spoken so far as though the second, third and fourth components of these identikits sprang into being of their own accord; and as though, once established, they were given, much as the colour of our eyes or the shape of our nose is given. Patently, this is not so. A married man may discover, in mid-life, that he is a homosexual; an apparently gentle and submissive wife can find, to her surprise, that she harbours both the desire and the ability to control and dominate. Gender identity, object-choice and presentation of self may be the end-products of internal conflict, and may often be less secure than they seem. To borrow a phrase I have heard attributed to Nietzsche, they may well constitute the 'dead residue of struggle'.

Not only may there be conflict between the elements in a person's identikit; there may also be doubt about whether a particular element is as solidly established as it seems. The proposition is one that can be put in a general form. For whatever shape a society takes, it regulates; and, among much else, it regulates the relations between the sexes. Granted human variety, each regulative pattern must leave some libidinal enterprises out of account. There are bound to be amorous propensities that get overruled, repressed. But the mechanisms whereby the unacceptable is expunged from the mind are imperfectly efficient, so some erotic projects remain latent: the homosexual fantasies that encroach on the settled married life of Mr Smith; the hankering for the sexually farouche that lurks below the surface in the apparently placid Mrs Jones. Our most convenient points of access to these loose ends of desire are the dream, the daydream, the cinema and television play, the advertisement, and, I want to suggest, those paintings, sculptures and photographs that portray the human body.

Let me offer another diagram.

In terms of the decision tree, any choice that is made with

difficulty can be seen (a) as leaving behind it a residual path that is the reverse of the one overtly adopted; and (b) as exerting an unsettling influence on subsequent choices. A man who achieves a heterosexual object-choice only with some difficulty, perhaps because his gender identity is itself shaky, may lay down in his imagination, beyond his powers of conscious recall, a pattern of homosexual appetite quite at variance with the one he actually pursues. One shaky decision begets another; and a series of shaky decisions beget several quite different paths, scripts, scenarios or response repertoires, each of which the individual may eventually be able to excavate and explore.

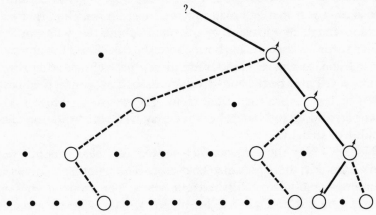

Figure 6 Three latent patterns of sex and gender

The figure shows the path of a man who sees himself as a male, who is attracted to women, but who is submissive; and also the three latent paths that three shaky choices have set in being. Reading from the left, these depict the homosexual male who sees himself as feminine but presents himself as dominant; the homosexual male who sees himself as masculine and presents himself as dominant; and – Victorian paragon – the heterosexual male who sees himself as masculine and presents himself as dominant. Each, I am suggesting, is an erotic avenue that the man in question might one day find himself free to pursue.

Normally, if not invariably, such avenues involve other people. Here, too, there is scope for dissonance. We know little about those aspects of intimacy and marriage which release imaginative

energy, as opposed to those which stifle it. The topic is mysterious; but the identikits do suggest how preliminary advances into this territory might be made.

The two extreme members of the array, Nos. 1 and 16, are in theory made for one another, being complementary to one another in all four respects: biology, gender identity, object-choice and presentation of self (Figure 7).

More intriguing, but more complex, is the congruent relationship between two people, each of whom is internally dissonant; for example, that between Nos. 9 and 8 (Figure 8).

More complex still is the incongruous marriage of two people who are themselves dissonant, as would arise if No. 9 were to marry not No. 8 but No. 11 (Figure 9).

It will be instructive, as research on sex and gender unfolds, to see what the consequences of these three patterns of relationship are for those caught up in them. It is perhaps idle to speculate, but my own interest would focus on the second, the congruent relation of the internally dissonant, the first being too harmonious, perhaps, and the third too chaotic to sustain imaginative discovery.

Whatever the outcome, it is plain that the two sorts of dissonance, within people and between people, interact. As it happens, I recently came across a case that illustrates this well. It touches on visual images and their role in bringing the latent to life; and, as a good illustration should, it springs at least one surprise.

It concerns a timid, physically delicate man in his thirties, who grew up in the shadow of elder sisters. As a teenager, he was taken up by a young lady of exceptional vivacity. They married and became parents. As he now describes them, their sexual intimacies followed a fairly conventional pattern, but were ones in which her appetites outran his. She exhausted him sexually, and then embarked on a series of affairs. Isolated, he began to read pornography and, particularly, to look at pictures of boys. An openly affectionate man, he had fallen into the habit of fondling a neighbouring boy – like his own son, pubescent. Without realizing in the least that this was about to happen, he found one day that he was enacting with that boy (and, later, with some of the boy's friends) every carnal fantasy that two male bodies permit. It was as if his pornographic looking had marshalled in his mind a repertoire of gross and forbidden acts; ones that had led him, more or

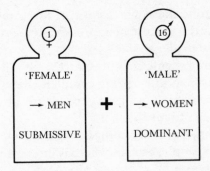

Figure 7 Marriage partners who are mutually complementary

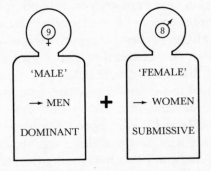

Figure 8 Partners who are complementary but
internally dissonant

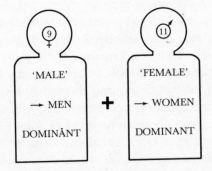

Figure 9 Partners who are non-complementary *and*
internally dissonant

less without warning, into outrageous and illegal behaviour, and thence into a maximum security gaol.

When I talked to him some while later, he displayed no guilt over the boys he had violated, all of whom, he argued, were willing, and one of whom turned out to be a young male prostitute. On the other hand, he shed hot tears over his wife, who had by now left him, yet about whom he still seemed obsessed.

I learnt nothing, talking to this unexpectedly likeable man, about the central puzzle of sexual crime: why, when many people's heads are full of fantasies of rape or degradation, only a minority act these out. The rules governing this movement from fantasy to action, from inside to outside, remain inscrutable. What I did carry away from our conversation was the sense of sexual acts forming an unacknowledged repertoire in the mind, long before they are identified or acted upon; and – a point not accommodated by my decision tree – of the categorical discontinuity that can exist between what we do and what we care about. This man's homosexual exploits were devoid, in retrospect, both of prudish scruple and of emotional significance. Far from being the discovery of his true self, they were simply things he had done. It was as if he were free to experiment only when he was emotionally unengaged. His life with his wife, on the other hand, still a matter of intense emotional concern to him, was the focus of considerable prudery. (He cited his wife's interest in oral sex as though this were evidence of her abnormality.) She had taunted him publicly for his lack of manliness, was blatantly unfaithful to him, and had abandoned him now he was in prison; yet he was bound to her, it seemed, with hoops of steel. His fate seemed inseparable from his wife, or some other woman closely resembling her.

There may well be cases, then, in which the pattern of need we openly display represents our 'true' self, and in which latent patterns embody fragments of ourselves that are, if not false exactly, at best tangential to the main enterprise of our lives.

With that important caveat, this shy man with his pornographic pictures conforms quite closely to my theme. The more internally inconsistent our identikit, the shakier the decisions on which it is based, the more likely we are to explore alternatives; and to do so, in the first instance, at one symbolic remove, in terms of the visual images, stories and songs that our culture provides. What we can

squeeze into our acknowledged intimacies is often only a fraction of what we wish to squeeze. Accordingly, it is through images, stories and songs that we hope to discover what it is that these intimacies omit.

Notes

1 Money and Ehrhardt (1972) discuss these sexual abnormalities, illustrating their text with disconcerting photographs of the conditions in question.

2 Tanner (1978), p. 70.

3 Stoller (1968, 1975). Stoller is outstanding among those now writing about sex and gender, not least because he allows the people he studies room in which to breathe.

4 Goffman (1959). Goffman, a sociologist, uses this phrase to sustain a view of the self that is essentially theatrical. He sees the self as a repertoire of performances elicited from us by others. This does less than justice, though, to the internal processes of professional actors (Hudson 1975); and it precludes the discovery of a 'true' self underlying the 'false' one on public display (Laing 1960, 1961). To my eye, the 'archaeological' reconstruction of the 'true' self remains a plausible endeavour. Without it, both personal discovery and psychotherapy remain matters of rhetoric, of swapping one sustaining story for another.

5 The scheme I offer here is grossly oversimplified, of course. A person's presentation of self is often inconsistent. The lion of the locker-room may enjoy making jewellery, or even experience the impulse to cross-dress. An adequate scheme of sex and gender must take into account not only inconsistencies between levels but inconsistencies *within* levels. Recent thinking about androgyny encompasses some at least of these difficulties (Hartnett, *et al.* 1979): the man with passionate interests in rugby and flower-arranging is certainly a different kettle of fish, psychologically speaking, from his neighbour, all of whose interests are luke-warm. A further criticism of the decision tree model I have used is its implication that, for example, gender identity is established before object-choice, and that while a shaky gender identity may disrupt object-choice, the reverse does not occur. Such an assumption may well be unsound. Such faults notwithstanding, this kind of modelling seems to me in every way more fertile than orthodox approaches to the measurement of masculinity and femininity, especially those in which

the various facets of an individual's masculinity or femininity are scrambled together into an average score. In a field like sex and gender, where the individual's choices are complex, and where solutions are often ambiguous, conventional arithmetical procedures seem more than normally obstructive.

3 In Two Minds

Implicit in what I have said so far is the assumption that images of the body matter because they provide us with access to some of the more intimate contradictions of our nature. I want now to lift this assumption into the light of day: to spell it out in a way that may seem excessively literal. What I have in mind, in essence, is a simple model of creativeness; and I propose to leave it in a generalized form in order to counterbalance the unavoidable particularity of what follows. While contradictions of sex and gender are going to have a special bearing on my argument, I want to treat them for the time being as a sub-set of all the muddles and confusions that assail us.

As a first step I propose to be less apologetic than psychologists usually are about the state of being in two or more minds. Over the years, philosophers and psychologists have come to treat crisp dictionary definitions as the norm, and as a result equivocation is now seen as vaguely discreditable; muddle to be tidied up, rather than a fact of life to be described or explained. Vast mischief was done to British academic psychology in this respect by positivistic texts like A. J. Ayer's *Language, Truth and Logic*. Whatever their author's intention, these placed beyond the pale of legitimate debate all those issues that could not be construed as matters of fact: notably the arts; all ethical, moral and religious considerations; and all questions of introspection or perceived meaning. Although superficially astringent, the effect of such positivistic views was to encourage sloppiness in psychological debate. It became normal for the empirically-minded to muddle together, for example, the question of whether behaviour is inherited with

whether it can be modified; the question of what is conscious with what is rational. The psychoanalysts have muddied the pool, too; admirable in that they addressed the non-rational aspects of our thought, they did so as if they had access to some private lexicon of 'real' meanings. Thus dreams about fish are 'really' dreams about the phallus; hills are 'really' breasts; salt is 'really' semen.[1]

While equivocations of meaning may well be a nuisance when one writes as a scientist, it is upon resonances and dissonances of meaning that the professional skills of the artist or poet turn. In a univocal world, art is unintelligible except as fun. While it is no part of my purpose to attack science, it is central to it that art should be treated as a focus of intelligent concern. To that end, let me list, in no special order, some of the everyday respects in which we find ourselves in two minds:

1 Ambivalence
A new job promises opportunity and insecurity in equal proportions; a publication brings a sense of achievement and nakedness to criticism; a child needs his mother and resents her simultaneously; the housewife is both attracted to the postman and despises him socially; the politician balances party loyalty against public interest, honesty against survival.

2 Dithering
A wife dithers about whether to declare her overseas earnings to the inspector of taxes; her husband changes his mind repeatedly about whether to stay with her for the children's sake, or set up home with the woman he thinks he loves. Rival scenarios, rival patterns of cost and benefit, jostle against one another perplexingly in the mind.

3 Censorship
Daily, we censor part of what we say, comforting the neighbour we are sorry for but suspect of self-indulgence, smiling at the boss we depend on but suspect of malevolence. Responsible relationships all encourage this fissure between what is said and what is held back: many doctors, social workers, teachers, nurses, administrators, politicians, spouses and parents not only settle for the dualism of front-stage and back-stage, but cease in the end to see the public

performance as any less 'real' or 'sincere' than the commentary that could be offered behind the hand.

4 Pretence
Some awareness of the truth usually hovers at the back of the mind while a pretence is being sustained, a lie being told. Truth and falsity coexist rather in the way that thoughts of the slaughterhouse hover behind a mouthful of beef.

5 Discrepant yearnings
One pattern of behaviour can inspire another that contradicts it. An appetite for danger, even disaster, can take shape in the mind of someone ostensibly committed to worldly security and success; religious sentiments in the mind of a dedicated rationalist; the capacity for contempt in someone given over to being kind. We are all susceptible to such uncomfortable surprises.

6 Disowned acts
The executioner enjoys his work, and the urban guerrilla too, yet both may tell themselves that they are instruments of some higher cause, people doing their impersonal duty. More prosaically, the drunken man who takes his clothes off while drunk, or the drunken woman who goes to bed with a stranger, both dissociate themselves from their actions by explaining that they are drunk, and the rest of us collude.

7 Fantasy at odds with reality
Ordinary men may lay waste to their marriages with tirades about their wives' infidelity; suspicions that they know are ill-founded. Their sons, the while, produce each tennis service as Björn Borg, although the ball lobs gently each time into the net.

8 Alternative selves
Some switches of mood are superficial; others carry with them whole systems of belief and need. Proust remarked on this:

> I learned to distinguish between these states which reigned alternately in my mind ... each one returning to dispossess the other with the regularity of a fever and ague: contiguous, and yet so foreign to one another, so devoid of means of communication, that I could no longer

understand, or even picture to myself, in one state what I had desired or dreaded or even done in the other.[2]

Both in the superficial and more exacting passages of our lives, we can find that we are divided against ourselves. In another context, I would be willing to argue that all forthright self-expression carries its own negation in tow; that each policy we adopt, each relationship we enter, represents a victory for one of our dispositions over a rival, or several rivals. Marriage, on this view, is inseparable from thoughts of disunity; love creates the conditions for hate; and the middle way, the path of moderation, is not genuinely moderate, but reflects a stable truce between internal forces that are opposed. Here, though, a more cautious position is all my argument requires: the claim that everyone is in two minds some of the time, and that some of us are in two minds a great deal.

Grant this, and a simple model of creativeness offers itself directly – 'creative' in that the activity in question demands imaginative effort, and leads to the discovery of something new. This model holds that in the face of irreconcilable conflict, we move spontaneously from the level of the literal to that of the symbol: from people and places to poems, paintings, songs and plays. The symbolic establishes itself as the venue within which we can then explore our confusions, gain manageable excitement from them, and attempt their resolution at one remove.

As far as I know, the neatest and most broadly generalized formulation of such a model is to be found in an article by the American psychologist Donald Mackinnon.[3] In it, he draws on the views of Otto Rank, a psychoanalyst who was one of Freud's intimates, but who was later denounced by the faithful as a crackpot. The Rank–Mackinnon model holds that as infants, and ever after, we are trapped between two irreconcilable fears. The first is the fear of separation; of having to stand alone. The second is the fear of being engulfed; of being swallowed up by those parents and parent-substitutes on whom we depend.

Rank seems to have reached this existential formulation via his interest in birth trauma; his conviction that none of us ever fully recovers from the shock of being uttered into the world from the security of the womb. Excessively literal and even slightly dotty

though its inspiration may have been, the Rank–Mackinnon model can obviously be stretched to accommodate all manner of ambivalences and contradictions; and it has the profound virtue of instability. Being dialectical in form, it conceives of the individual as suspended between needs that are mutually incompatible. All he can do, under the pressure they exert, is to move in search of temporary and partial solutions. The model countenances three. The first is arbitrary. It consists in taking refuge in whatever way of life is perceived at the time as orthodox or conventional. The second carries the individual further afield, into projects that seem genuinely self-expressive, but in which he continually undermines his own best efforts; a pattern of internally generated frustration. Only the third solution is satisfactory: the path, to borrow a Rankian phrase, which leads the individual to perform feats of 'will and deed', and in which the contradictory pressures at work upon him are symbolically reconciled.

In form rather than content, this Rank–Mackinnon model is reminiscent of the startling suggestion that Freud made, years earlier, in the course of his essay on Leonardo, where he claims that all thinking has its origin in 'infantile sexual research'. The infant, especially the gifted one, is moved to think about sexual intercourse, pregnancy, and the differentiation of the male and female anatomy. His research, in other words, concerns the nature of his parents' bodies. This curiosity is then repressed: 'research shares the fate of sexuality; thenceforward curiosity remains inhibited and the free activity of intelligence may be limited for the whole of the subject's lifetime'.[4] Alternatively, it may lead to an interminable and unproductive brooding over the mysteries of sexuality. Or, the third possibility, thinking to some extent liberates itself from its sexual past; it is 'sublimated', and although it retains certain formal characteristics of its origin, it can now be directed to concerns other than sex.

Like Freud's, like any other, the Rank–Mackinnon model of creativeness is too simple to be true. The temptation is to hedge it around with qualifications. Here I will restrict myself to two.

The first concerns art's subversive function. Although similar in many ways to works of science, works of art not only threaten established orders of thought (as good science does); characteristically, they threaten the order they themselves create. Often, they

are intrinsically subversive, in other words, creating order and threatening to undermine it at one and the same time. As such, they belong to a much wider family of human games, some of which are of an altogether humbler nature, and many of which never see the light of day; Robert Stoller, for example, likens art to sexual excitement, and sees both as the search for 'controlled, managed ambiguity'.[5]

My other worry about the Rank–Mackinnon model centres on the relation of creativeness to depression. The model seems to idealize feats of 'will and deed', and to overlook their cost to the individual who performs them. In order to create any product of value, he must be willing to 'export' some significant element of himself, moving it from the security of his own imagination, and placing it in a public arena which is at once impersonal and fraught with the possibility of hostile criticism and rejection. Such effort seems naturally to leave a sense of emptiness and depression behind it. More specifically, I am attracted to the psychoanalytic theory which holds that depression is not merely the natural consequence of creative achievement, but a necessary prelude to it; that bouts of creativeness and depression are locked together cyclically. Vivid examples are easily come by. My own favourite is that of the German poet Rilke.

Throughout the years 1912 to 1921, Rilke, a poet of renown, remained in a state of depression, producing little. Then, in the autumn of 1921, he set himself up in isolation ready to write. 'Utterance and release' came to him six months later. Within the space of eighteen days, he wrote, largely without effort or revision, no less than 1230 lines of polished verse. When he began to write, he had expected to finish his *Duino Elegies*; what he in fact wrote were the first twenty-six *Sonnets to Orpheus*, poems of which he had no prior knowledge whatever. He then finished the *Elegies*, wrote twenty-nine further *Sonnets* and then, 'a radiant afterstorm', one last *Elegy*.[6]

The relation of creative effort both to depression and to the prospect of death is stressed in Elliott Jaques's striking essay 'Death and the Mid-Life Crisis'; it also informs many novelists', painters' and poets' reflections on their own activities.[7] In his *Collected Essays*, Graham Greene draws a parallel between the risks such people run and those of the professional explorer. He

suggests that it requires the same 'urge to surrender and self-destruction' to 'fill in the map' as it does to 'fill in the character or features of a human being'. A few lines later, he quotes from Mungo Park: 'When the human mind has for some time been fluctuating between hope and despair, tortured with anxiety, and hurried from one extreme to another, it affords a sort of gloomy relief to know the worst that can possibly happen ...' Again and again in Park's narrative, he observes, 'the prose quickens with that gloomy relief as his fingers touched the rock bottom of experience'. As Greene says in another context, that of warfare: 'There is something just a little unsavoury about a safe area – as if a corpse were to keep alive in some of its members, the fingers fumbling or the tongue seeking to taste.'[8]

One must be cautious of course. There are many thousands of depressive episodes for every one that issues in a creative achievement; and – as Anthony Storr has pointed out – creative individuals differ among themselves.[9] In some, work seems fuelled not so much by depression as by a carefully regulated hostility. One thinks for example of Picasso, for whom good paintings are 'instruments of war' that ought to 'bristle with razor blades', and whose working life seems to have been activated by the urge to dismantle the human body at one remove.

However, my point is not one specifically about depression but about personal danger, irrespective of whether this takes the form of depressive or schizoid episodes, bouts of dependence on drink or drugs, or physical collapse. Such danger, I want to suggest, is not simply a cost or consequence of creative effort, but frequently accompanies it; because it is in taking such risks that, in spite of himself, the individual reaches beyond the dictates of common sense, and, however fleetingly, catches himself unawares. Psychically, there are strong reasons for seeing what we expect to see. Somehow, the individual who wants to break new ground must engineer a hole – or, to use Kurt Vonnegut's expression, a 'leak' – in the otherwise seamless fabric of his expectations.[10] Ingmar Bergman has put it well: 'A film for me begins with something very vague ... split second impressions that disappear as quickly as they come ... Most of all, it is a brightly coloured thread sticking out of the dark sack of the unconscious. If I begin to wind up this thread, and do it carefully, a complete film will emerge.'[11] The

implication is that, like Rilke's sonnets, Bergman's film is already there; that his task is not to invent a film but to gain access to one that is already in existence and is waiting to be deployed.

Works of quality in art or science are in this respect alike: each depends on a step into the dark. As Einstein once remarked: 'theory can be proved by experiment; but no path leads from experiment to the birth of a theory'.[12] So much is by now commonplace. Taken together, though, the two qualifications I have made to the Rank–Mackinnon model – concerning the subversiveness of the work itself and its cost to the person who creates it – have implications that are less obvious. Just as the individual who produces a poem, film, painting or scientific theory has an interior life, so too, I would want to propose, has the work he produces.

In the case of a painting, the work is the artist's product; but it has its own integrity, and is in a position to offer recalcitrance much as a person might. The work is a device that the artist uses to discover where the boundary between the acknowledged and unacknowledged aspects of his own imaginative activity lies. This remains moveable, permeable, while the work is still in progress, but as soon as the work is complete, it becomes defining.

The artist constructs a sign that has an accessible surface structure, and at least half-hidden, a cargo of meanings which neither he nor his spectator is fully in a position to grasp. It will remain vividly alive to him, and unambiguously his, until it is finished, perhaps put on exhibition and sold. At this point, it becomes the trace or recollection of an intimacy rather than the intimacy itself. It is a relationship, in other words, that has a sense of loss built into it. Consequently, it should not surprise us that painters, and creative people more generally, are inclined either to see themselves a shade impersonally, as channels for the expression of ideas that lie partially outside the scope of their responsibility, or to become hankerers and tinkerers. The poet Rilke seems to have been an instance of the first condition; the painters Bonnard and Degas, instances of the second. Bonnard, it is said, used to sneak into public galleries and make alterations to his own works on exhibition there while the attendants were not looking. Degas was much the same. Ernest Rouart, son of one of Degas's patrons, claims of Degas that:

Whenever he came upon some more or less early work of his own, he always wanted to get it back on the easel and rework it. Thus, after seeing again and again at our house a delightful pastel my father had bought and was very fond of, Degas was seized with his habitual and imperious urge to retouch it. He would not let the matter alone, and in the end my father, from sheer weariness, let him take it away. It was never seen again.'[13]

Restitution was eventually made in the form of the famous *Danseuses à la Barre*. Degas fervently longed to rework this too, but was never given the chance.

If an artist (or scientist) uses his work to explore the limits of his own imaginative powers, and then, by making them public property, abandons them, he will experience not just post-parturitional gloom, but a state in which his own boundaries, both internal and external, have been dangerously weakened. He has subjected himself to a species of leaching, and, temporarily at least, will be vulnerable both to the alien from without and the alien from within. Each successive work thus becomes a means of repairing the damage the artist has done to himself by the publication of the work previous to it. In this respect, the production of symbolically significant objects, of whatever sort, becomes the temporary cure for the disease of which it is itself the cause. We produce in order to recover our equilibrium; but our equilibrium is in question because we produce.

These existential games, however, are not what they seem. At first sight, they look like flirtations, more or less serious, with the psychological dangers that the alien represents; games concerning the wilful loss and subsequent recovery of control. In fact, though, they disguise a paradox. As Norman Brown points out in *Love's Body*, 'the external world and inner id' are 'both foreign territory – the same foreign territory'.[14] In our feats of colonization, whereby we create and defend safe spaces in this alien landscape, we construct a world that is at once familiar but insipid, even spectral. And the more rigidly impermeable our defensive boundaries become, the more unreal the life we lead within their protection is perceived to be.

It seems that every time we reassert the boundary between the familiar and the alien, the acknowledged and the unacknowledged, we cut ourselves off from a source of vitality that we perceive as

life-enhancing and dangerous at one and the same time. A work of art (and also perhaps of science) retains its value, for artist and spectator alike, in as much as it contains, latent within it, hints of the feral energies on which it originally drew – in as much as it retains its status as a window or 'leak' on territory that is inescapably strange.

Notes

1 There are signs that philosophers are, once again, beginning to give the normal workings of the human mind their due; witness the papers in Amelie Rorty's recent collection *Explaining Emotions* (1980). There are indications, too, that a more realistic attitude to the natural history of mental processes may emerge from efforts to simulate the brain with a computer. Cyberneticists find no difficulty with systems in which separate sets of data are dealt with in parallel, rather than serially, and in which this processing is automatic and quite distinct from conscious access or review. Physical, biological and psychological systems often display 'bistability' or 'multistability', in that they have two or more configurations in which they are in equilibrium, and effect abrupt reversals between these (Apter, in press).

2 Proust (1966), p. 252.

3 Mackinnon (1965): an article which, at the time, attracted little attention.

4 Freud (1963), p. 114. Freud's tripartite solution to this puzzle is discussed sympathetically by Wollheim (1971). A virtue of such Oedipal theories is that they help explain the fear that new thoughts inspire. As David McClelland (1963) suggests in his paper 'The Calculated Risk', nine research students out of ten, faced with the possibility of making a discovery, will back nervously away. They will pirouette with any degree of elegance, but resist with panic the step that separates the familiar from the new.

5 Stoller (1976), p. 117.

6 Hudson (1975).

7 Jaques (1965). Kleinian analysts view this cycle as one of reparation and attack, of integration and fragmentation: the point is put clearly in Donald Meltzer's conversation with Adrian Stokes (Stokes, 1963).

Ehrenzweig, on the other hand, claims that 'projection (expulsion, scattering, casting-out) and containment (burial alive, trapping) are two poles in the creative rhythm of the ego'; and he sees this as tied to a 'severe crisis in the young child's development' ... 'the emergence of anal disgust at the age of about eighteen months' (1970, p. 228).

8 Greene (1970), pp. 239, 336.

9 Storr (1972). Storr differentiates three pertinent personality types: the manic-depressive, the schizoid and the obsessional. My suggestion is not that all creative people conform to the first of these types, but that, whatever the personality type, there is a personal cost. Newton is a good example. A paradigmatic instance of the schizoid pattern, he endured a prolonged mental breakdown at the end of his forties, from which he was to emerge, in Keynes's phrase, 'slightly gaga', never again able fully to concentrate, never again to do original work (Keynes 1963).

10 For psychologist and novelist alike, Vonnegut's *Breakfast of Champions* is an important and frightening text.

11 Quoted in Kinder (1980), p. 62.

12 Quoted by Storr, p. 89.

13 Dunlop (1979), p. 124. Bonnard's weaknesses in this direction are mentioned by Fermigier, p. 33.

14 Brown (1966). The implications of Brown's insight are worked out in some detail in an earlier book of my own, *Human Beings* (1975). There, I make use of octagonal lattice patterns; ones that apply equally to the relations between people and to the relation of individuals to works of art. One of their implications is that no one work of art (or, for that matter, any other symbolically significant product) can be perceived by two people in precisely the same light.

4 Containers of Consciousness

From their very beginnings, our traditions of visual imagery have been 'thoughtful'. Curiously, the only book I have read that illuminates this aspect of the visual arts is not about the visual arts at all, but one by a philosopher about novels and poetry: William Gass's *On Being Blue*. Gass, himself a novelist as well as a philosopher, discusses the technical means available to a novelist who wants to 'make his sentences sexual'. Only at the crudest level is it a matter of describing sexual acts or using sexual words: rather, a matter of fashioning 'containers of consciousness':

> It is not simple, not a matter for amateurs, making sentences sexual; it is not easy to structure the consciousness of the reader with the real thing, to use one wonder to speak of another, until in the place of the voyeur who reads we have fashioned the reader who sings; but the secret lies in seeing sentences as containers of consciousness, as constructions whose purpose it is to create conceptual perceptions – blue in every area and range: emotion moving through the space of the imagination, the mind at gleeful hop and scotch, qualities, through the arrangement of relations, which seem alive within the limits they pale and redden like spanked cheeks, and thus the bodies, objects, happenings, they essentially define.[1]

Like poets and novelists, visual artists of any quality 'structure the consciousness' of those who look at their works. They create illusions, certainly; but they freight those illusions with meaning.[2] Public images, and especially perhaps images of the body, have rarely been merely pretty or merely frightening; rather, they constitute carefully wrought systems of meaning that play on the intelligence as well as on the sensibilities of the people who stand

in front of them. The spectator is at liberty to respond intuitively; but he is also free to unpack such systems, and that is what I propose to do here.[3]

For those unfamiliar with it, a brief historical glance may help to make this view of the visual arts more acceptable. For history is in this respect quite unambiguous: while memorable images have usually reflected the appearance of the natural world quite closely, they have rarely been reflections and nothing more.

Sometime in the fifth century BC, and using precedents that now seem remarkably scanty, Greek sculptors began to produce lifelike images of men, and then, more slowly, of women, which were of high artistry. We know from contemporary accounts that the resemblance of these images to real men and women was seen as startling. Yet from the very outset, this lifelike accuracy was counterposed with two other considerations: the religious and the formal.

Our perception of these early works, and of those of the Renaissance that followed in their wake, has been blunted by their very availability: as postcards, illustrations in coffee-table books, posters, advertisements. They now constitute a species of visual Musak. (Photography is nothing if not two-edged.) One consequence is a loss of pleasure, of course; but there is also an impoverishment in our understanding of what works of art *are*. We find them 'charming', 'beautiful' or 'great'; detect in them 'social comment' perhaps, 'irony', or even the vestiges, still, of a certain 'frisson'. But we retreat progressively towards a view of paintings, sculpture and photographs that is stunting: the belief that they exist to evoke an emotional response; that they succeed in as much as they give us an undifferentiated 'buzz'.

My aim here is to bring certain of these mummified images back to life, showing that, like poems, they constitute 'texts' that shape and direct our thought. In doing so, I want to scotch any suspicion that the painters and sculptors in question were naïve about the feats of image-making they performed. As in psychology, so with the visual arts: sophistication seems if anything to have decreased with the passage of the years.

The most celebrated female figure in the antique world was Praxiteles's marble Aphrodite, now known to us only through copies and as the *Cnidian Venus*. She stood in a small shrine on an

island off the coast of Asia Minor, a goddess about to step into her bath. Yet contemporaries spoke of her as if she were a live woman. It was taken for granted that she was the embodiment of physical desire, and that this embodiment was an essential component of her sanctity. It was also taken for granted that she was a portrait of Praxiteles's model Phryne; a girl who shared with him some of the credit for the likenesses he produced, and to whom the grateful citizenry erected a nude statue in gilt bronze – one that was openly a portrait and yet was placed in a setting that was sacred.

For the Greeks of Praxiteles's day images of the nude body constituted a central component of society's public life. Likenesses and deities at one and the same time, these Greek statues were also products of a strongly developed impulse towards formal regularity. This is especially marked, Kenneth Clark suggests, in a forerunner of the *Cnidian Venus*, again known to us only through copies, and referred to by him as the *Esquiline Venus* (see Plate 1). She is constructed on a modular scheme in which the unit of measurement is the head. As Clark describes her, she is seven heads tall. There is one head's length between her breasts, one between her breast and her navel, and one from her navel to the division of her legs. Although waists grew narrower, breasts larger, and hips more generous, the *Esquiline Venus* established the model of the nude that was to 'control the observations of classically minded artists' until the end of the nineteenth century.[4]

Formal concerns do not end with this modular scheme. Conspicuously, the *Esquiline Venus* has been tidied up; her body has been smoothed and simplified. This is especially so in the treatment of the pelvis, which, although based on observation of what women are actually like, reaches some solutions to the torso's formal difficulties that are those of abstraction: the crease running up from the navel; the saddle of flesh joining the bottom of the stomach to the *mons veneris*; and the treatment of the *mons veneris* itself. Such tidying and smoothing creates an image that we immediately recognize as idealized; and in so doing, we acknowledge, whether we realize it or not, that the alarmingly earthy aspects of the body and its functions are associated in our minds with its untidy detail: its pimples, creases, puckers, hairs, blotches. Crucially, a formal treatment of the body encourages in us the denial that these dangerously particular features of the body are in fact there.

What separates us, historically, from the Greeks and Romans is the influence of the Christian Church. For a millennium, it was doctrinally inadmissible to portray the naked human form; and medieval art is our evidence of how completely Christian dogma expunged the imagery of physical beauty. The body, in Clark's words, 'ceased to be the mirror of divine perfection and became an object of humiliation and shame'. The 'bulb-like women and root-like men' of Gothic painting 'seem to have been dragged out of the protective darkness in which the human body had lain muffled for a thousand years'.[5]

Once the Church's prohibition was lifted, events north and south of the Alps took different courses. In Italy, the idealizing conventions of the ancient world were quite soon readopted, while in Germany and the Netherlands, the spirit of rebirth fused both with the Gothic sense of shame, and with an analytic concern for detail. This fascination with the particular is exemplified in the attitude, north of the Alps, to draughtsmanship. In Italy, drawing frequently served as an aid to painting and sculpture, but in the north it became an end in itself, the artists evolving a technique ideally suited to their needs. They created a polished surface on unsized paper with a mixture of chalk or pulverized bone and glue, and worked on this with the most scrupulous accuracy in silver-point or lead pencil.[6]

This concern with the body's particularity is shown beautifully, as Clark says, in van der Goes's *Adam and Eve*, a Flemish work of the fifteenth century (see Plate 2). Clark speaks of the 'humble usefulness' of Eve's figure; and of her as the 'docile mother of our race, home-keeping, child-bearing, flat-footed with much serving'. Van der Goes's Adam and Eve make no claim on the ideal at all; as remote as they could be from the Greek gods and goddesses, they look like nothing so much as a pair of research students caught without their clothes.[7]

Although these northern images had none of the grandeur of their counterparts in the south, they did focus the mind sharply on certain of the eternal verities: conspicuously those of sexuality and death. An eloquent feature of these northern nudes is the stress that artists like van der Goes, van Eyck and Dürer place on the female stomach. This is not fat or flabby but tensely swollen. Patently, to the modern eye, van der Goes's Eve is a young woman

six or seven months pregnant. While in Italy, painters and sculptors produced images of young women as goddesses, as remote from earthy obstetric detail as the modern pin-up, those in the north were evidently intrigued by these facts of life, a fascination mixed with dismay (see Plate 4).

In his chapter on this 'alternative convention' in *The Nude*, Clark touches more or less in passing on a small carved figure of *Judith and Holofernes* by Conrad Meit, pointing out that the 'sculptor has intended her to be physically desirable', and that 'after the eye trained in classical proportions has allowed the first shock to subside', we must allow that he succeeds (see Plate 3). This creation of Meit's is the first of the ones that I would like to look at more closely, because it perfectly exemplifies the notion of an image as a 'container' – sharpening our awareness, but hemming us in too, forcing us to contemplate certain associations that we might otherwise find it natural to avoid.

Meit was a carver; one of a large number working at the beginning of the sixteenth century in the Netherlands and Germany, producing small effigies in wood, silver, ivory, or, as in this case, alabaster. In the years of his maturity, Meit will have produced his tiny sculptures not for the Church, then entering a phase of unprecedented upheaval, but for 'amateurs of humanistic leanings'.[8] Although his *Judith* cannot be dated with precision – scholarly estimates span the years from 1510 to 1528 – we do know that betwen 1506 and 1510 Meit was at the court of Friedrich the Wise in Wittenberg, where he collaborated with Cranach the Elder; and that, from there, he moved on to the Netherlands. In 1514, he was court sculptor at Malines, where he was employed by Margaret of Austria; and he died in 1550 or 1551 in Antwerp. Like other artists of his era, Meit travelled a good deal, and did so at a time of exceptional artistic vitality: besides Dürer, Holbein the Younger and Cranach the Elder, Altdorfer and Grünewald were his approximate contemporaries.

At first sight, Meit's *Judith* is grotesque: head and hips too large; shoulders, rib-cage and breasts too small. Conspicuously, her torso has lengthened: the distance from breast to navel is now twice what we expect it to be. Worse, rather than being gathered into firmly structured masses, her flesh threatens to sag. Her stomach protrudes; and a series of related curves – across the

bottom of her stomach and, arching upwards, across the tops of her thighs – direct the gaze to her vaginal cleft. Instead of being smoothed away, this is plainly marked, in a manner analogous to her mouth and navel. Hers is a body not only capable of bearing children, but one that has already done so. In her right hand, she props a massive sword; in her left, she holds Holofernes's head by its hair.

Looking back, a little hazy about dates, we might conclude that Judith's physical attributes are the result of naïvety. This would be a mistake, though. Communications across the Alps, between Italy and Germany, were better than one might imagine; and those up and down the Rhine between Austria, Switzerland, southern Germany and the Netherlands likewise. It follows that news of Italian work, that of Donatello, Leonardo, Michelangelo and Raphael, will have spread. A marble virgin by Michelangelo, for example, was installed in Bruges as early as 1506, but seems to have had little immediate effect. Meit's contemporaries in the north – Dürer, conspicuously, and Holbein the Younger – were in any case capable of a startling verisimilitude. One must conclude, I think, that Meit's *Judith* expresses not ineptitude but consciously exercised choice.

An obvious standard of comparison is Donatello's *David* (see Plate 5). Produced some seventy-five or eighty years earlier, south of the Alps rather than north, it is a work of the highest originality. A beautiful lad in floppy hat, notably Victorian-looking to our eyes, David, like Judith, holds a huge sword, and has a severed head in his possession. Without question, Donatello was the sculptor of the greater stature, and not solely because he worked on a monumental scale rather than in miniature. But the comparison of these two particular figures, Meit's *Judith* and Donatello's *David*, by no means unambiguously favours the Donatello.

David *is* sumptuously attractive, even chic; but sumptuous physical attraction makes a claim that is relatively superficial. Judith's impact is altogether more disconcerting. Where David conveys the classical virtue of aplomb, it is Meit's Judith that more thoroughly infiltrates our defences. In Clark's terms, David is unequivocally *nude*, whereas Judith in unequivocally *naked*: where the Italian tradition denies the shamefulness of the body, the

Germans announce and exploit it. Osten remarks on Judith's 'corporeality', and on the 'supreme sensuousness' of her Düreresque proportions. For the first time in the north, he claims, sculpture exists for its own sake, with no support from architecture. Quite effortlessly, it creates its own space; 'probably the most satisfying' expression of the Renaissance 'the north ever saw'. Hibbard, too, acknowledges her 'serene command of space', but also comments on her eroticism, which he finds 'almost repulsive'.[9]

Plainly, Meit operates in the hinterland of our imaginations where sexual excitement and fear meet. Puritanical influences, you sense, cannot be far away. Working in Wittenberg, roughly at the time his *Judith* was produced, he will not only have met the court painter, Cranach, but also Cranach's friend Martin Luther. It was only a few years later, in 1517, that Luther, a philosophy teacher at the University of Wittenberg, was to nail his ninety-five theses to the door of a church, and set the Reformation under way.

Like any other artist, Meit worked, of course, from precedents. The proportions of Judith's body, her rather odd facial expression, follow those of the ivory carvings of the preceding century or two. What Meit did was to soften and to elaborate; and, in the process, to focus our minds sharply on the physical nature of Judith's dealings with the unfortunate Holofernes.

The story of Judith and Holofernes, the sculpture's literary message, comes from the Apocrypha. Judith, its heroine, is a widow, and when her people are threatened by Nebuchadnezzar's army, she saves them by insinuating herself into the favours of the army's general, Holofernes. She beguiles him, and allows him to take her to his tent, where he gets helplessly drunk. Judith cuts off his head and takes it back to her people, who rout the Assyrians in the battles that follow.

Prior to the Renaissance, the Church treated this story as symbolic of Virtue conquering Vice, but such a construction of Meit's work is bound to seem strained, for, like his contemporaries, Meit was using the story of Judith and Holofernes as a pretext to probe. Although it is never easy to 'read' a sign as multifaceted as this over a span of nearly five hundred years, we can follow him some of the way. In doing so, it is worth bearing in mind Clark's comment that the Reformation seemed to release an appetite for provocative nudity throughout Protestant Germany. It was

Cranach, Luther's ardent supporter, who developed a new and explicitly provocative version of the female nude, elongated in the oriental fashion, and bedecked with jewels and the flimsiest of drapery. Evidently, the relation of puritanism, sexual provocation and explicitness about the body's functions is a topic about which psychologists ought to know more than they do.[10]

Having gazed at Judith herself for a while, one's attention switches to the severed head. In Donatello's *David* and dozens of other Italian works of the era, this serves either as a stage prop or as a device for eliciting horror; but in Meit's, the arrangement is more carefully poised. With her left hand, Judith rests Holofernes's head on top of a plinth. With her right, she holds the handle of his sword. Between bearded head and massive sword handle, delicately modelled in alabaster, is placed what is most unambiguously sexual about Judith's body: the space that includes her navel and her vagina. For once, it is easy to accept the psychoanalytic suggestion that the sword is emblematic of physical potency and power: a 'phallic symbol'. Leaving aside the question of what does and does not count as 'phallic', one cannot escape the conjunction of Holofernes's face with Judith's sexual quarters. Both at the level of a pun, and more literally, Meit is reminding his male spectators that, in our desire, we lose our heads. The soft, apparently defenceless female form separates head from sword: our powers of sentience and reflection from our power to act. The bearded, armoured male is destroyed in a moment's inattention, not by a rival male, but by a creature who seems to present no possibility of threat at all.

Armed with vicarious expertise by Graham Greene and John Le Carré, we can scarcely avoid other questions. In Le Carré's terms, Judith set a 'honey trap' for Holofernes, and he fell in. It is a curious mentality, the one that sets out to sleep with a man in order to betray or kill him. Is the woman sexually excited, one wonders, or calmly manipulative? Does she have orgasms, or only pretend to have them? Is she taking revenge? – and, if so, on whom?

At a fairly straightforward level of interpretation, death is the embodiment of decay, disgust. More subtly, it also signals the annihilation that awaits us in love; the collapse, as Roland Barthes observes in *A Lover's Discourse*, of all our most carefully mar-

shalled skills and capabilities.[11] Once seized by amorous senti-
ment, in a sense the only sentiment worth being seized by, we find
ourselves locked within a circle from which there is no escape: we
are banal, we cry, we feel fully alive yet disintegrating, we suffer
reversals of identity, we find the loved object both transparent and
inscrutable. Our head remains on the block because we lack the
will to remove it.

If we are male, it is hard not to identify with poor Holofernes,
our head in one of Judith's hands, our sword in the other, and the
rest cut clean away. Abolished, our bodies have been replaced by
Meit's carefully architectural plinth, on which the head rests,
slightly askew.

In old-fashioned psychopathological terms, Meit's is a sado-
masochistic fantasy,[12] but viewed more transactionally, it becomes
an exercise in the paradoxes of power. This is plain if the sculpture
is viewed from Judith's vantage point rather than Holofernes's; the
female rather than the male. Judith reduces a predatory general,
administrator of an invading army, to spare parts: head, sword,
plinth. But her power is paradoxical in that she can only exercise
it when defenceless, naked. She wields the power of life and death
because Holofernes assumes that she is not in a position to do so.
Hers is the power, in other words, of undisclosed intentions. The
expression on Judith's face might encourage a cynical reading of
the hidden strength she possesses: that she and perhaps all women
depend for their power on deceit, offering love and affection they
do not feel, and manipulating the male's jealousy and possessive-
ness. The delicacy of her body, flanked by metal sword, geomet-
rical plinth and Holofernes's hairy creased face, on the other hand,
suggests a more generous and more cosmic view: that assertive
masculinity reduces in principle to head and sword, and the loss
of all more subtly physical pleasures, while femininity embraces
all those contradictory qualities, delightful and alarming, fertile
and mortal, that Judith's body conveys.

This northern vision of the female body was to reach its extreme
form a century later, in the pouched and baggy nudes of Rem-
brandt (see Plate 5). Adrian Stokes once evoked their quality
somewhat fancifully, but with eloquence:

> Rembrandt, it seems to me, painted the female nude as the sagging
> repository of jewels and dirt, of fabulous babies and magical faeces

despoiled yet later repaired and restored, a body often flaccid and creased yet still the desirable source of a scarred bounty: not the bounty of the perfected, stable breast housed in the temple of the integrated psyche that we possess in the rounded forms of classical art, but riches and drabness joined by the infant's interfering envy, sometimes with the character of an oppressive weight or listlessness left by his thefts. There supervenes, none the less, a noble acceptance of ambivalence in which love shines.[13]

Whether or not this particular interpretative thread commends itself, it is Judith who rules the imaginative space that Meit has created: about that there is no question. The stock psychoanalytic response is to say that such an image depicts 'castration'. This seems to me both conceptually misleading and anatomically inaccurate. Holofernes has not been castrated, nor have his sexual organs been in any way tampered with: rather he has been beheaded, annihilated.[14] The repose of the group, its sense of brooding calm and finality rather than of exultation or butchery, triggers off yet another interpretative reverberation, to my eye the most enduring. To be hacked up, as in a Caravaggio, is a fearful thing; but to be relieved of the burden of life within the confines of a sexual intimacy is quite another. It might almost come as a relief. The point has been made by Ehrenzweig: the more combat-fatigued among us may come to welcome death as a refuge from apparently inexorable tension. For a man, death at the hands of a beautiful, mature and naked woman, soft rather than muscularly resilient, is an illusion come true: the tension-dissolving but momentary swoon of intercourse become permanent and irreversible. In the face of an image like Meit's, it is tempting (but dangerous) to envisage sex as the abandonment of the struggle to remain separate, and as the return to the female body, fertile *and* fallible, whence we came.

If I have read his *Judith* aright, Meit's thought was very sophisticated indeed. Any question of naïvety drops away entirely in the case of the second image I want to consider: Titian's *Venus and the Organ Player* (see Plate 6). Emotionally, the contrast with Meit's *Judith* is complete. It was painted some thirty years later, and declares itself as Italian with every brush-stroke. Nothing was ever painted north of the Alps that much resembles it: guilt and shame are banished; Luther might never have existed. Now in the

Prado, it is one of a series of Titians, all of naked women with musicians, all on much the same format. Their mood is of candid acknowledgement of the body, even celebration; and, as such, they are in direct line of succession from Giorgione's Dresden *Venus* and Titian's own *Venus of Urbino*. As Wayland Young put it: 'through the door Giorgione opened there poured two armies of painters: one was Titian and the other was everyone else'.[15]

The composition of *Venus and the Organ Player* is original, and Clark stresses particularly the frontality of the pose, which gave Titian the opportunity to render in paint 'his admiration for an expanse of soft skin, fully and evenly illuminated': the body of a woman like a 'full-blown rose, rich, heavy and a trifle coarse'. Clark also remarks on the painting's 'singularly un-aphrodisiac' quality.[16] What he does not comment on is the complexity of the painting's internal arrangements.

Let us begin with Venus herself. Her hair is dressed; she wears a necklace and bracelets on each wrist, but otherwise has nothing on. She is not naked, in other words, as someone might be when getting out of the bath; she is a woman who has dressed in high fashion but happens to be without her clothes. Although she presents her body to us frontally, she does so without any special pride or allure. She looks away, in fact, to her dog – modestly, as though her body were a gift as natural as landscape: something she owns and yet over which she exerts no special claim.

On the end of her sumptuous couch sits the Musician; fully dressed, with sword at his side. He is seated with his back to Venus, playing the keyboard of an organ, but is craning back over his shoulder and is staring fixedly at Venus's body.[17] His expression is in no sense lubricious: rather one of concentration, almost as if he were reading. He looks towards Venus while she looks away.

Behind them is an outdoor scene; a formal garden. The most conspicuous figure in the garden is a satyr in the shape of a fountain; but, in addition, there are two figures walking along together embracing, a stag, two dogs, a peacock, and two more animals which are either deer or sheep. The status of this garden scene, however, is equivocal. It might be a view seen from a loggia, as Wethey seems to assume; but it might equally be a painting of an outdoor scene on a boudoir wall – a painting of a painting.

Whatever Titian's original conception, the stylistic incongruity between background and foreground exerts a continuous strain on the spectator's eye, forcing him to treat the garden not as a harmonious component of the painting as a whole, but as a space-within-a-space. The result, curiously, is to give the garden a status in some ways equivalent to that of a memory or a dream.[18]

Titian's painting had an exceptionally chequered history once it left his hands: negligently, in 1814, the French army dropped it into a river, and it was heavily restored in Paris before being returned to Madrid two years later. Consequently, it would be an error to build too much on any one detail. It is plain, though, that Titian placed figures in his garden for a reason. The satyr-fountain holds a huge jar on his head from which squirt jets of water; just discernible, the man and woman walking along the garden's path towards distant buildings are lovers; the stag, bottom left, is traditionally a symbol of the erotic; the deer or sheep just visible to the right are about to mate; the peacock traditionally signifies pride in self-display. The mood of events in the garden, then, is patently reproductive. And despite the separation of background from foreground, garden from boudoir, Titian is at pains to emphasize certain continuities between the two: albeit awkwardly, the rhythm of the trees continues that of the organ pipes; the line of the path, equally awkwardly, continues the line of the keyboard. We are clearly intended to integrate the events of foreground and background into a single frame of reference, but to accept as we do so a sense of categorical discontinuity: two spaces, two levels of reality, not one. The figures in the garden are 'there', but not quite in the flesh-and-blood sense that the Musician and Venus are. It is as if the Musician and Venus are people; the figures in the background, ideas.

Historians have stressed that while Titian drew on classical sources like Ovid's *Metamorphoses*, he was in no sense a philosopher; that his genius was intuitive. This seems to me misleading. There can be no mistaking the conclusion, as you work your way around the system of signs that make up *Venus and the Organ Player*, that you are in dextrous hands. His friends may well have been better versed in the precepts of humanism; but no one, before or since, has been more sensitive to the paradoxes a painter faces

when he sits before a naked woman and turns her into a work of art. We underrate Titian at our peril.

There are several routes into the delicately posed nest of ironies that Titian has woven. It is a matter of personal choice where you begin. My starting point is the undoubted fact that Venus is displaying her body not to the Musician, but to us, the spectators. We see her frontally, whereas the Musician can only see her sideways-on. Tactfully, Titian is forcing our hand, requiring us to countenance not just one layer of illusion, nor even two, but as many as three: (1) the *picture-within-a-picture*, where you find the satyr-fountain, the lovers and the various beasts in their garden; (2) the *pictorial*, the space in the boudoir, or on the loggia, that Venus and the Musician share; and (3) the *actual*, in which, standing in a gallery or sitting in an armchair, you look at an image of a man, a woman, and a garden. Of these three, the *actual* space, which we now take for granted, especially in those pin-ups and advertisements where the model stares invitingly straight into our eyes, was in Titian's day something of a novelty. Likewise, the device of a *picture-within-a-picture*. And Titian not only establishes these three spaces, but serves notice, as you glance round his picture in a preliminary way, that interesting things will happen in the movement of the imagination from one to the next. As you grow used to them, Titian's three spaces come to seem like three systems of self locked within a single head, almost as if they were the three faces of Eve; and the freedom you acquire in moving from one space to another is an exhilaration. From being restricted to one system of representation, one plane of construction, you are now free to explore the resonances and dissonances of three.

The fact that Venus shows her body to us in preference to the Musician suggests straightaway that, however impressive-looking, the Musician is a figure Titian views with less than solemnity; even as a figure of fun. The Musician's posture, after all, is very odd. Sitting there, fully dressed on the end of a naked woman's bed, he cranes over his shoulder to stare at her, but does not respond to her sexually, as a satyr might. Too civilized or too pretentious, he shows every sign of translating his desire for her into art. He is busy turning Venus into music. But if the Musician is a figure of fun, overcivilized and lacking in spontaneity, so too is Titian himself, painting pictures of beautiful women rather than

making love to them. And so, by implication, are we: poring over pictures of beautiful women painted by other people rather than doing those things together that men and women are naturally designed to do.

Grasp this irony, and you immediately face another. The earthly mechanism whereby Venus is translated into art is a musical instrument, the organ, and carved conspicuously on it is a face: a Medusa. Medusa, Ovid tells, was one of three sisters, the Gorgons, whom Poseidon ravished in the temple of the goddess Athene. In her resentment, Athene entwined Medusa's hair with serpents, turned her hands to brass, covered her body with scales, gave her teeth like a wild boar's tusks, and, a telling consideration, ensured that she would turn to stone everyone on whom she fixed her gaze, even after her own death. Perseus, who eventually slew her and carried off her head, was able to do so because he had a helmet that rendered him invisible, and a shield that acted as a mirror. He was thus able to avoid the eye-contact that would otherwise have been lethal.

In each of the five paintings in Titian's Venus and Musician series, Venus looks away: in this case, at her dog, in the other four at a child. Arguably at least, Venus is sparing both the Musician and ourselves her compromising Medusa-like gaze. As in the story of Diana and Actaeon, also treated memorably by Titian, it is sight that spells disaster. The message is plain: looking is dangerous. It can turn desire to stone. The translation of desire into art creates the Arcadian world of the garden into which Titian leads us by means of the visual echoes of organ pipes and trees, trees and fountain jets. But there, in the middle of the garden, at the heart of Titian's design, stands the Satyr: a symbol of priapic energy now doing service as a garden ornament. By looking, we translate sexual desire into an *idea*: that of pagan concupiscence. But there it stands, trapped, in a *painting-within-a-painting*, with no chance of making its way back into *pictorial* space or *actual* space.

Once committed to an eroticized looking, to translating, we are enclosed. The system is hermetic. The conceit is worthy of a metaphysical poet; Donne, say. Catching your breath, you realize that Titian is making you *think* – much as you might be forced to think about the implications of a new theory in molecular biology or physics. Identifying symbols and provenances, and making

appreciative noises about the painting's 'greatness' or 'beauty', will not serve.

If, chastened, you now go back to the painting as a whole, you find an array that must have posed Titian a formal problem: that of preventing the eye from resting entirely on Venus's resplendent body. Somehow, he had to make the spectator's gaze travel around the canvas, rather than leaving an unpleasant impression of lop-sidedness. Turner, looking at the version in the Fitzwilliam, saw the problem plainly. It is the landscape that must pull the eye to the left:

> Brilliant, clear and with deep-toned shadows, it makes up the equili-brium of the whole by contrasting its variety with the pulpy softness of the female figure, glowing with all the charms of colour, bright, gleaming, mellow, full of all the voluptuous luxury of female charms, rich and swelling ... To keep up that union of interest and support its assistance in attracting the eye from the right hand of the picture can be no small honour.[19]

Here, although the formal perspective of the garden's trees plays a part, it is the figures of Musician and Satyr that do the trick. As your eye moves between the three, dwelling on Venus, touching more lightly on the Musician, and more lightly still on the Satyr, you find each pairing of figures generating its own carefully poised oppositions.

If you happen to start with the movement from Musician to Satyr, you find the first of three structural oppositions, each rem-iniscent of those unearthed by anthropologists like Lévi-Strauss. Superficially, the relation is a straightforward contrast: the over-civilized Musician with the untamed Satyr. The Satyr's status is conditional, though; traditionally a figure of rude vigour, he is nonetheless a creature of myth, and can exist only in as much as people like the cultivated, perhaps excessively cultivated, Musi-cian see fit to envisage him. He has no existence outside art. The Musician is recognizably an individual (Ottavio Farnese, it has been suggested, though Wethey doubts this). The Satyr is in contrast a notion, a conceit. Among humans, we are being told, unbridled lust is an artifact; a fiction that occupies the imaginations of those men and women who are too complex to experience untrammelled release for themselves.

If the eye now moves, as it must, from the carnal exuberance of the Satyr to Venus and her dog, a second opposition offers itself; almost a pun this time.[20] The Satyr lives in a garden, a *formal* garden; that is to say, a piece of landscape rescued from the surrounding countryside by human effort, and subjected to a stringently geometrical sense of design. Venus's body, on the other hand, the presence around which the rest of the painting rotates, is in a sense the only unspoilt landscape left to us; the only landscape-like surface over which the eye can play without confronting the regulative effects of human intelligence.

If the gaze now switches, right to left, between Titian's two main protagonists, Venus and the Musician, a third discovery awaits you. Between them, Venus and the Musician define a view of gender. Venus is undressed, but decorated with jewels; the Musician is fully dressed. Venus is looked at; the Musician is looking. Venus's possession, the beauty of her body, is *given*; the Musician's accomplishments are all external to him: his music, his air of importance, his sword. They have all been striven for and achieved. (Figure 10.)

The interpretation so far may seem an exceptional yield from what looks, at first sight, like a work of mere decoration. In truth, we have only just begun. We are at liberty, for instance, to see the Satyr as a fantasy that Venus entertains in her mind's eye; her vision of an adequate response to her gifts, in contrast to the self-absorbed cavalier she finds on the end of her bed. Alternatively, we can begin with the Musician, and see him as making music as the only response adequate to the sublime sensations that Venus's beauty inspires; as creating an orderly garden of sound, a hymn to her presence – but one that contains broad hints of the bawdy.

Or again, we can return to the tension that Titian set up between the *pictorial* and the *picture-within-a-picture*, between events in the boudoir and events in the garden, and muse over the relation of common sense to myth. In the everyday world of the boudoir, a man and woman are having trouble of some unspecified kind with their scripts; with their roles as male and female. These are set out in archetypical form in the garden behind them. Common sense holds that the man and woman are free to revamp their garden at will; and the obvious inference is that the everyday world of men and women on beds is real while the mythical one of the

the garden:
the body as landscape

the artificially wild:
the civilized

the achieved:
the given

Figure 10 Structural oppositions in Titian's *Venus and the Organ Player*

garden is unreal. Yet if thoughts are real, which they undoubtedly are, and if thoughts move men and women, which they undoubtedly do, how can one be so sure about what is real and what is not?

And so on and on. Like any image that endures, Titian's painting *channels* thought, lifting its spectators from the world they immediately recognize – in this case, a man and woman perched uneasily on a bed – and carrying them back among their own more private ruminations. It does this not in a harshly determinate way, as a theory in small particle physics might, but with a strong sense of direction, even so. The metaphor of the garden is as useful in this context as it was to Titian; a tract of landscape rescued from the wilderness and brought under human control. As spectators, we can kick footballs across the grass if we feel we must; even find ideological reasons for urinating in the fountain. But we are usually best poised to learn something we do not already know if we follow the paths the artist has laid down.

Notes

1 Gass, p. 86. I wrote a pedestrian review of *On Being Blue* for the *Times Literary Supplement*; but, on this side of the Atlantic at least, it is a book that has received only a small portion of the praise it deserves. A difficulty is that Gass cuts verbal corners, wrapping solemnities in jokes and jokes in solemnities, in a way that makes any more plodding search after sense seem inept. Whereas Gass pursues thought in its own elliptical terms, I have used illustrations to provide evidence of the mind at full stretch, and have aimed otherwise to be plain. In the short run at least, these are bound to seem like expressions of two calibres of intelligence: one brilliant and the other parasitic. The question of lists exemplifies the difference. Gass offers to list the technical means available to the novelist in making his sentences sexual; but the reader, in the end, is never quite sure what the list contains, or where precisely it ends. Although the image of a list melting back into evocative prose is a wonderfully apt analogy of sexual experience itself, boringly complete lists do seem nevertheless to have their place.

2 I take it for granted that the artist works with an historically constituted stock of conventions and illusions: see, for example, Gregory and Gombrich's (1973) collection of essays on *Illusion in Nature and Art*.

3 I hope that my use of terms like 'text' and 'sign' will not be read as limply affiliative gestures towards Roland Barthes and his discipline of semiotics. As with psychoanalysis, this is an academic relationship that I would prefer to maintain at the level of friendly acquaintanceship rather than intimacy.

4 Clark (1960), p. 68. The interpretation of early Greek and Roman sculpture is a field of daunting erudition. I have taken Kenneth Clark's admirable *The Nude* as my guide through it. *The Nude* presents the outsider with an intellectual problem, however. Dextrously, Clark steers his readers past the excesses of the great iconographers, but in doing this he is continually at risk of overstressing the 'etymology' of an image (the question of who influenced whom) at the expense of the imaginative world it creates. He also makes the risky assumption that, give or take certain peripheral influences, all Western nudes up to the end of the nineteenth century flow from the same Greek and Roman source. This assumption leads him to overvalue the 'nude' at the expense of the 'naked', the idealized at the expense of the particular. It leaves him ill equipped when he comes to the twentieth century, and largely at sea with photography.

5 Clark, p. 300. Clark is illuminating about the alternative convention that sprang up north of the Alps; but, committed to a Graecocentric view of art history, he manages to convey the impression that what happened in the north was provincial, even mildly aberrant.

6 Delen (1950).

7 Clark, p. 313.

8 Osten and Vey (1969), p. 30.

9 Osten and Vey, p. 30; Hibbard, pp. 66, 220.

10 Clark, p. 319. A legacy of nine long years in Edinburgh is the discovery that the extreme puritanism of the Scottish Free Church is compatible with exceptional explicitness about the physical details of, for example, childbirth. One finds that superabundantly respectable young matrons of the Kirk will talk about their own bodies to superficial acquaintances, male and female, as though they were commenting on repairs to the guttering or drains.

11 Barthes (1979). Normally I find Barthes hard to follow, but this particular text strikes me as exceptionally shrewd.

12 I believe, though I have not read it myself, that the hero of Sacher-Masoch's *Venus in Furs* has a fantasy in which he identifies with the

implacable Judith's victim: Lucie-Smith (1972), p. 227. Other 'psycho-pathological' themes suggest themselves: that Holofernes's luxuriant beard is a transposition of female pubic hair; and that Meit is toying here with the parallel of mouth and vagina, hinting perhaps at fantasies of *vagina dentata*. Ehrenzweig (1970) discusses the pertinent myth figures of Gaea, her castrated husband Uranus, and her castrating son Cronus. I certainly do not want to discount such thoughts; they provide further layers of association to the danger implicit in Meit's image.

13 Stokes (1967), p. 36.

14 Like 'phallic', 'castration' is a term that has suffered from indiscriminate use. Lucie-Smith (1972), who offers a vigorous exposition of eroticism in Renaissance art, applies psychoanalytic theory to themes like Judith and Holofernes and Salome as though he were applying a law of physical science: 'The basic fear of the male, from the sexual point of view, is that of castration, and, more specifically, that of the castrating female The story of Judith and Holofernes is ... the one which symbolizes the castration fear in perhaps its simplest form ...' (p. 227). To use Oedipal notions in this way is to misunderstand the different roles that theory can sensibly be expected to play in psychology and physics: in one, a heuristic device, in the other, a law. When applied to people, theory serves as an aid to inquiry, not as a summary of inquiry's results.

15 Young (1965), p. 80. Wethey's (1975) scholarly account of Titian's work is the one on which I have mainly relied.

16 Clark, p. 122.

17 Arguably, the Musician is staring past Venus's body at her distracting dog. However, in both the other versions with organists, the Musician is gazing quite unambiguously at Venus's body.

18 In other works in the same series (e.g. in the Fitzwilliam's *Venus and Cupid with a Lute Player*), a far greater sense of formal congruity is achieved; and in another work of 1550 or thereabouts, very similar in composition, *Venus and Cupid with a Partridge*, the architectural presence of the loggia's parapet is registered with perfect clarity. On the other hand, the treatment of the garden in the two Prado versions is, in formal terms, more or less identical. It seems, in other words, that Titian intended his foreground and background to be stylistically incongruous; and it is this incongruity, when the painting is viewed as a whole, that is decisive. In exploiting this device, Titian was building, perhaps consciously, on a precedent that Michelangelo had established some seventy

years earlier. In painting the ceiling of the Sistine Chapel, Michelangelo used different systems of perspective to establish a distinction that was conceptual: that between the *Histories*, which depict God, Creation, the Fall and the Flood, and the *Ignudi*, male nudes who are the embodiment of a beauty that is perfect but nonetheless human.

19 Wethey, p. 67.

20 Dogs present conventionally-minded iconographers with problems, as they can either symbolize devotion or, like the unfortunate partridge, concupiscence. As Wethey says, a relentless effort to choose the correct iconographic reading can drown out all thought of a painting's beauty. It can also trivialize the sort of interpretation that Titian's work deserves.

5 What Ruskin Saw in What Turner Saw

There is no noun, unfortunately, that describes the person who responds passionately to paintings and photographs. 'Fan' implies membership of an enthusiastic herd rather than individuality, and in any case is falsely matey. 'Enthusiast' is too general; 'aficionado' too pretentious. A better word might be 'iconolater', one who worships images, but that is pretentious too. I have settled for 'spectator', knowing as I do so that it is hopelessly deficient.

When the visually alert person looks at a Titian or a Meit, the wiles of the artist and the needs of the spectator can sometimes mingle in a meeting of minds as compelling as any our culture permits. In those who look with passionate intensity, equilibrium can be threatened in unforeseen ways, and images as tightly freighted as Titian's or Meit's can enjoy a status close to that of a hallucination.

Often, we know little about the personal lives either of artist or spectator, and are left with conjecture. In the cases of John Ruskin, however, probably the greatest critic of the nineteenth century, and of Turner, perhaps the greatest British painter of any century, we know a good deal. Ruskin (see Plate 8) wrote about himself and his responses to Turner's paintings with an eloquence and particularity that have rarely been matched; and Turner, although a secretive man, has been the focus of much scholarly research.[1]

In broadest outline, the details are these. Ruskin published the first volume of *Modern Painters* in 1843, within a few years of graduating from Oxford. His book took shape as a defence of Turner's reputation; a claim that he should be considered among the very great. At this point in a long career, Turner was in some

need of advocacy, for although still engaged on what we now see as his finest work, he was seen by many of his contemporaries as having slipped from a state of precocious brilliance to one of impending senility. The year before, he had exhibited the magnificent *Snowstorm* at the Royal Academy, but had found it denounced in one quarter as a 'mass of soapsuds and whitewash'. For years, public comment on his work, although broadly respectful in tone, had been laced with expostulations; and one of the tendencies of these comments had been to stress his 'madness'. Hazlitt saw in Turner's works 'visionary absurdities' and 'affectation and refinement run mad'. Others agreed: 'This is madness'; 'it would excite pity if painted by a maniac'; 'a daub of the most ridiculous kind'. Even Thackeray chimed in, seeing Turner's latest product as 'not a whit more natural, or less mad' than those that had gone before.

Modern Painters was a success, and Turner's reputation was assured. What had been seen as madness or eccentricity was now seen as genius. It is clear, though, that Ruskin's feat of advocacy carried ironies within it. For when he published his first volume, Ruskin was not only very young – twenty-four – but knew surprisingly little about art. Intelligibly, Turner viewed his new champion with reserve. To make matters worse, Ruskin seemed to be advocating Turner's greatness in terms of a philosophy that had little bearing on the works that Turner had actually produced. What Ruskin enjoined on painters, over and again, was 'truth to nature', whereas Turner's paintings, especially those of his later years, were those of a visionary, a man who translated landscape into light. Moreover, he was a painter whose handling of his medium had, over the years, become almost unprecedentedly experimental and free.

By 'truth to nature', Ruskin is often taken to have meant literal, photographic reproduction. Many of his own drawings certainly show a preternatural sharpness of focus; and so, too, do the paintings of the Pre-Raphaelites, whom he was to support so vigorously later on in his career.[2] But Rosenberg, in *The Darkening Glass*, has put the matter more subtly. Ruskin emerges from his pages as a Romantic, in direct line of succession from Coleridge and Wordsworth. Rosenberg sees him as prizing, like all Romantics, the 'far higher and deeper truth of mental vision – rather than that of the

physical facts'. Turner's compositions, far from being copies of nature, were ones that Ruskin saw as recreations from memory, an arrangement of remembrances, acts of 'dream-vision'. For Ruskin, nature was 'infinitely various, infinitely potent, but visible only to eyes which, in Wordsworth's phrase, half create what they perceive'.[3]

Rosenberg is a shade generous, I think. As he admits, Ruskin habitually used the same word, 'truth', in contradictory ways. Sometimes he equated it with the 'bare, clean, downright statement of facts', and claimed that 'every alteration of the features of nature has its origin either in powerless indolence or blind audacity'. Yet at others, he argues that 'it is in this power of saying everything, and yet saying nothing too plainly, that the perfection of art ... consists'. Rosenberg insists that there is a reverence in Ruskin both for Turner's visionary qualities and for his literal-mindedness; the literal-mindedness that led him, in his late sixties, to be lashed for four hours to the mast of the steamship *Ariel* in order to paint the *Snowstorm* – not as it might be, but as it actually was. What Turner was truthful to was nature as 'unwearied unconquerable power'; as a 'wild, various, fantastic, tameless unity'.

Ruskin's notion of truth was perhaps less muddled than it looks. But the psychologist must still ask, I think, why this young man should have picked with such absolute conviction on Turner as his hero – as opposed, say, to Turner's contemporary, Constable. Constable, after all, was a landscape painter too, and, in hindsight, as precise a match to Ruskin's specification of 'truth to nature' as one could find anywhere in the history of the medium.

There are, I want to suggest, two sorts of answer: and both draw us back to Ruskin's exceptional upbringing. He was the only son of a successful sherry importer (see Plate 8) and his puritanical Scottish wife. Ruskin grew up in great prosperity, but without friends, and without toys:

> He passed his childhood in serene but unrelenting solitude, lightened only by the ingenuities of his own observation. He examined the patches of colour on the floor, counted the bricks in the walls of the neighbouring houses, and, with rapturous and riveted attention, watched from the nursery window as the watercarts were filled from a dripping iron post at the pavement edge.[4]

Ruskin's education was largely at the hands of his mother, and was based on the Bible. In a post-Laingian era, it is easy to see such a regime as absurd and cruel, but it seems to have arisen in fact from an excessive solicitude. There grew up between Ruskin and his parents such an intensity of respect that he was to consult them on every major decision, and to publish nothing during his father's lifetime of which his father did not approve.

Each summer, the family visited relatives in the country, and later, with post-chaise and courier, they toured the Continent. These trips abroad were occasions of intense excitement for Ruskin; his diaries, Rosenberg tells us, are a 'prolonged, ecstatic hymn to sights which moved him more deeply than anything else he was ever to experience'. On his thirteenth birthday, he received a most significant present. He was given a copy of the poet Rogers's *Italy*, illustrated by Turner. 'The gift initiated him into his life's work. In Turner's vignettes he discovered the divinity of nature which he was later to celebrate in *Modern Painters*.'[5]

We might explain his dedication to Turner, then, as one of loyalty; imprinting almost. It was pictures from Turner's hand, or, more strictly, from Turner's engraver's hand, that were the first to seize his febrile imagination. But there is more to it than loyalty, of that I am almost sure; because Ruskin saw in Turner's paintings something that was of enduring fascination to him, and something, if I am right, of which he cannot have been more than half-aware.

Ruskin's imagination was highly charged; its very vigour seemed to throw his sanity into question. In Rosenberg's words, he was 'eye-driven, even photoerotic'. He confessed to 'a sensual faculty of pleasure in sight to which he knew no parallel'. The visible world leaped to life before his eyes, and, a remarkable gift, he was able, all his life, to translate these perceptions into prose. He had begun to write in earnest when seven, and thereafter was to publish more than forty books and several hundred lectures and articles; with the 'accuracy of a solitary fanatic', he recorded in his diaries every 'thought, image, and emotion which crossed his consciousness'. His medium was a prose charged with the 'sudden clarity of first sight'. As Rosenberg says, it is not 'diffuseness, but an almost licentious amassing of detail' that characterizes the purple passages in *Modern Painters*. He was a man who looked at

the material universe with 'preternatural vivacity and clarity, and believed that what he saw was divine'.

Throughout his life, Ruskin used his writing to preach, and the range of his influence can rarely have been matched. He shaped the sensibilities of a generation in matters of painting and architecture; and, through his political writing, altered the lives of men as disparate as William Morris, Clement Attlee and Gandhi, being seen in hindsight as one of the founding fathers of welfare socialism. His autobiographical *Praeterita* is also said to have exerted a formative influence on Proust. Yet, to an extent that is now a little hard to imagine, he remained innocent of ordinary sexual knowledge. It has been claimed by Mary Lutyens that he discovered, on his wedding night, that in Effie Gray (see Plate 8) he had married the only woman in the world with pubic hair, and was accordingly horrified into impotence. Effie's comment to her father certainly seems to support this: Ruskin 'had imagined that women were quite different to what he saw I was, and that the reason he did not make me his wife was because he was disgusted with my person the first evening 10th April'.[6] Lutyens concedes that Ruskin could have trumped up this explanation to hurt Effie, and that the true reason may have been his well-attested horror of pregnancy and babies. Either way, it was the mature female body and its reproductive functions that appalled Ruskin and ruined what life he had with Effie.

Later in his life, Ruskin sought to expunge all memory of his marriage and the emotion that Effie had inspired in him. At the time, though, he was deeply moved. When first in love, he wrote to her for example: 'I shall have no more independent existence than your shadow has – I feel as I should faint away for love of you – and become a mist or smoke, like the genie in the Arabian nights – and as if the best you could do with me, would be to get me all folded up and gathered into a little box – and put on your toilet table.'[7]

In the years after the scandal of his marriage, Ruskin's private life was dominated by a fascination with pre-adolescent girls. As they became women, he recoiled in dismay, seeming to suffer what, in another context, has been called a 'noxious hostility' to the mature female body. In his late thirties, it is true, he succumbed to what he saw as the pagan vitality of the women in

Veronese's paintings and Titian's, but he was never able to cope with the sexuality of women as adults. His marriage to Effie was dissolved after six years on grounds of non-consummation. (Years later, when married to the painter Millais, she was to describe Ruskin with real bitterness as 'most inhuman, unnatural, and utterly incapable of making a woman happy'.) Thereafter, his erotic imagination was invaded to a greater and greater degree by his passion for a girl thirty years his junior, Rose La Touche.

Ruskin seems to have reached a turning point at the end of his thirties. He met Rose; suffered a religious 'unconversion' in Italy; came face to face with the 'magnificent animality' of Renaissance nudes; and, more or less simultaneously, encountered a black-haired urchin girl of ten, 'half-naked, bare-limbed to above the knees, and beautifully limbed ... her little breasts, scarce dimpled yet, – white, – marble-like – but, as wasted marble, thin with the scorching and rains of Time'.[8]

Thereafter, Ruskin's morbid but innocent preoccupation with Rose was counterbalanced with thoughts of pollution and with dreams of an increasing obscenity. In his forties, his demeanour became gloomy, and his fascination with painting began to give way to a concern for politics. Although he took shelter in pathetic games with the girls at Winnington Hall School, his dreams pursued him. Moved by self-disgust, Ruskin, Rosenberg claims, viewed with horrified fascination the processes whereby the 'child-like innocence' he saw in Rose and the girls at Winnington became 'suddenly and loathesomely adult'.

One night, ten years after his 'unconversion', he dreamed of showing his young cousin Joan a snake and of making her feel its scales. 'Then she made me feel it, and it became a fat thing, like a leech, and adhered to my hands, so that I could hardly pull it off.' A year later, he records 'the most horrible serpent dream I ever had yet in my life. The deadliest came out into the room under a door. It rose up like a Cobra – with horrible round eyes and had woman's, or at least Medusa's, breasts ...'[9] He repelled this snake by throwing pieces of marble table-top at it, but another smaller one attached itself to his neck and he could not remove it. Eventually, towards the end of his fifties, a grotesque hallucination of 'the Evil One' appeared in Ruskin's bedroom. He wrestled with it all

night, and the next morning was discovered naked and insane, in a delirium from which he was never fully to recover.

Rosenberg describes Ruskin's thoughts as the triumph of a unified vision over an often divided and ravaged mind. His father's father had gone mad and committed suicide, and Ruskin himself always seems to have been at risk. Whether or not his imbalance was 'endogenous', as the psychiatrists say, what seems to have consumed his mind was an unresolvable conflict between innocence and 'animality'; a conflict that centred quite directly on the maturational and sexual processes of the female body. Although circumstantial, the evidence suggests that Ruskin's misgivings were conveyed to him fairly directly by his parents. In an age of large families, they had only one child, and when John was ill soon after his wedding to Effie, his father would seem to have interpreted this as a nervous response to the rigours of intercourse – intercourse that did not in fact occur. Later, Effie was to write revealingly to John's mother, reminding her of John's illness, 'which he told me his Father supposed to arise from his recent connection with me'. She goes on to say that John 'used to laugh and say his Father was imagining things very different to what they were'.[10]

In what way does all this biographical information about Ruskin help to explain the appeal that Turner's painting held for him? The answer is partially straightforward, partially more contentious. The straightforward part of the answer lies in the fact that Turner was a painter both of the sublime and of the disastrous. Just as there are few more tranquil paintings in the world than certain of his watercolours of Venice, so there are few more frightening than his shipwrecks, fires, avalanches. *The Slave Ship* can stand here for the rest (see Plate 9). It depicts sick and dying slaves being pitched overboard as bad weather approaches: a painting inspired by an account in Clarkson's *History of the Abolition of the Slave Trade*, reissued in the previous year, of how, in 1783, the captain of the slave ship *Zong* had thrown his diseased slaves overboard, because insurance could only be claimed for those lost at sea, not those dying through illness. Without question, it is an appalling image.

As so often in Turner's later work, *The Slave Ship* conveys an indelible impression of man's helplessness in the face of the

elements. The full title of the work was *Slavers throwing overboard the Dead and Dying – Typhon coming on*, and when it was exhibited in 1840, Turner attached to it these lines of his own doggerel:

Aloft all hands, strike the top-masts and belay;
Yon angry setting sun and fierce-edged clouds
Declare the Typhon's coming.
Before it sweeps your decks, throw overboard
The dead and dying – n'er heed their chains.
Hope, Hope, fallacious Hope!
Where is thy market now?

The painting was to play an important part in Ruskin's life. He praised it extravagantly in *Modern Painters* as 'beyond dispute, the noblest sea that Turner has painted, and, if so, the noblest certainly ever painted by man'. If the case for Turner's immortality were to rest on any one canvas, this, in Ruskin's view, would be the one: 'Its daring conception, ideal in the highest sense of the word, is based on the purest truth ... the whole picture dedicated to the most sublime of subjects and impressions ... the power, majesty, and deathfulness of the open, deep, illimitable sea!' (Thackeray, on the other hand, was more cautious: 'Is the picture sublime or ridiculous? Indeed I don't know which. Rocks of gamboge are marked down upon the canvass; flakes of white laid on with a trowel; Bladders of vermillion madly spirited here and there ... The sun glows down upon a horrible sea of emerald and purple.')[11]

In the year after the publication of Ruskin's eulogy, his father gave *The Slave Ship* to Ruskin as a New Year's present, and it enjoyed pride of place for some years in Ruskin's home. Gradually, though, the meaning of what he was looking at must have dawned upon him, and after a few years, finding the subject 'too painful to live with', he sold it.

Surely, there can be little doubt about it: Turner's sense of man's helplessness in the face of overwhelming natural forces must have exerted a strong appeal over Ruskin because he was himself beginning to struggle with potentially overwhelming forces within his own head.

But there is more to it than that; for, to the psychologist's eye, there is something decidedly worrying about the ways in which

77

Turner portrayed the human body (see Plate 10). Primarily a painter of landscape, and a magnificent one, he only exceptionally painted the figure as his prime concern. When he did tackle it, he usually did so in a spirit of rivalry with one of the great masters; Titian, for example, or Rembrandt. The results are almost uniformly distressing: *What You Will!*, *Jessica* and *The Letter* are examples, all of which share the same air of infelicity. The life drawings from his early years, completed as an academic exercise compare unfavourably with those of a contemporary like William Mulready (see Plate 11). And those sketches of sexual intercourse which he left behind him, and which escaped Ruskin's depredations as his executor, contain figures with limbs like flippers and heads like walking sticks. These serve to heighten the general sense of unease.[12]

Contemporaries noticed this weakness of Turner's. More recently, Butlin comments on Turner's 'inability to depict the human figure with any conviction on a large scale'; and Stokes, speaking as a psychologist, observes that: 'We cannot discover in Turner's art much affirmative relationship to the whole body, to human beings. They tend to be sticks, or fish that bob or flop or are stuffed ... To use the psychoanalytic term, they suggest part-objects.' The Tate's *Woman Reclining on a Couch* has been claimed as an exception, the flesh being praised by Rothenstein and Butlin for a 'freshness and luminosity unmatched in English painting of the nineteenth century'. The painting is a pastiche, though, and only half-finished, there being no other Turner in which the luminosity he accorded to landscape as a matter of course was extended to the human form.[13]

It is natural to inquire whether there is anything in Turner's private life to account for this curious shortcoming. Unfortunately, we know little. The son of an East End barber, to whom he remained devoted, Turner kept himself to himself. It has been claimed that he had two illegitimate children with his mistress Sarah Danby; but it seems that he never acknowledged her, and never married. A loyal member of the Royal Academy and a kind teacher, he was prodigiously hard-working: when Ruskin came to catalogue Turner's work after his death, there proved to be no fewer than 19,000 watercolours and sketches, to say nothing of his more public works. Socially, though, he was unexpansive; and in

his versifying inept. Malapropisms are forever threatening to rear their heads. A sad little poem from his sketchbook, probably composed in his mid-twenties, catches his gloom as well as his clumsiness:[14]

Love is like the raging Ocean
Wind[s] that sway its troubled motion
Woman's temper will supply

Man the easy bark which sailing
On the unblest treacherous sea
Where Cares like waves in fell succession
Frown destruction oer his days
Oerwhelming crews in traitrous way

Thus thro life we circling tread
Recr[e]ant poor or vainly wise
Unheed[ing] grasp the bubble Pleasure
Which bursts his grasp or flies

His biographers stress Turner's distrust of women. They suggest, reasonably enough, that this distrust had its root in a sympathy with his father, and in the shared horror of living with a mother who went mad; she was to die, still insane, when Turner was twenty-nine. An awkwardness with images of the body would certainly flow naturally enough from such distrust. We might predict, in a moment of naïvety, that Turner would even have found distasteful the academic discipline of the life class: drawing from the nude model, both male and female. But to make such a prediction is to fall into the trap of expecting people to be as simple as our theories. In fact, Turner was devoted to the Academy's life class. He worked there as a student for twelve years, spending four years with the casts of classical sculptures and a further eight with the live model. When, later in his career, he was placed in charge of the life class, he even introduced a new twist to the discipline it imposes. He placed living models beside the appropriate plaster casts and arranged them so that they would echo the classical poses. There can be few more eloquent resolutions to an anxiety about the depiction of the body than to assimilate the living model to the classical but dead one, and to use the comparison between them as a basis for a minutely accurate academic scrutiny.

All these awkwardnesses notwithstanding, it would be an error

79

to assume that Turner excluded figures from most of the paintings he produced. Far from it. Figures turn up in a large proportion of his landscapes. Ugly, doll-like presences, they often seem too small for the buildings and landscapes that contain them. They are often placed strangely, too; either isolated or gathered together in spawn-like masses. If their treatment is compared with the use made of the figure by other landscape artists of the time, Richard Bonington say, Turner's are conspicuously discrepant. Rather than growing out of the paint surface as if they belong there, they are stylistically incongruous; a dissonance that is especially unpleasant in Turner, because it is in his works, more than any other, that the inanimate elements of the scene – sky, trees, waves, ships, castles – are gathered together into a single coherent scheme.

Obviously, Turner's infelicities with the figure differ in their degree, some fitting their contexts less uneasily than others. As it happens, this discontinuity in style between figure and landscape is especially distressing in the work I have already mentioned, and which Ruskin singled out for praise: *The Slave Ship*. A drowning slave's leg sticks up arbitrarily out of the water in the bottom right-hand corner of the canvas, surrounded by predatory fish and gulls. In fact the sea, the whole lower half of the painting, is littered with bodies, floating debris, fish, squid-like creatures; a feature of Turner's work remarked on by Ruskin, who likened it to the litter left behind in the Covent Garden market of Turner's youth: 'His pictures are often full of it, from side to side; their foregrounds differ from all others in the natural way that things have of lying about in them.' Sometimes these items of unrelated clutter are harmlessly domestic, but in *The Slave Ship* the mood is a Grand Guignol mixture of the menacing and the ludicrous. Moving in from the extreme right, at speed, is a goggle-eyed monster of the deep, rushing to join the feast; all this set towards the margins of one of Turner's most breathtakingly coherent organizations of sea, sailing ship and sky. The painting of the fish, big and small alike, is almost insultingly cartoon-like; insulting, because we know from his sketches that if he chose, Turner, a keen angler, could paint fish with delicacy and sophistication.[15]

In a strictly stylistic sense, *The Slave Ship* is a 'schizophrenic' work; and however well-rehearsed his self-deceptions, it is remarkable that any one as fragile as Ruskin could have lived with

it at all. It must have been a dangerous property to contemplate at close quarters, above the hearth. It enabled Ruskin to play with terror without admitting to himself that this is what he was doing. More particularly, it enabled him to entertain the idea of the adult human body as a horribly dissonant element in the midst of God's great and otherwise congruous design.

Ruskin was using Turner's paintings to test the boundary that we all draw around ourselves in order to stay sane. In seizing him, they enabled Ruskin to paddle vicariously in waters that he would otherwise have been too frightened to approach. Both these great men, you strongly suspect, were driven: they worked so hard because without their work their lives would have been unendurable. Small surprise, then, that the works they produced, both of genius in their own ways, should show evidence, in their quirks and fissures, of the contradictions from which such ferocious energies derive.

It is revealing of Ruskin's divided nature that, as Turner declined into his terminal illness, he should publicly adopt the cause of a group of painters who, visually speaking, were Turner's opposite in every significant respect. In 1850 and 1851, the Pre-Raphaelites were under critical fire to an even greater extent than Turner had been ten years earlier. Millais's work, in particular, was furiously attacked. Ruskin came to Millais's rescue. Within the year, Turner died; within four more years, amid great scandal, Millais married Ruskin's wife Effie. It is hard to see how Ruskin could embrace Turner and the Pre-Raphaelites within the same criterion of 'truth', yet he did. Millais, Holman Hunt, Rossetti and Burne-Jones produced paintings that were meticulously detailed where Turner's were painterly; decorative and painstaking where his were swiftly dextrous. They were remarkable after their fashion, but the two fashions are, to our eyes, as dissimilar as any two could be.

Notes

1 Rosenberg (1963) offers the best discussion I know of Ruskin's thought, although subsequent authors like Hewison (1976) provide a useful supplement, and Lutyens (1965, 1967, 1972) throws light on

Ruskin's extraordinary marriage. Our knowledge of Turner's life is dominated by Finberg's posthumously completed biography (1961). One of Finberg's concerns was to counteract the scurrilous impression of Turner's private life left by his first biographer, Thornbury. This bias has subsequently been redressed somewhat; for example, by Lindsay (1966). Recently, there has been a spate of publications about Turner's paintings and their significance; for instance, those of Butlin (1962), Rothenstein and Butlin (1964), Gage (1969), Wilkinson (1977), and also the catalogue of Turner's bicentenary exhibition (1974). It is on these secondary sources that I have depended. Beyond looking carefully at certain pictures, I have made no fresh inquiries of my own.

2 The precision of Ruskin's observation was also influenced by the newly invented daguerreotypes, of which more in the next chapter.

3 My quotations, here, are drawn from the early pages of Rosenberg's text.

4 Hewison (1976) suggests that Rosenberg has been too swayed by Ruskin's recollections of his own childhood, an account coloured by the gloom of his later years, and at odds with certain biographical facts. The point is a delicate one. Notoriously, we do rewrite our own biographies; and in a mind as spectacularly divided as Ruskin's, this process of rewriting could well have taken an extreme form. On the other hand, biographical fact – in this case, evidence of a certain staid social round – says little about the terms in which such events were experienced by a child caught up in them.

5 Rosenberg (1963), p. 2.

6 Lutyens (1972), p. 108; also Lutyens (1965, 1967).

7 Lutyens (1972), p. 201.

8 Rosenberg, p. 162.

9 Rosenberg, p. 169.

10 Lutyens (1972), p. 128.

11 Turner Bicentenary Catalogue (1974), p. 145.

12 Rorimer (1972); Lindsay (1966).

13 Butlin (1962), p. 56; Stokes (1963), p. 60; Rothenstein and Butlin (1964), p. 46. I was sobered, some years ago, to find myself snubbed over this question by a Turner scholar whom I shall not name. He claimed that Turner suffered no special difficulty with the human form at all.

There are, of course, several explanations for such a divergence of opinion. The first, put to me by an art historian of even greater distinction, is that those who specialize in the history of the visual arts are frequently visually insensitive, being alert rather to the verbal significance of paintings; their provenance and their iconography. (By the same token, psychologists are characteristically incompetent in their personal relations, sex experts are sexually handicapped, and so on. More generally, as the theorizing in chapter 3 suggests, we are all prone to cope with personal inadequacies or bafflements by translating them into topics for scientific or scholarly research.) A second possibility is that a professional immersion in anyone else's vision gradually makes that vision seem perfectly normal, whatever it is. A third, that members of all academic clans automatically resist trespassing forays from outsiders, and do so on reflex. A fourth, that scholarship thrives on special pleading, it being essential to academic debate that any generalization should be contradicted – at least in part as a means of focusing attention where it belongs: on the evidence and its shortcomings. In the art world, however, special pleading has seamier implications, being part of any attempt to enhance a particular artist's 'importance' (and hence marketability). Whatever the motive, it seems to me unsatisfactory to note, as the Bicentenary Catalogue does (p. 102), that Turner's *What You Will!* draws on the precedent of Watteau, without being candid about the ludicrous discrepancy between the awkwardness of the one and the exceptional grace of the other. Or, to note (p. 106) that Turner's *Jessica* refers back to the authority of Rembrandt, without admitting to the light years that separate the gaucheness of Turner's figure from the subtlety of insight that almost all Rembrandt's portraits achieve.

14 Lindsay, p. 73.

15 Ruskin saw the two watercolour sketches of gurnard that Turner did in preparation for *The Slave Ship* as symbolic criticisms of society. One, looking up, depicts 'modern philosophy'; the other, 'coming on at speed', stands for 'modern trade'. In his own high terms, in other words, Ruskin acknowledges the menace of these fish. The quality of one at least of the sketches is superb (it is reproduced in Butlin, 1962), its only worrying feature being the fish's disconcertingly human eyes.

6 The Image-making Machine

If I have laboured Ruskin's passion for Turner's paintings, it is because I have a point to make. I want it to be clear that the work can have properties of which neither the artist who produces it, nor the spectator who feeds upon it, is fully aware. Further, that we become intimate with such works, either as artists or spectators, in as much as they enable us to conduct psychic manœuvres without fully acknowledging to ourselves that this is what we are doing.

Such events do not occur, of course, in a historical vacuum. At precisely the moment Ruskin was drafting his defence of Turner, something of the profoundest significance was happening to the visual arts; but happening, as it were, off-stage. The 1840s were the decade in which, for the first time, the literal reproduction of the human image became a commonplace. Prior to 1839, when Daguerre first made photography public knowledge, the taking of likenesses had been an arcane affair, dependent on the intervention of the artist: a matter of arduous training, and finely focused human skill. After 1839, it was abruptly translated to the realm of technology, and became a business of lenses, chemicals, photosensitive plates and papers. The consequences were momentous.[1]

In 1839, Ruskin was still in fact an Oxford undergraduate. Granted the doctrine of truth to nature already taking shape in his mind, one might expect him to have responded to photography with the utmost vigour, either welcoming it as providing a truth to nature that was literal and therefore perfect; or, alternatively, denouncing it as a threat to the whole enterprise of art. For once, strange creature, his initial reaction seems to have been compara-

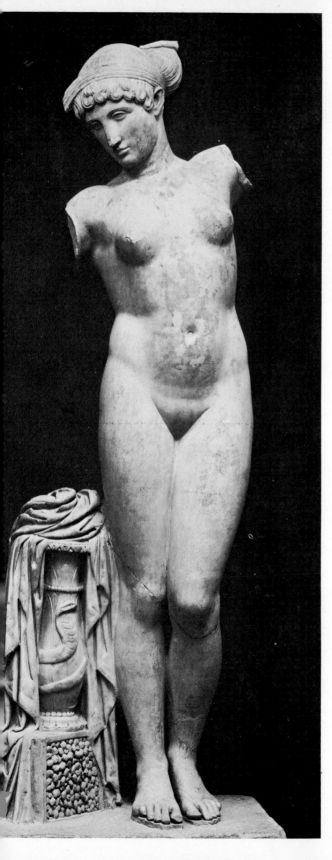

1 The classical nude of Greece and Rome, the *Esquiline Venus* (replica). She was constructed on a modular scheme in which the unit of measurement was the head. 'Breasts will become fuller, waists narrower and hips will describe a more generous arc; but fundamentally this is the architecture of the body which will control the observations of classically minded artists till the end of the 19th century' (Kenneth Clark).

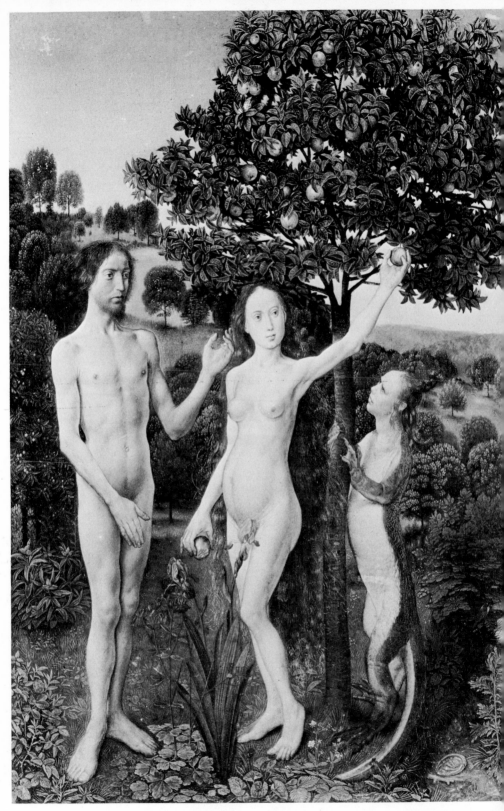

2 The alternative convention of 'naked' nudes that evolved in the fourteenth and fifteenth centuries, north of the Alps: van der Goes's *Adam and Eve*.

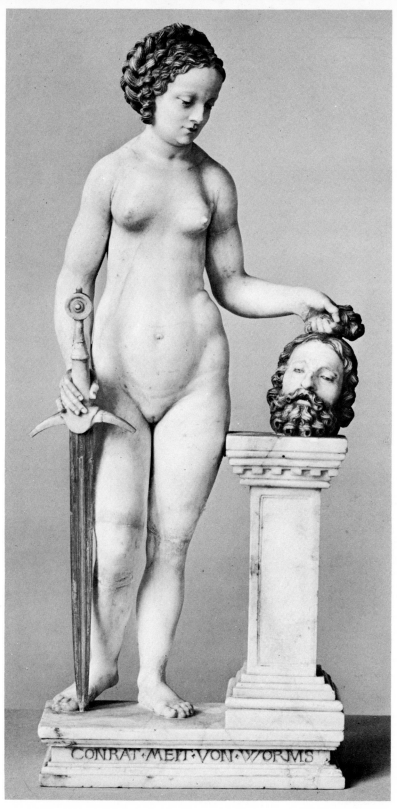

3 Conrad Meit's *Judith and Holofernes*.

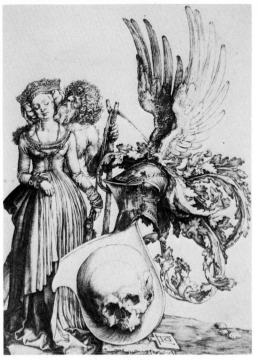

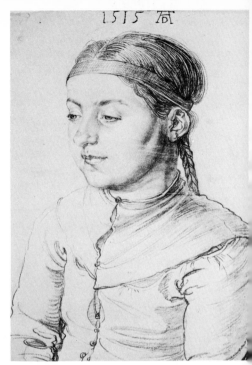

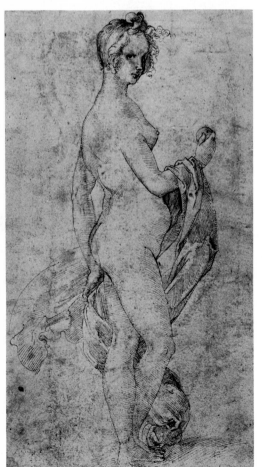

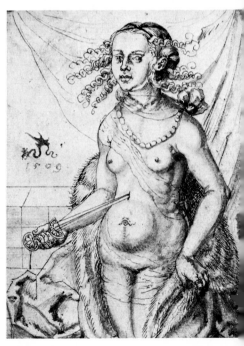

4 Four facets of the northern preoccupation with images of the person; the naturalistic, the symbolic, the erotic, and the cruel. Dürer's *Portrait of a Young Girl* (top right) and *The Arms of Death* (top left), Grien's *Venus with an Apple* (left), and Cranach's *Lucretia* (above).

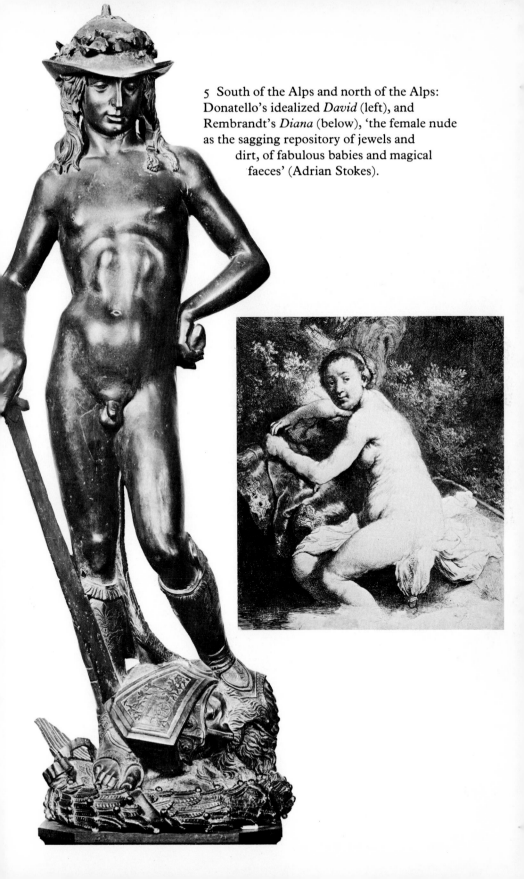

5 South of the Alps and north of the Alps: Donatello's idealized *David* (left), and Rembrandt's *Diana* (below), 'the female nude as the sagging repository of jewels and dirt, of fabulous babies and magical faeces' (Adrian Stokes).

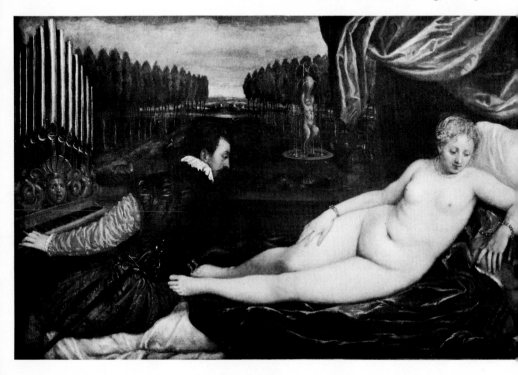

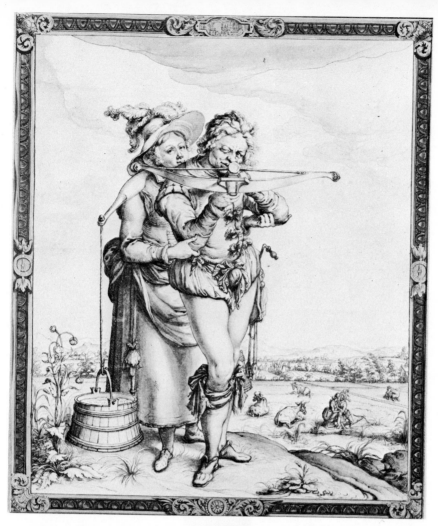

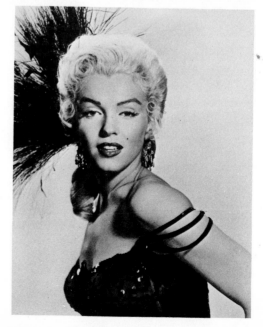

7 A seventeenth-century bid to implicate the spectator, and its modern counterpart: Jacob de Gheyn's *Cross-Bowman Assisted by a Milkmaid*, and Marilyn Monroe.

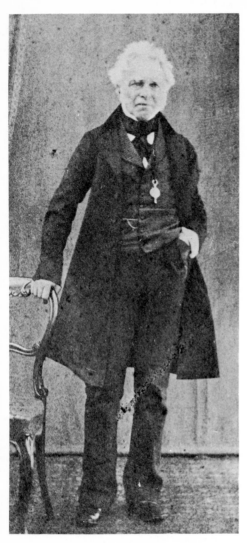

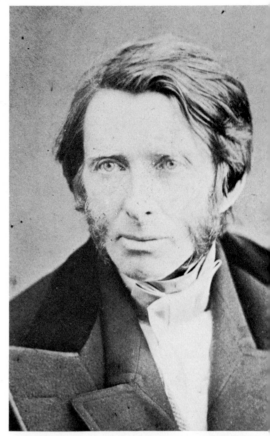

8 The Ruskins: John James, the sherry importer (above); his son John (above right); and Effie, John's wife (right), here depicted in a portrait by Millais (whom she later married) called *The Foxglove*.

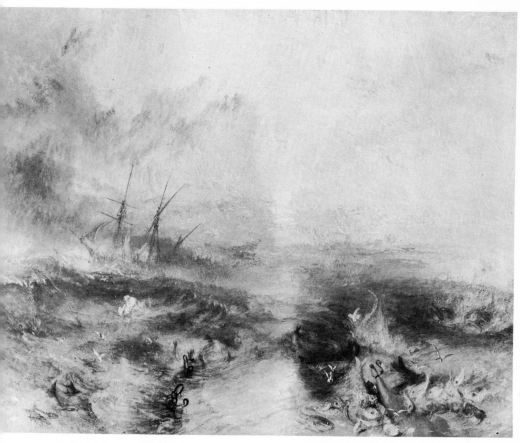

9 Turner's *The Slave Ship*: 'beyond dispute, the noblest sea that Turner has painted, and, if so, the noblest certainly ever painted by man' (John Ruskin). The human leg, sticking out of the sea like a pig's trotter, remains discrepant nonetheless (below).

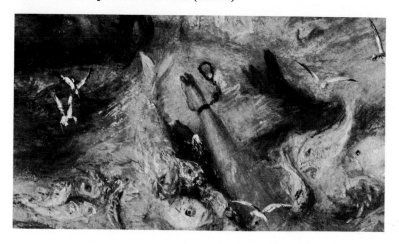

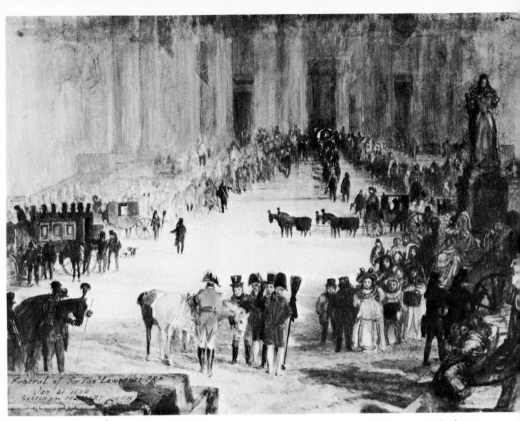

10 Turner was unable 'to depict the human figure with any conviction on a large scale' (Martin Butlin). Many of his scenes, like *The Funeral of Sir Thomas Lawrence* (above), exhibited at the Royal Academy in 1830, are peopled with ugly puppets. Occasionally, though, in small sketches from life – of his mistress Sarah Danby, it has been suggested – he did achieve a mood of carnal urgency, as in the nude study below.

11 In drawing from life, the best of the Victorians convey a sense of ease that few artists in our century can match: two nude studies by William Mulready.

12 An apparently snapshot-like pose of Degas's that echoes a pose of Rubens's: Degas's *The Morning Bath* (right), and a detail from Rubens's *Four nude figures round a basin* (below).

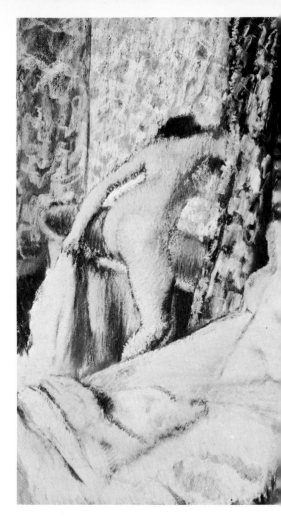

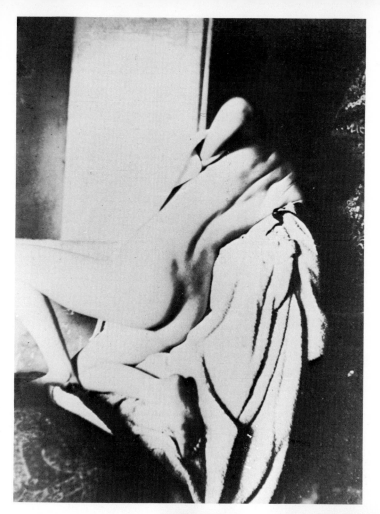

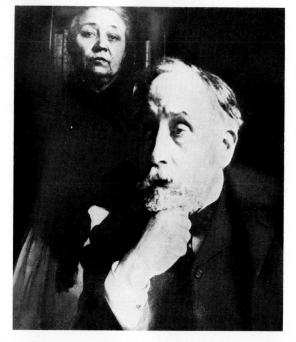

13 Towards the end of his life, as his eyesight began to fail, Degas displayed great gifts as a photographer: a nude, attributed to him, resembling his own pastels of women bathing; and a self-portrait with his housekeeper, Zoé.

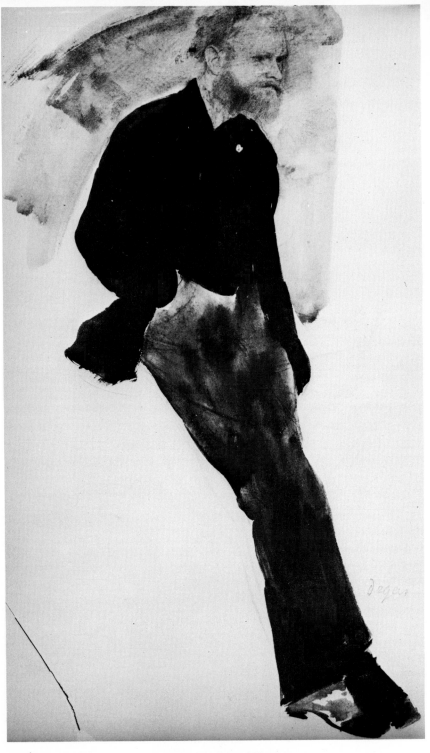

14 Édouard Manet, portrayed by his friend Degas.

15 *Opposite:* Manet's *Olympia* (top), and *Gare Saint-Lazare* (bottom): both paintings show Victorine Meurend, his favourite model.

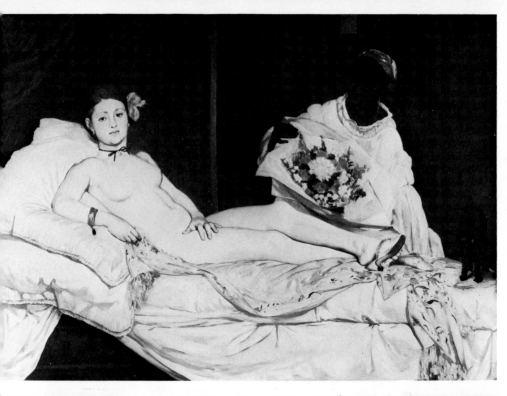

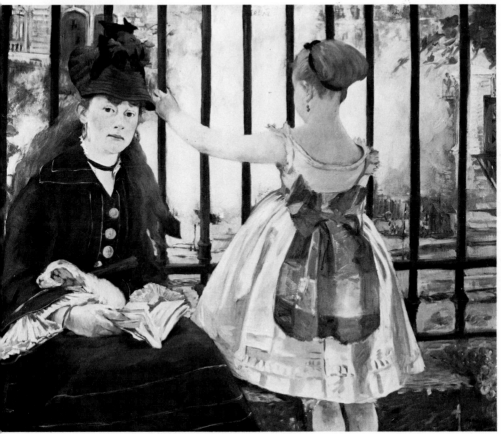

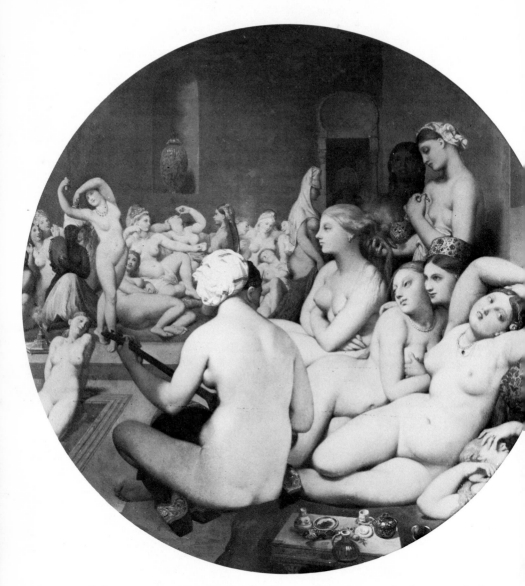

16 An apparent contradiction in nineteenth-century attitudes towards the nude: Ingres's *Le Bain Turc* was perceived as legitimate, even though openly erotic in the scene it depicts. Sickert likened it to 'a dish of spaghetti or maccheroni'.

17 *Opposite:* Photo from the *Twin* collection by Kishin Shinoyama.

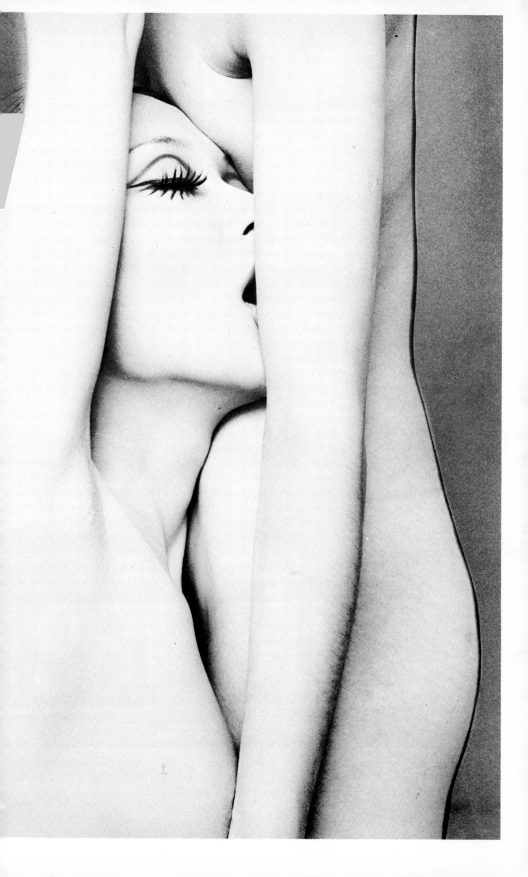

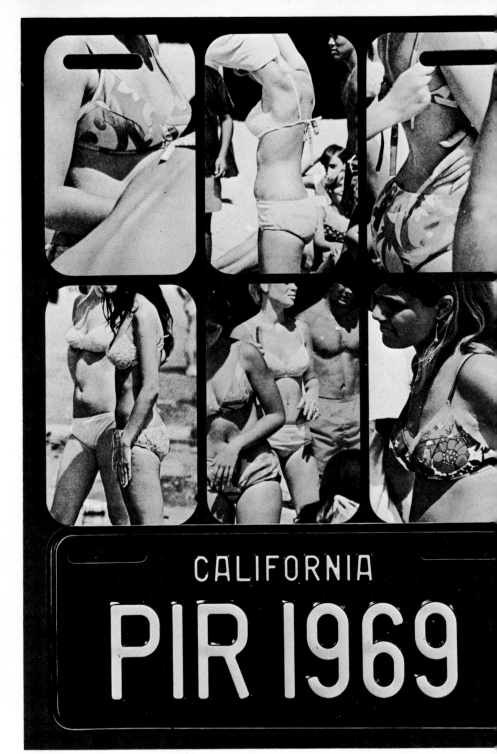

18 *Pirelli Calendar*, 1969, by Harri Peccinotti.

19 As Degas was quick to realize, the techniques of photographic repro-
duction enable us to pass a single image through a great variety of states.
This is a reproduction in black and white of a hand-tinted photograph:
Containers. It depicts tea chests and an oil painting derived by means of a
pantograph from part of a reproduction in the *Pirelli Calendar* of a colour
photograph taken by Harri Peccinotti. (Author's painting and photo.)

20 *Pirelli Calendar*, September 1973. A heavily airbrushed photograph by
Duffy, based on a sketch by Allen Jones; half a painting, half a photograph.

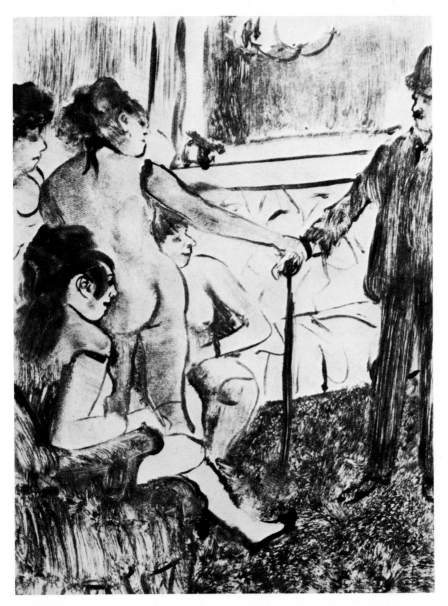

21 Although shy with women, even a misogynist, Degas is one of few modern painters to have depicted life inside a brothel with any appearance of sympathy: *Le Client Sérieux*.

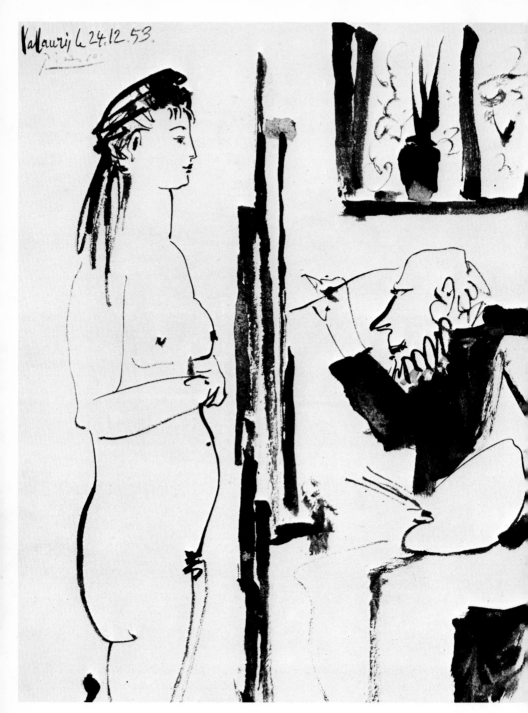

22 'In nearly every drawing there is a young woman. Not necessarily the same one. Usually she is naked. Always she is desirable. . . . Beside her Picasso is old, ugly, small, and – above all – absurd.' (John Berger.) Picasso's *Artist and Model*.

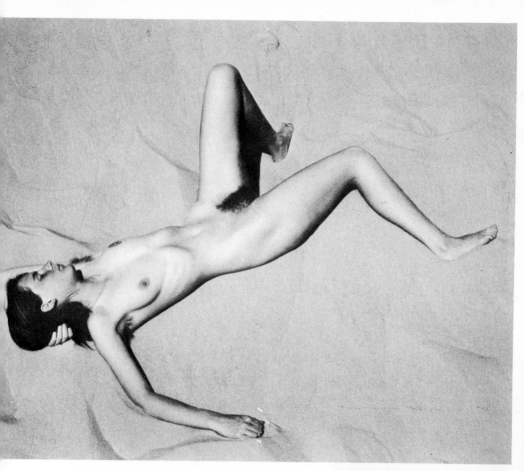

23 The photographer Edward Weston and one of
his meticulously focused nude portraits of his
second wife, Charis Wilson.

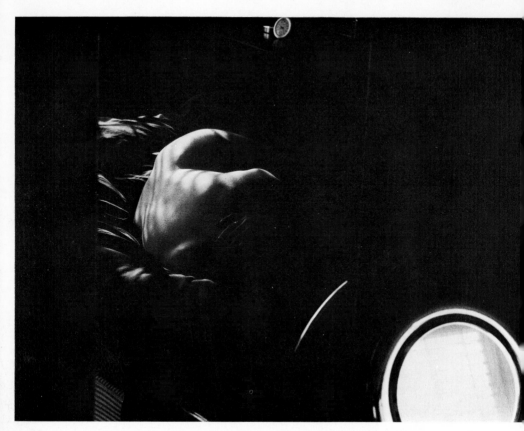

24 By means of photographs, we work back towards the discovery of what it is, at the telling moments in our lives, we think and feel. (Author's photo.)

tively balanced and restrained. A rich young man, he had daguer-
reotypes sent over to him from Paris, and quickly discovered their
usefulness as an aid in architectural and landscape drawing. He
bought plates avidly, and traced from them illustrations for his
books. Writing to his father from Italy in 1845, he was fulsome:
daguerreotypes taken in vivid sunlight seemed to him glorious
things, an antidote to 'all the mechanical poison' that his century
has poured upon his fellow-men. In that same year, he bought an
apparatus of his own; and from that date onwards, his man-servant
George Hobbs carried this with them on their trips abroad. How-
ever, it was Hobbs who was the camera enthusiast, not Ruskin.
Hobbs used it, for example, to take the first photographs of the
Matterhorn. But while Ruskin was happy to use Hobbs's plates to
correct his own drawings, and advocated this practice quite openly
to others, he displayed no special interest in the equipment itself.
As far as we know, he did not learn to take photographs of his
own.[2]

Ruskin's determination to make photography the 'handmaiden
to art' was already plain, Scharf tells us, by the early 1850s.
Thereafter, although he continued to recommend the use of photo-
graphs to improve accuracy in drawing, his attitude turned first
into one of suspicion and then of dislike. By the time he came to
give his inaugural lectures as Slade Professor at Oxford in 1870,
his references to photography are derogatory: 'let me assure you,
once for all, that photographs ... will themselves give you nothing
valuable that you do not work for. They supersede no good art,
for the definition of art is "human labour regulated by human
design" ... they are not true, though they seem so. They are
merely spoiled nature.'[3]

Executed in slow motion, over a period of twenty-five years,
Ruskin's somersault is complete. It is eloquent, too, in what it tells
us of the place that photography came to occupy in the Victorian
attitude to art. Trudging together up the Swiss Alps, Ruskin and
his servant Hobbs exemplify quite poignantly one of the most
stubborn of our culture's convictions about image-making. It was
the young gentleman who painted and sketched; the young gentle-
man's gentleman who buried his head in the chemicals. To this
day, we harbour the suspicion that while there is something fine
about applying brush to canvas, or charcoal to paper, the act of

taking photographs is inherently more lowly. The prejudice is a class distinction of sorts, and it still colours any discussion of the kinds of truthfulness to which painting and photography can plausibly aspire.

In the event, the discovery of photography seems to have conformed closely to the dictates of catastrophe theory: over the centuries, a number of small increments to knowledge in astronomy, chemistry, draughtsmanship; and then the sudden, categorical shift. From the day, in January 1839, when the astronomer Arago told the French Academy of Sciences about Daguerre's new technique, photography mushroomed. What had until that moment been of technical interest only to inventors, painters and scientists became a popular rage.

To begin with, progress had been slow. The properties of the camera obscura were certainly known to the painters of the Renaissance; and by the beginning of the nineteenth century, portable versions of this device enabled the artist to trace onto a sheet of paper the image of any well-lit scene. (The light passed through a lens in the side of a box, and was then thrown, via a mirror, onto a ground-glass screen.) The lenses which made this possible had been developed by astronomers like Kepler early in the seventeenth century; and, in the eighteenth century, chemists had begun to explore procedures whereby a visual image could be fixed onto a sensitized plate. Research proceeded piecemeal though. The first person to fix such an image was the Frenchman Niepce, in 1827, and on the strength of this, he is usually given credit as being the inventor of photography; but had he thought to wash his plates in common salt, the Englishman Tom Wedgwood would have qualified for this honour fully a quarter of a century before.

Niepce's method was time-consuming and cumbersome, and the resulting images were little more than blurs. It took the intervention of his partner Daguerre, a talented painter and entrepreneur, to refine Niepce's technique and offer it to the world as a marketable package. Previously, Daguerre had made a name for himself as a painter of meticulously lifelike landscapes, some of them on an enormous scale; those used in his Diorama, for example, were of the order of 70 feet by 45 feet, and spotlit rudimentarily, they created a spectacle that is said to have been as popular in its day as the cinema was later to become. The paintings that

Daguerre did in the 1820s are so lifelike that when they are set side by side in black-and-white reproduction with early daguerreotypes, it is by no means obvious which is which.[4]

A formidable technician, Daguerre moved quickly from Niepce's smudges to prints of superb quality. Arago was in a position, in other words, not just to announce a technical advance, but to display images that must have taken away the breath of those whose eyes first fell on them. Within months, the technique was further refined; and the commercial exploitation of the daguerreotype and its rivals, Fox Talbot's calotype and then Scott Archer's wet-collodion process, began. Millions of photographs were printed and sold each year: family portraits, pictures of exotic lands, pictures of the royal and illustrious.

The photographs taken by the pioneers of this new form were remarkable. In 1860, the Bisson brothers climbed Mont Blanc, accompanying Napoleon III and Empress Eugénie, and although they had to wash their plates in melted snow, took mountainscapes that have never been bettered. Likewise Francis Frith's pictures of Egypt: to take them he had to cope with equipment that weighed 120 pounds, and with temperatures that threatened to boil the collodion with which his huge plates were coated. Such works, however, did not qualify to the Victorian eye as art. Photographers' efforts to create works that did qualify centred, typically, on allegories of a sort that now seem mildly ridiculous: Rejlander's *Two Paths of Life*, for example, a composite photograph built up from some thirty separate negatives, and a popular sensation when shown in 1856. (Although banned in Scotland on the grounds that it depicted nudity, it was bought by Queen Victoria.)

The influence of art on photography was to make it banal. It is the traffic that flowed in the opposite direction, the influence of photography on painters, that is of keener interest; and the indications are that the painters were very quick off the mark indeed. Straightaway, there were those who learnt to use photographs as a short-cut. To this extent, the camera took the place of the camera obscura. Scharf presents convincing evidence that, as early as 1841, the great academician Ingres, then in his early sixties, was using daguerreotypes to help with the chore of portrait painting. There were others who, like Ruskin, used photographs as a means of sharpening their powers of perception: of forcing themselves to

see precisely what it was that stood before their eyes when they came to paint a face or sketch a campanile.

Delacroix was the first painter of the highest rank to be explicit about this. Towards the end of his life, he came to rely on photographs as a source of inspiration, in some cases using other people's prints, in others arranging the poses of male and female nudes for himself. In a well-known but eloquent passage, Delacroix tells of looking at these photographs, and then at Raimondi's sixteenth-century engravings of the nude, based on Raphael's originals. Of the engravings he says: 'We all experienced a feeling of revulsion, almost disgust, for their incorrectness, their mannerisms and their lack of naturalness ... Truly, if a man of genius should use the daguerreotype as it ought to be used, he will raise himself to heights unknown to us.'5 The quotation reveals the strength of Delacroix's commitment to these new images, and reminds us, too, of something easily lost sight of: the extent to which painting of the human form was governed by certain classical but stereotyped 'solutions', all of them simplified, many of them highly artificial. To see an image of the body as it actually was came as a therapeutic shock to the best of the Victorians, forcing them to countenance new conventions, solutions that were less glib.

The while, public debate about the influence of photography on painting gathered momentum. In the 1859 Paris Salon, photographs were exhibited separately, but on an equal footing with paintings: a triumph of sorts. But painters under the spell of photography were widely castigated, and on two grounds. Some, with justice, were accused of lamely copying nature – in extreme cases, photographs were tinted and passed off as paintings, or used as the surface on which oil paint was laid. Others were accused of being wilfully coarse, especially in their treatment of the human body. Courbet, particularly, became the focus of contention. His paintings used the idealized settings that the art-viewing public had come to expect, but introduced into them figures that were unglamorous. His *Bather* of 1853 is set in a woodland glade, but confronts the spectator with a huge and ungainly female backside. Louis Napoleon was moved to thump her angrily on the bottom, Scharf suggests, because he was irritated not so much by her ugliness as by her incongruity; a massively proletarian woman masquerading in front of him as a nymph.

This question of ugliness is a delicate one, because it illustrates the ease with which painters of Courbet's sophistication used photographs as an aid in reaching back into the traditions of their own craft. Courbet certainly seems to have used a photograph of a nude woman by Villeneuve in composing the *Bather*, and Scharf speaks of the 'awkward miscegenation' that results: of the real with the ideal, of the conventions of Greece and Rome with those of 'vulgar photographic naturalism'. However, Courbet's main figure is disproportionate, being massive from the waist down in a way that Villeneuve's photographs of real women are not. As Princess Eugénie noticed, Courbet's is a figure that brings to mind not a nymph or even a washerwoman, but a carthorse. It is as if a figure of Dürer's had wandered into a setting designed for one of Titian's pastoral allegories: a miscegenation, in other words, both of styles – the Teutonic with the Italian, the Lutheran with the Catholic – and of the different psychological mechanisms for the containment of ambivalence about the body that underlie those styles: 'horrified curiosity' on the one hand, idealization on the other.[6]

Of more psychological interest than Courbet, though, is a younger man, Edgar Degas. Degas belonged to the first generation of painters to grow up with photography all around them; who accepted it as exciting but also as given, much as our own children accept the television set or the pocket calculator. Degas was five when the daguerreotype was invented; his friend Manet, whom I want to talk about later, was seven.

His exceptional talents apart, Degas is important as the first painter to absorb the influence of photography on the *composition* of the works he produced. He seems first to have worked from photographs in his mid-twenties. By his late twenties, he was composing his paintings in ways that were quite new. Figures are set towards the edges of his compositions, and stare sideways, out of the space defined by the frame. Others are grouped quite arbitrarily. Figures are superimposed, and sharp differences in scale are introduced: huge figures in the foreground, small in the midground, tiny in the distance. Figures are blurred, too, the blurring being used not to create an overall haze, as in Corot's landscapes, nor to denote distance, but to suggest that movement has suddenly been arrested, frozen. There are precedents for some of these

conventions in the Japanese prints then fashionable among French painters, but the only place in which they are all found together is in the photograph: the new 'snapshot'.

In his maturity, Degas produced many works of ballet dancers in which, it appears, the same individual is portrayed in a series of different but related positions. The precedents here are again quite plain: first, the *cartes de visite* produced in enormous numbers from the mid-1850s onwards by photographers like Disderi, in which eight different pictures of the same person or scene are presented side by side on the same plate; and then, in the 1870s and 1880s, Muybridge's photographs of animals and people in motion, frozen into series of stills. As a friend said after Degas's death:

> His system of composition was new ... The instantaneous photograph with its unexpected cutting-off, its shocking differences in scale, has become so familiar to us that the easel-paintings of that period no longer astonish us ... [but] no one before Degas ever thought of doing them, no one source has put such 'gravity' ... into the kind of composition which utilizes to advantage the accidents of the camera.[7]

That said, there remains an air of mystery about quite how Degas assimilated these photographic influences. A photographer of superb gifts in his own right, he seems to have taken up photography with any seriousness of intent only late in life, when his eyesight had already begun to fade (see Plate 13). What is more, his snapshot-like paintings clearly predate the general use of the Kodak box camera, the instrument that made casual photography by amateurs a possibility; Eastman did not market this until the late 1880s. To describe Degas as someone who immediately translated the lessons of photography into painting is, in any case, to make him seem a radical, swinging from bough to bough with the effortlessness of a gibbon. Nothing could be more misleading. Like Manet, unlike Courbet, he was conservative in disposition and deeply wedded to traditions embodied, particularly, in the work of Ingres. A secretive man, Degas exhibited only exceptionally, and excluded all but the most privileged from sight of work in progress. A painting, to Degas, was a conjuring trick, even a 'falsehood'; an accomplishment that called for as much 'cunning, trickery and vice as the perpetration of a crime'.[8]

Whatever his means, Degas was using the photograph to force himself onto new ground: to avoid pat solutions to old problems, and to pose problems to himself that were new. Rarely if ever was he merely copying. For Degas, the photograph had simply joined the stock of stimuli on which the artist is free to draw: nature in the raw, other paintings, and now the snapshot. Photography's influence on him was pervasive, however; and one of the first aspects of his skill to benefit may well have been his draughtsmanship. We think of him, now, as among the greatest of draughtsmen. Yet until the early 1860s, his drawing has a slightly wooden, lifeless air about it; and it was only thereafter that it developed the freshness and immediacy that we take for granted in his work. Again, as with the question of ugliness, the point is a tricky one: the role of photography was not to free Degas from classical precedents, but to open his eyes to what such precedents had to teach. Work of a comparable verisimilitude had been produced before the camera's invention. Ingres was turning out portraits of daguerreotype-like precision while Niepce was still struggling to fix the blurriest of images on his photographic plates; and there are Dürer drawings, done centuries earlier, that, at a quick glance, could have come from Degas's hand.

Within a few years of absorbing photography's first impact, Degas was examining its more conceptual implications, posing the spectator edgy visual conundrums in a way wholly characteristic of his own convoluted, cryptic manner of relating to the world around him. Sometime in the 1870s, for instance, he painted a work, now in the Pushkin Museum, entitled *La Danseuse Posant chez le Photographe*. We see the dancer herself; and, plainly, she is posing. But who for? She is frontal to us, but seems to be posing for her own benefit, looking at herself in the mirror just visible. But who has recorded her image? Is it the photographer – of whom there is no sign? Or is it Degas? And if Degas, did he use a camera or a brush? Or was it perhaps a photographer like Disderi, taking photographs on Degas's behalf? Granted Degas's great secrecy about his use of photographs, one senses that a new conceptual game is being played: one that toys with, and even puns upon, the parallels between the canvas, mirror and photograph as records of experience.

Towards the end of his life, as his sight weakened, Degas made

more and more use of pastels. Normally a pretty medium, he applied it layer on layer, building up surfaces of great density, yet ones which disintegrate as you look at them into a mass of scrawls, scribbles and cross-hatchings. Often, too, he would reverse the conventions of colour perspective, his foreground figures being sombre, while his backgrounds of wallpapers, draperies and towels were in firework yellows, purples, greens and reds. He used this technique to capture images of dancers resting, laundresses, women washing and dressing; private, fleeting moments, that nonetheless convey a potent sense of physicality. Never before, you feel, have women's bodies been portrayed so straightforwardly: not posed, but simply as they are. Consciously concerned, it seems, to create a misogynistic impression, Degas himself said of these women: 'I show them deprived of their airs and affectations reduced to the level of animals cleaning themselves.'[9]

Again the influence of photography is unmistakable, but again it is transmuted. These pastels look for all the world as if they have been worked up from candid snapshots; the fruits of keyhole photography. Yet the classical precedents are never far away. Dunlop points to the echo of Rembrandt's superb *Bathsheba*, now in the Louvre, but once owned by a friend of Degas's father, in the pastel *Woman Having Her Hair Combed*.[10] Even more striking is a similarity I have not seen discussed: that between the woman stepping into her tub in *The Morning Bath* and the pose of a pen-and-ink drawing by Rubens, now at Chatsworth (see Plate 12).[11] Drawn nearly three hundred years earlier, this illustrates a scene from Ovid's *Metamorphoses*. The scene in question is that of 'Midas celebrating the arrival of Silenus' – a libidinous reference but also a mercenary one, and very much in keeping with what I take to be Degas's oblique and private style. (The son of a banker, Degas's maturity was to some extent blighted by the family bank's failure, and by his determination to pay off its debts.)

Degas was using the stimulus of the photograph to refresh his vision of long-established Renaissance precedents, and then to create an apparently casual, snapshot-like setting for the body as classically portrayed. The result is one of exceptional dignity: not that of a Greek or Roman statue, presenting itself to the spectator in pride, but of the sort that any of us might glimpse in the interstices of our everyday lives.

The moment is a complicated one, and symptomatic. For a period of a hundred years or so, beginning in the middle of the nineteenth century and ending in the middle of the twentieth, painting entered a state of unparalleled invention. In place of steady accumulation, broadly within the terms of reference established by the masters of the Renaissance, there ensued a phase of experimentation in which one movement succeeded another with startling rapidity: impressionism, post-impressionism, fauvism, pointillism, expressionism, cubism, dada, surrealism, abstract expressionism, and many more besides.

Beyond their extraordinary exploratory energy, these movements display two significant drifts: a heightened conceptual self-awareness about the act of painting, and a progressive slackening of interest in the use of the human body as a symbol. By the 1930s, representations of the body were usually fragmented or caricatured, Picasso's distortions being typical in this respect. By the late 1940s, fashionably significant painting like Jackson Pollock's, although demanding great conceptual sophistication on the spectator's part, made no detectable reference to the body whatever. There were exceptions of course: Bonnard continued to paint into the 1940s, and Francis Bacon was handling the human figure altogether more disrespectfully in the 1950s and 1960s. The trend, though, was clear.

Meanwhile, the photographer grew used to his status as the painter's poor cousin. Françoise Gilot records Picasso as saying that 'there are two professions whose practitioners were never satisfied with what they do: dentists and photographers. Every dentist would like to be a doctor and every photographer would like to be a painter.'[12]

But more recently, within the last ten years, the position has abruptly reversed. The photographer is again of the keenest concern to those interested in art, the use of the camera for serious aesthetic purposes is accepted as a matter of course, and the volume of critical comment has boomed. The sequence of events leading up to this transformation in the status of the photograph is a little hard to grasp. One is tempted to look for a resurgence among professional photographers that spilled over into the worlds of the painter and sculptor. Chronology suggests, though, a relation of art to photography that is altogether more convoluted. A shift in

attitude seems first to have been detectable among painters and sculptors, not photographers, and to have centred on photographs that, far from being of high quality, were by general concensus hackneyed.

In the early 1950s, a painter of high sophistication like Nicolas de Stael was still struggling, by no means entirely successfully, to reintroduce human figures – footballers, nudes – into paint surfaces that had become largely abstract. The early 1960s saw a radical change: the emergence of Pop Art, and the use in painting and sculpture of photographs from advertisements and pin-up magazines. By the early 1970s, at a time when editorials in journals for the serious photographer were still bemoaning the lack of public regard for photographers of quality like Atget and Capa, Stieglitz and Cartier Bresson, the initial muddle and striving of Pop Art was over, and visual puns like Mel Ramos's *Ode to Ang*, a pastiche of Ingres's *La Source*, derived from a photograph, had become part of our visual currency.

Especially to begin with, the Pop Artist's attitude towards the photographs he used was one of a patrician slumming. Painters like Warhol and Lichtenstein delighted in pin-ups, advertisements and comic books precisely because they were tawdry or banal. As at least one critic was quick to notice, the Pop Artist's risks, in playing such games, were close to those run by eighteenth-century aristocrats who played at shepherds and milkmaids. If the aristocrat's disguise was unconvincing, the game was pointless; if too convincing, he might be taken at face value, as a peasant, and judged as such; 'impractical, useless, and, worst of all, no longer amusing'.[13]

Painters and sculptors had recovered the human figure, I want to claim, at the cost of placing it within quotation marks; of treating it knowingly, as a vehicle for esoteric conceits. And since the pioneering days of Pop, the nude has stayed very largely where Warhol and his cohorts put it. There are exceptions, naturally, but even among these, many support the rule. John de Andrea's extraordinarily lifelike male and female nudes in fibreglass are cast directly from the model and spray-painted to achieve the greatest possible verisimilitude. Like Madame Tussaud's waxworks, they do everything, it seems, but sneeze. Apparently an extreme expression of the purest naturalism, as close to the literal as any piece of

sculpture can hope to come, their appeal proves at root cerebral, dwelling impassively on the borderlines between real and imitation, the ordinary and the artistic.

It is as if, as a tribe, painters and sculptors had first retreated from the live model, and had now returned, but had felt free to do so only if they could place the body at two removes, insulating themselves from its embarrassments and demands both by means of the camera and by a sustained posture of the ironic. But it was not until this shift of sensibility among painters and sculptors was complete, or so it now seems, that the rest of us were free to see in photography, *real* photography, the fascinations that had been there all along; a vast edifice of image-making, extending over nearly a century and a half, and not banal in the least.

How such shifts in the *Zeitgeist* are to be calibrated, I am far from sure. The publication in 1968 of Aaron Scharf's remarkable *Art and Photography* was perhaps a turning point. I certainly recall with clarity the moment the penny dropped for me: it was at an exhibition of Edward Weston's photographs in the Museum of Modern Art in 1975. As a devotee of thirty years' standing, I was surprised and shocked to find myself bored by most of the great works of modern painting on permanent display in the Museum. With the exception of the Mondrians and one or two others besides, they struck me as overblown and stale. In contrast, the rows of Weston's photographs, tiny by comparison, were magnetically attractive. There seemed so much more *in* them: not least, evidence that Weston had been fascinated both by certain women, and by the business of turning them into meticulous black-and-white.

It is hard to avoid the impression that it was the invention of the camera that triggered the surge of experimental energy that painters experienced in the hundred years from 1850 to 1950: not, as Weston believed, because it released painters from the burden of representation, and set them free to follow the true path of abstraction, but because it confronted them with the profound challenge and threat of a 'truth to nature' that was mechanical, almost automatic. Admittedly, there exists an alternative explanation. This points not so much to a specific technological change as to a more diffuse reaction against accepted canons of good taste. As it happens, the invention of the camera coincided almost exactly

with the Gothic Revival, in itself, Summerson suggests, a species of attack:

> Too often, this phenomenon is represented merely as a pietistic inten-
> sification of the antiquarian revival of Gothic. It was far more than
> that. Its intuition was deep and formidable, perhaps more clearly
> conscious of what it wanted to destroy than what it wanted to build.
> To disrupt the rule of taste was the first objective, performed with
> incredible ease. The three-centuries-old fabric collapsed within ten
> years of the publication of Pugin's *Contrasts* in 1836; the common stuff
> of early Victorian architecture was made up out of its ruins.[14]

Whether the root causes were technological or more diffusely cultural, the impact of the camera on art was initially fertilizing, in that it provided painters like Degas with a fresh repertoire of formal devices, sharpened their powers of observation, and sharpened their curiosity, too, about the conceptual oddities and paradoxes of image-making. But it also seems to have encouraged in subsequent generations of painters a desire to cut themselves off from the abiding preoccupations of their craft: a concern with what the world actually looks like, and a respect for the achievements of previous generations that is sufficient to sustain a living language of forms.

In short, the impact of photography on painting was destabilizing. Soon after the turn of the twentieth century, painters of the avant-garde were already slipping free of the literal as a reference point in their image-making; one thinks of Picasso's *Les Demoiselles d'Avignon*, Kandinsky's abstractions, Duchamp's *Nude Descending the Stairs*, all produced in the years just before the First World War. Literal representation was left more and more to the photographer, while the painters concentrated on the formal properties of the visual array, and on investigations in paint of a more purely conceptual nature.

Such cultural shifts are rarely simple, of course; and the retreat from the body as a source of fascination that the painting of the twentieth century so sadly exemplifies may well express a more comprehensive alienation. It may be part of the painter's response to the increasingly abstract technology of his everyday life, of which the camera was the harbinger: the telephone and radio; more recently the television set and the computer.

Like a radio set flicked from station to station, or a sequence of advertisements on the television screen, the camera does offer a plethora of stimuli and of attendant psychological concerns. As critics like Susan Sontag suggest, this promiscuity may be inherently alienating.[15] But while there are grounds for anxiety about the part that the camera plays in our everyday lives, it has also become the last refuge for those still interested in what the world – and especially a particular person – actually looks like. It is to the camera that we turn if, in visual terms, we want to know what is actually *there*.

For the sociologically deft, notions like 'literal' representation or what a person 'actually' looks like are, I recognize, a battlefield. One view, normally assumed to be naïve, holds that we see a literal representation of ourselves when we look into a mirror, or at a photographic plate exposed under normal conditions of light. Another view, reputedly more sophisticated, holds that what we accept as 'literal' or 'actual' is culturally constructed, and will therefore vary from culture to culture, and from one age to the next.[16] Some reconciliation must be attempted, I think; and the photographic likeness seems as good a starting point as any. Without question, there are dozens of methods whereby we generate images that are accepted as lifelike. We can choose black and white or colour film; a wide-angle or telephoto lens; artificial or natural light; a studio or an everyday setting; a model who poses or one who is unawares, and so on. It is also true that, in a photograph, the perception of a likeness will depend to some extent on the simplifications implicit in a sense of style. But this plurality of means does not place the photograph on all fours with any other form of visual representation: an oil painting, say, or a caricature. Handled with the necessary skill, a camera is better suited than any other visual device to push us beyond what we expect to see to what is indisputably there. This discipline, inherent in the camera, is reminiscent of that imposed by the traditional life class, but is more nearly impersonal and therefore in principle more stringent.

Of late, most painters and sculptors of the avant-garde have seen this discipline as one to avoid. They have decamped; and equipped like a guerrilla band with weapons borrowed from sociology, linguistics and philosophy, they have set themselves up to investigate ideas. To date, the results provide scope for misgiving.

There has been the occasional thrill of surprise as the assumptions implicit in more conventional forms of art have been teased out, caricatured, recombined. Earthworks have sprung up; whole landscapes have been wrapped like parcels; doors have been arranged perpetually to slam; constellations of bricks and boiler plates have taken shape on gallery floors. But despite their daring, these feats of the imagination have left behind them, disconcertingly, nothing so much as a sense of chic.

An explanation of this disappointment may lie in a distinction of principle that separates art from science. Without experiment, both alike stagnate. But if detached from the traditional concerns that sustain it, the impulse to experiment in art leads inexorably, it seems, towards the ephemeral: the exhibition, for example, in an otherwise empty gallery of a glass of water on a glass shelf – a work of art because the glass of water was deemed to become an oak tree in the imagination of the artist who put it there.[17]

The established arts and the established sciences differ, it would seem, in their management of their own pasts. A young scientist is usually free to ignore all work in his own field that is more than a few years old. A painter like Degas cannot. In an art, the practitioner continually recreates the achievements of his predecessors: not imitating, but redefining and recasting the besetting problems as previous practitioners have posed them. Radical innovation is possible; but if the genre is to remain a genre and retain its vitality, the impulse to diverge is one that artists must contain.[18]

There is a respect in which the arts are committed, then, endlessly to mine their own pasts. Progress, when it occurs, is usually iterative: a matter of successive approximations to truths that are, in some sense, already known. Discovery, like personal discovery, is in part 'archaeological': a question of unearthing rather than of mantling together structures that are quite new.

Granted such a difference between artistic and scientific pursuits, there remains a certain uneasiness about mid-ground activities like photography (half an art, half a technology) and psychology (half an art, half a science). The difficulty with photography, as serious photographers themselves realize, is the absence, still, of any deep-rooted and pertinent tradition of image-making, the result being a wilderness of styles that is close to a wilderness of gimmicks. The difficulty with psychology lies in

the unresolved tension between the empirical pragmatism that a scientific training fosters, and the painstaking reanalysis of problems that previous generations of psychologists have posed. On the other hand, photography and psychology share a great deal besides their shortcomings, their points of similarity constituting fertile points of growth.[19] Both are representational activities; both are heavily enmeshed in issues of technique; and both depend at heart on John Ruskin's notion of 'truth to nature' – a difficult doctrine, but one that turns in practice on a patient, even obsessive, concern with what is actually there.

Notes

1 For the outsider, Scharf's *Art and Photography* (1968) is indispensable. It is perhaps churlish to say so, but I suspect that the history of photography is still a field in which telling snippets are transferred, as I am transferring them here, from one secondary source to another. In Jay's (1971) interesting, semi-popular account of the nude in photography, for example, I found the gripping intelligence that: 'In the early 1880s it was fashionable in America for better-bred young ladies to pose in the nude for their photographic portraits. The photographers were female. At the end of the century in England it was commonplace for young ladies to collect such nude portraits of their friends in a special album' (p. 40). I found the same remarks, almost word for word, in a footnote of Scharf's (p. 270), where he cites Stenger's *The March of Photography* (1958) as source. When consulted, Stenger offers almost exactly the same phrases, but puts them in quotation marks, without citing any source at all. Despite the exceptional psychological and historical significance of such a convention of nude photography in an apparently puritanical era, Jay, Scharf and Stenger offer no pertinent illustration. I have never seen such pictures, and have a sneaking suspicion that they do not exist.

2 Scharf quotes from Ruskin's diary for 1849, where, on several occasions, he records 'took daguerreotypes' or 'took dag'; but these seem to be references to photographs that Hobbs took at Ruskin's behest.

3 Scharf, p. 73.

4 Pollack (1977).

5 Scharf, p. 90. Sadly, Delacroix was by then set in his ways. When he came to paint, old habits reasserted themselves. As a result, the best of

his photographs of the nude are better, to my eye at least, than the paintings they inspired.

6 Specifically, there is an echo in Courbet's *Bather* of Dürer's drawing *Nude Woman from the Back*, in the Louvre, and of his *Four Witches*, in which, in Clark's words, 'the Three Graces become infernal gossips, with a skull at their feet and the devil peering round the corner'. There is a ferocity in Dürer that is lacking in Courbet; but the echo is there all the same – not of bosky groves, smooth limbs and vapid gestures, but of the guilt that permeated the German states in the age of Luther. Farwell (1973) points out, obviously correctly, that Courbet also drew on the popular nineteenth-century genre of erotic prints, which often showed a woman bathing, more or less naked, with an admiring maid fully clothed.

7 Scharf, p. 143.

8 Dunlop (1979), p. 133.

9 Dunlop, p. 190.

10 Some of the most remarkable of Degas's pastels are illustrated in Werner (1977). Degas's highly experimental approach to matters of technique is discussed by Reff (1976).

11 Shaw (1973). It seems that Rubens, in turn, copied his poses from plaquettes by the Flemish sculptor Jacob Cobbe.

12 Gilot and Lake (1966), p. 80. This remark seems to have been directed particularly at Dora Maar, one of Picasso's previous mistresses, and a photographer in her own right. Brassai is also mentioned as 'a very gifted draughtsman', and Man Ray, a pioneer of surreal photography and the first to exploit solarization, as 'a painter of sorts'.

13 Licht (1967), p. 47. A feature of Pop Art, interesting to the social scientist, is that the attack on good taste and on 'high' or mandarin conceptions of art it expressed was launched more or less simultaneously in London and New York. The two attacks were largely independent, however, and took related but different routes. Robert Rauschenberg's *Bed* (1955), an early American work in this genre, consists of real bedding daubed in paint, and is strongly reminiscent of the splashy abstract expressionism of Jackson Pollock and de Kooning that preceded it; whereas in a contemporary English work like Richard Hamilton's collage *Just What Is It That Makes Today's Homes So Different, So Appealing?* (1956), the influence of Marcel Duchamp, the dadaists and the surrealists is plain, but the conventions of abstract expressionism play no part.

14 Summerson (1962), p. 292.

15 Sontag (1979).

16 Professor Raymond Wilson recently passed on to me an excellent aphorism. It consists in the following exchange. Question: 'What is the dominant metaphor of the age? – any age?' Answer: 'What that age accepts as literal.'

17 Vaizey (1980). Back numbers of the magazine *Studio International* are goldmines of equally gloomy examples.

18 What counts as essential to a genre is notoriously difficult to decide. This is so whether the genre in question is artistic (painting, say, or the novel) or academic (the journal article or Ph.D thesis). Ground rules exist, but these are often artificial, and can easily become maladaptive. Genres blur, and it is essential that they should. On the other hand, a promiscuous flexibility of forms is out of the question: one might as well imagine sports like football or tennis with rules that altered with every game. The choices are uncomfortable, especially in those areas – and psychology is an instance – where the accumulation of wisdom is still to some extent in question.

19 The connections are spelt out in a little more detail in Hudson (1981), an exhibition catalogue. They deserve, however, a book to themselves.

7 Odalisque

Most works of art, even the tawdry, convey an initial sense of surprise. With most, the surprise is slight, and, quite rapidly, it subsides. Every now and again, this movement from novelty to acceptance takes on a more extreme form; and occasionally it is paradoxical, the initial response being one of outrage, and the more considered attitude being one of veneration. Despite their rarity, such cases are valuable to the psychologist because they reveal the power over spectators' imaginations that the artist in principle enjoys.

Again it is the mid-nineteenth century that furnishes the perfect example. When first shown to the Paris public in 1865, Manet's *Olympia* (see Plate 15) caused a furore. The authorities had to post two uniformed guards to protect it from assault. Yet, twenty-five years later, and only seven years after the artist's death, *Olympia* was bought from Manet's widow by public subscription and hung in the Luxembourg Museum. In 1907, it was moved to the Louvre, and, since, has been treated as one of the nation's most prized possessions. Obviously a work of the highest quality, or almost the highest quality, it now seems as harmless as a postage stamp. Not only does it not shock, it conveys scarcely a whisper of where its power to shock once lay.

Like many before and since, Manet's canvas depicts a young woman undressed. She lies on a bed, propped up by cushions. Beside the bed, holding a bouquet of flowers, stands a black woman, presumably a servant. At the foot of the bed, arching its back, there is a cat. The young woman has a compact, beautifully proportioned body.[1] She neither smiles nor pouts, but stares at us,

or just past us, with an air of composure. The tone of the work is unerotic; less erotic by far than Meit's, less even that Titian's.

Why, then, was the Parisian public scandalized? The pat answer – to my mind wrong, as pat answers almost invariably are – lies in the notion of prudery. It is taken for granted in our own age that the second half of the nineteenth century was a time of great inhibition in sexual matters, and that the general outrage at *Olympia* was part of a more comprehensive denial of the body's sexual significance. This explanation sits clumsily on the facts, however; and in coming to terms with these, even in a preliminary way, we discover that the prevalent Victorian attitude to the body was at least as complex and as fissured as our own.

The nude woman was, in truth, an emblem of the Victorian age. Canvases in the Royal Academy and Paris Salon were weighed down with nudes; sculptures of naked women peered down at Victorian families from every cornice and monument.[2] What outraged the Victorians was not the naked body itself, but shifts and modulations in the representation of the body so subtle that we are now pressed for words with which to describe them.

The difficulty becomes obvious if *Olympia* is set side by side with a work finished a year or two earlier by the academician Ingres: his *Le Bain Turc* (see Plate 16). Now in the Louvre too, *Le Bain Turc* displays naked women in a harem, twenty-four of them, in postures that range from the languorous to the indecent. Two of the women clutch one another quite brazenly. The general air of entanglement is so comprehensive that Sickert likened the image to 'a dish of spaghetti or maccheroni' – his own more sympathetic view of the nude, in contrast, being that it should provide 'a gleam – a gleam of light and warmth and life'. Less appetizingly, the *Le Bain Turc* is also reminiscent of fishermen's maggots, squirming in their circular tin.[3]

Eroticism of this sort was normal in Ingres's work: his *Sleeper of Naples* executes a pagan swoon, and so too do the women in the various versions of *Odalisque with Slave*. And although he incurred public hostility from time to time, this seems to have been directed against the least provocative of his compositions, not the most.[4] His imagery, which to our eye verges on the lubricious, was broadly acceptable to the Victorians; and it was so, one surmises, because it contributed to a collective fantasy: that of an exotic

sexuality from which all trace of shame or purpose has been expunged. But if *Le Bain Turc* is a work fit for a roué, *Olympia* creates, in comparison, a mood that is conspicuously cool and detached. We have not begun to explain why it should have caused such an unprecedented uproar.

Initially, looking at the Manet, one is stumped. Critics and public seem to have seen revolutionary mischief where none exists. The pose is covered by the legitimating authority of Titian. There is nothing provocative about Manet's handling of the paint itself, as there was in the case of Turner. Nor is there any hint of the proscribed: no hint, for example, of pubic hair. In search of straws to clutch at, one turns to the critical remarks made at the time. Astonishingly vituperative, some are like the protestations of a hysterical patient; they cannot mean quite what they claim to mean, but they open interpretative avenues nonetheless.

The first of these was the accusation that Manet had depicted a prostitute. As recently as the 1930s, Paul Valéry spoke of *Olympia* as:

> ...scandalous, idolatrous, the lewd force and presentment of a wretched arcana of society.... The purity of a perfect line encloses this most impure of creatures, whose profession forces her to remain forever in blissful ignorance of modesty. An animal Vestal, vowed to complete nakedness, she forces us to reflect on all the primitive barbarism and bestial ritual which is hidden and preserved in the habits and activities of prostitution in our big cities.[5]

But why prostitution? It cannot be a matter of her setting. The trappings with which Manet has surrounded his nude might be those of an exceptionally luxurious corner of the demi-monde, but what they resemble most are updated versions of the contexts that Titian had created for his various Venuses, and that generation after generation of critics had accepted without a murmur.

One clue lies not in pose or setting, but in the face. What Manet offers is a nude portrait of an identifiable woman: in fact, his favourite model, Victorine Meurend (see Plate 15). As far as we know, Victorine was not a prostitute, nor does she look like one.[6] In any event, other painters had offered nude portraits – Rubens, Rembrandt, Boucher – without provoking an outcry. Victorine does *stare*, however. She looks not so much at you as *through* you, weighing you up. It is this reciprocity, I think, that must have

brought the idea of whoring so forcibly to mind. Prostitutes, after all, were at that time the only women men knew about who, while naked, could appraise while being appraised.

Contemporaries protested vehemently about *Olympia* on other grounds besides. It was claimed that she was corpse-like; and that the crowd gathered round her, held back by the guards, might as well have been in a mortuary. Also that she was 'a sort of female gorilla, an india-rubber deformity'; and, yet again, that her pose was obscene: that her left hand as it lay across her right thigh, preserving her modesty, was 'clenched' in an 'indecent contraction'.[7]

The claim that *Olympia* is corpse-like is baffling. Manet's tonalities are cool, but his treatment of Victorine's flesh is delicate; far more so than that employed by Ingres, or by the consciously provocative Courbet. It is as if Victorine was seen as a corpse because so lifelike a body could only be seen legitimately in a mortuary. The claim that she was a gorilla and an india-rubber deformity is equally odd: a conjunction of opposites – the feral with the synthetic, the menacing with the inert – that brings to mind modern pornography. There seems to be some inherent tendency, when males turn the female body into a fetish, to stress the impermeability of its skin: to conceive of it as smoothly resilient like an inner tube. It was perhaps a hint of the perverse that Manet's critics thought they perceived and felt moved to denounce.

More accessible is the suggestion that Victorine's clenched hand represents an indecent contraction. A comparison with Manet's precedent, Titian's *Venus of Urbino*, is instructive. In the Titian, the left hand dangles inertly, the fingers covering the pubic region itself; superficially the more indelicate gesture of the two. The difference lies in the fact that Victorine's fingers press onto the flesh of her thigh. This makes the thigh itself more palpably present, and it also conveys the impression that Victorine is alert, and has ideas of her own. And, a subtle detail, the pressure of those fingers belies the cool appraisal of her gaze: instinctively, she is protecting that part of herself which, by implication, a male visitor has come to use. Her gesture is judged indecent because it recognizes the indecency of the interest that her male visitor-cum-spectator is showing in her. The Victorian male poses as a

connoisseur, his head full of high-minded thoughts about Art. In truth, Manet's image implies, he is eager to see and use this woman's vagina; a lecher and a hypocrite.

Contemporaries were also alert to the curious air of artificiality that Manet's painting conveys. It is as if the conventions of academic art are being guyed: Pop Art a hundred years before its time. Courbet's reaction acknowledged this: 'It's flat; there is no modelling; you could imagine she was the Queen of Spades in a pack of cards, coming out of her bath.'[8] Manet uses two technical devices to achieve this effect. The first is incongruity of style. Victorine's body is painted with exceptional care, the offending left hand, for example, being a tour de force; whereas the cat on the end of her bed comes from a different genre of painting altogether: the comic cartoon.

It is the second of his devices, though, that is the more remarkable: the presentation of the figures in his composition as though they were cut-outs. In painting, this 'playing-card' illusion is novel. On the other hand, it is one that the Paris audience of the 1860s will have recognized at once, not from the world of high art at all, but from the new-fangled and immensely popular stereoscope. This device, a small box or frame which allows two photographs to be viewed through separate lenses, was invented in the late 1840s, and by the middle of the 1850s more than a million had been sold in England alone. Used predominantly to yield three-dimensional images of exotic landscapes, the stereoscope was also employed for smuttier purposes, some of the images viewed through it being pornographic. An essential element in the excitement of these images was the knowledge that the women depicted were actual women, not a painter's or draughtsman's whim. By referring to them through the convention of the 'cut-out', Manet was perceived as cheapening the high ideals of art. Lofty thoughts of gods and goddesses are cashed here in terms that could scarcely be more prosaic.[9]

As John Berger says, Manet represents a turning point: 'If one compares his *Olympia* with Titian's original, one sees a woman, cast in the traditional role, beginning to question that role, somewhat defiantly.'[10] Question both her role in society and her role in the erotic imagination, she most certainly does, but not solely, I am suggesting, by the expression on her face. She does it – or,

rather, Manet does it through her – by reminding his male audience of a traditional boundary between the artistic image and the literal world of their everyday appetites and curiosities which they are now in a position to breach. He does not breach it himself; he merely alludes to the possibility. Victorine's facial expression; that clenching left hand; the stylistic incongruity of the cat; the spatial illusion of the 'cut-out' and its pornographic connotations: all these resonate on one another, and combine to shift the luckless spectator from a posture of comfortable immunity to one of choice and risk.

Most powerfully disconcerting of all Manet's devices, though, is the one that Titian exploited three hundred years earlier in *Venus and the Organ Player:* the use of pictorial space to invade actual space. Altogether more high-handedly than Titian, Manet implicates the spectator. Where Titian's Venus presents her body to the spectator, but turns her gaze aside, Olympia protects her body instinctively, yet stares straight out of her frame; and so too does her cat – in alarm. The while, the black woman, a shade uneasily perhaps, looks sideways towards Olympia, with bouquet in hand.

The implication of this network of gazes is unavoidable: the spectator and the intruding male are one and the same. The bouquet is ours. It is we who have come to enjoy Olympia's favours. It is our sexual desirability (or even cleanliness) that is being appraised. And it is we who cause that shiver of anxiety that Olympia's hand betrays. Worse, there is evidence that, as intruders, it is we who are being treated with less than full seriousness, caught not only between two gazes – Victorine's and the cat's – but between two styles, those of high art and of the mocking, irreverent cartoon. Like Titian's musician, we are to be treated, obliquely, as figures of fun. To Victorian men, vouchsafed the privilege of looking at images of naked women non-reciprocally, as connoisseurs, this grouping of Manet's must have seemed very threatening indeed.

It goes without saying that a painter who shocks as deeply as Manet did with *Olympia* must be sensitive to the collective prohibitions and denials on which the equilibrium of his society depends. Also, that the equilibrium must be precarious. By the middle of the nineteenth century, great cities like London and

Paris harboured unprecedented poverty and squalor. Alcoholism and prostitution were rife and uncontrolled: it has been estimated, for example, that at any one time in the 1850s there were as many as 80,000 prostitutes in London. Among the urban poor, these conditions gave rise to a new puritanism; among the well-heeled, whose prosperity depended more or less directly on the continuing poverty of the poor, uneasiness expressed itself in what seem to us arbitrary and quirky feats of denial.

As memoirs and diaries of Victorian gentlefolk are unearthed and published, we begin to grasp just how convoluted the erotic imaginations of certain Victorians became. An intensely puritanical prime minister, Gladstone, tramped the streets at night, in the hope that prostitutes might solicit him. He would then take them home to his wife, and together they would attempt to save the poor whores' souls. Lewis Carroll took nude photographs of the little girls of Oxford, yet, to the best of our knowledge, never molested them. And at the great public schools like Harrow, fashioned by the Victorians as instruments of moral inculcation, 'the seeds of vice' propagated themselves 'like mushrooms on a dunghill'. One headmaster, an ardent evangelist and pupil of Arnold at Rugby, was secretly sacked for his sexual depredations on his pupils, among whom the young were given girls' names and referred to as the older boys' 'bitches'. Yet, without irony, he preached for the last time to his boys on the theme 'Yet Once More'; a sermon that was to become a great Victorian favourite.[11]

To the prosperous Victorian male, Tennyson's 'slope of sensual slime' was a living reality. Far from inviting him to slip down it, what Manet did was indicate one of the contradictions in terms of which this slope was defined: a public iconography of naked and erotic but smoothed-out and mythical women, and a system of social relationships in which the most sordidly exploitative aspects of prostitution were perpetuated but set to one side. In attacking the spectator's privilege as an onlooker, and in reminding him of the illicitly literal possibilities inherent in the camera, Manet was violating a carefully evolved set of restrictions about what could and could not be looked at in a polite context. In *Olympia*, he was announcing that a crucial shift in the segregation of the world into manageable slices had occurred.[12]

The implications of this shift are ones that we have been working

out for ourselves in the hundred years since *Olympia* was first put on public display. More and more, it has been the photographer who has taken over the task of representing the body in lifelike form. The photographic pin-up has taken the place of the odalisque. Accordingly, it is with virtues and vices of the camera that we must come to terms.

Unquestionably, there are snags; for all its ease, the camera is a recalcitrant instrument. It is, for example, disconcertingly abrupt. In the time it takes a painter to make his first preliminary gestures, a photographer with a motor-drive can have thirty-six images of the world, literal and entire. But he must plan ahead, for once his shutter is released, he is committed. He can exercise a few pedestrian darkroom tricks (a little dodging, perhaps) or resort to repairs; but, in principle, all those things he does not want, cigarette butts in the grass, pimples on a flawless brow, he must exclude before the button is depressed. A curious consequence is that while most painters edge towards the literal, the photographer tries to escape it, looking for ways of asserting formal properties that will give his material a sense of style.

The photograph's surface is boring too. There are no pleasures in photography comparable to spreading a creamy swathe of oil paint across a new canvas, or the first contact of charcoal on paper. The photographer is confined to the manufacturer's matt, pearl and glossy papers. When Bonnard painted his wife in her bath, he filled his space with sumptuous colour, but could set against this the impression of the paint surface itself, a mass of apparently indecisive scratches and dabs – and create, thereby, a sense of nervous dislocation, of sensual pleasures missed or abjured. The photographer has no comparable resource; he looks straight through the surface of his paper into the illusion of space, and the spectator looks likewise. He is at the manufacturer's mercy as well in the matter of colour. Modern colour film yields hues and harmonies that sit comfortably on the page, but do not endure in the mind's eye; and memorable photographs, as opposed to pleasant ones, are usually as a consequence in black-and-white.

There are difficulties, besides, at the levels of fantasy and emotional connotation. There is something alienating, even at times predatory, about taking someone's likeness, especially a stranger's. Photographers have found it natural to speak of shots and snaps

- and, more knowingly, of 'pix'. Flashguns fire. Cameras, more generally, look like weapons. And in the smell of darkroom chemicals and a knowledge of the transformations they effect, there are residues of the alchemist's preoccupation with supernatural power.

Photography is not an affectionate trade. Yet, despite its disadvantages, it continues to move from the periphery of our cultural landscape towards its centre; to establish itself as an aesthetically potent activity in its own right. As usual, there are several explanations. Its very impersonal, manipulative air seems to suit our mood; and its reproducibility and expendability provide a new, more democratic aesthetic currency. In addition, it offers formal advantages that paintings lack; and, towards the end of this chapter, it is on certain of these that I want to dwell.

First, though, I would like to say something about the 'access' of the spectator to the photographic image, and to do so in terms of an image that is plainly erotic in its impact (see Plate 17). This picture is the work of the Japanese photographer Kishin Shinoyama. It achieves its potency, as William Gass implies it must, not through explicit reference to sexual acts or sexual parts, but by means that are altogether harder to isolate or discuss; and therein lies its special psychological interest. The focus of attention is the face, and in particular the mouth and the heavily made-up but closed eye. Two identical twins' oddly childlike bodies are pressed together, but with a stillness that is almost ritualistic. The contact between the two is conveyed with eloquence by the positioning of one twin's head: her mouth against the inside of her sister's upper arm, and her forehead pressed, the while, against her sister's breast.[13]

The access this configuration invites is remote from that of the conventional Western pin-up; and its appeal is not restricted, I think, to spectators who are male. What is at stake is not the magical availability of the model to the spectator, but the magical availability of one model to another, where both, for the restricted purposes of the image, are one and the same person. The spectator enters the image not as himself, as he might in a more conventional pin-up, or as he must in *Olympia*, but by identification with one or other of the models, or with both.

The erotic relationship evoked here, that of the individual with

himself, is usually labelled, somewhat pejoratively, narcissistic. Both men and, if I am right, women are lured by Shinoyama's image into a tract of the erotic imagination where desire becomes both narcissistic and gender-free; where, in his desire, the individual is at liberty to melt back not into a representation of the other, but into a representation of himself. The model's closed eye and the pressure of her head against her sister's breast seem to signify the existential melting of a baby back into the idea of its mother, a brief resolution in sexual intimacy of the quandary identified by Otto Rank.[14]

There is a hint of self-indulgence in the relation of Shinoyama's twins to one another; of a retreat from the constraints of an intimacy with another person, who exists 'out there' and is finally inaccessible, to a world of private and self-fuelling rumination. Nevertheless, the image is sufficiently poised, visually, to press the appreciative spectator of either sex towards certain conceptual discriminations. In particular, we are encouraged to ask to what extent, in sexual intimacy, we seek access not to someone who is objectively separate, nor even to the fantasy of such a person, but to a projection or idealization of ourselves.

Such thoughts demand discriminations that psychologists do not usually make. What the odalisque or pin-up offers is magical access to the body of someone who is not really there. And what distinguishes the run-of-the-mill image from the more distinguished are, ultimately, the terms on which this access is offered. At its coarsest, the pin-up offers irresponsible access to a body that is, in effect, a decorticate preparation: a body that will go through the moves of sexual response, but whose movements are uninformed by reflective intelligence or sensibility. It serves the spectator as a triggering device, much as an egg serves the herring gull. At the other extreme, it contributes to the genre established by Titian, Manet and Degas. What is more, this access constrains the spectator to greater or lesser degree. While Shinoyama's image offers us access in a state of fantasy, Manet's *Olympia* is more exacting: it suggests that we must enter as ourselves, and subject ourselves as we do so to appraisal.

Granted that any meeting of spectator and model occurs in the mind's eye, and is in that sense imaginary, several sorts of relationship are at issue. It is worth listing a few, each of which

straddles the traditional boundary between mind and body in a distinctive way. The categories apply equally to images of male and female bodies; to spectators who are female just as much as to those who are male, although the responses of male and female spectators may, of course, take different forms. An image of a body, for the sake of the argument, a woman's body, can encourage the idea of access to:

(1) A body that belongs to no one in particular, that is warm and responsive but nothing more;
(2) A body that belongs to a person, someone identifiable, but whose thoughts about her own body, like Titian's Venus, remain mysterious;
(3) The body of someone who offers to collude in make-believe – to play perverse games, perhaps, or act out sexual rituals;
(4) The body of someone identifiable, like Manet's Olympia, who is attractive but threatens to unsettle us;
(5) The body of someone attractive, Meit's Judith say, who presents a threat that is more corporeal, more a matter of life and limb;
(6) The body of someone who is mystified by herself, and for whom physical intimacy is a means of discovering who she really is.

It is tempting, surreptitiously, to order these varieties of erotic experience into a hierarchy of mental wholesomeness; but, in truth, they are simply options, and by no means mutually exclusive. Any one image, like any one person, may evoke several such responses in rapid succession, or set up a tension, an oscillation, between two. They are varieties of experience, what is more, that exist not just as fine shades of introspective meaning, but as properties that inhere in the containers designed to evoke them.

The point is important; for while the critic can restrict himself to nuances of response, the psychologist must push on, trying to relate these nuances to the objective properties of the image that elicits them. An advantage in this context of the photographic image over the painted one is that it is easier to say what the technical basis of a particular effect amounts to.[15]

Let me illustrate what I mean, and in doing so move from Shinoyama's *Twin*, an image that, in all probability, would have

spoken to Khalil Bey, the owner of Ingres's *Le Bain Turc*, to ones
that would almost certainly have left him baffled; images that are
specific to the twentieth century and no other. Both are pin-ups,
in the literal sense that they come from the *Pirelli Calendar*; but
both are works of genuine quality, and quite remote from the
manly preoccupations of the garage wall.

The first is one of Harri Peccinotti's assemblages for the *Cal-
endar*'s 1969 edition (see Plate 18). It shows six related shots of
the same young men and women standing around or sitting on a
cluttered beach. The emphasis is on the torsos of the women, and
on the complex patterns their bikinis form. Looking from one to
the next, it becomes plain that the same bikinis, the same torsos,
recur, two of them appearing three times each, the rest only once.
The view of the one at the centre of the top row is particularly
fine, to my eye more memorable than all but a few of the women's
bodies in Renaissance art: a body that is long and soft at the same
time, and that reveals a profile down the abdomen that conveys
the faintest hint of a sag.

Glancing to and fro, discovering that the same body can be seen
from different points of vantage, you have a strong sense of visual
constraint: of being trapped within a scene that, at one and the
same time, is in movement but stationary, arbitrarily restricted yet
free. These assembled images contain movement without freezing
it. Critics who see still photography as the poor relation of moving
photography have failed to grasp, I think, that it is precisely
around such ambiguities of movement – movement that is frozen,
frozen images that seem to move – that some of our most potent
aesthetic responses collect.

Of equal psychological interest is the way in which Peccinotti
has cropped his images in order to present not whole bodies but
parts of bodies. In a way that no painter can match, except by
imitating photography, the photographer can concentrate the
spectator's mind on the possibility that, in the realm of the erotic,
the 'other' is not a whole person at all, but an assemblage of parts.
Conventional wisdom suggests that this constitutes a disintegra-
tion of the body's image, and must be a sign of immaturity or
pathology. But the evident wholesomeness of Peccinotti's pic-
tures, partly a matter of style, partly his model's naturalness and
unconcern, tacitly poses an alternative. They suggest that while

common sense requires us to perceive the 'other' as a coherent entity, such perception may in fact be elusive: that from infancy onwards, and for boys perhaps especially, our vision of those with whom we are physically intimate consists, at root, in the perception of certain bodily parts; mouth, eyes, breasts, arms, legs, and so on. And that our sense of them as people, the integrating web that links these separate elements, may be a construction on a quite different and unrelated conceptual plane. Within the erotic realm, we deal, on this argument, not with people as entities or systems, but as fragments: parts of the body; situations that hover in the mind like stills from a film; personal identities that float free of their owners like labels, as they so often do in dreams.

Dream thought intrudes on the second of these Pirelli images too, but by another route. In the 1920s, the surrealists – poets as well as painters and photographers – set themselves to mine the vein of thought that lies below that of common sense; to create images that probed the realms of fantasy and dream. In Freudian terms, their aim was to tap 'primary' rather than 'secondary' process thought; to subvert the grip on our imaginations that common sense exerts.[16] In the fifty years since, the influence of surrealism has been profound, stretching far beyond the fine arts and permeating forms as familiar as those of the advertisement and record sleeve.

The impact of surrealism on the *Pirelli Calendar* becomes explicit in the collaboration, for the 1973 edition, of the photographer Duffy with the painter Allen Jones, an artist whose work has drawn heavily on the conventions both of surrealism and of pornography. (In each case, Duffy worked from a preliminary sketch by Jones, often introducing refinements, visual and conceptual, as he did so.) The images that emerged from this – as it happens, troubled – collaboration can have exerted little appeal to garage owners, but they are certainly ones that incorporate the dislocations of surrealism in telling ways.

In the pin-up for September 1973, a young woman sits at a glass-topped table or desk, with fountain-pen in hand and ink-pot and ledger before her, staring abstractedly just past us into space (see Plate 20). Her expression is pensive, and it reflects intelligence; a quality, among pin-ups, that is rare. If the girl's carefully made-up and pleasant face is emphasized, so too are the parapher-

nalia of fountain-pen, ledger and ink-pot. Evidently, they are not there by accident; and they could be seen as encouraging a reading of the image that is stalely 'Freudian', a possibility that gathers weight from Jones's preliminary sketch, which offers a slightly dirty-minded contiguity between the ink-pot and the model's private parts. On this dismal argument, the ink-pot doubles as chamber-pot; ink is faecal, a symbol of dirt; and the fountain-pen is a phallus filled with dirt. The ledger's virgin white pages are symbolic of purity that the girl is about, perhaps, to pollute.

However, such a reading is hackneyed, and also out of keeping with the tone of Duffy's photograph. The key to a more searching interpretation is found in the question of technique. The model's face and upper body have been photographed against a background with preternatural clarity, a device which, in pin-up photography, has become something of a cliché. More surprising is the fact that the image is cut into two halves along the edge of the glass table-top. This serves to divide the model into two halves as well. Her upper half is a brilliantly focused photograph; her body from the waist down, seen through the glass, in contrast seems artificial, an illusion achieved by the use of an airbrush.

Examined closely, 'September 1973' reveals herself for what she is: half a photograph, half a painting. Most of the Duffy-Jones images show this mixture of techniques, of the 'real' with the artificial; and as in a number of others, the distinction stressed here is that between the top and bottom halves of the body. The consequence is an air of tension or dissonance between what is perceived as real and what is perceived as unreal. At a purely technical level, in other words, complex and, one suspects, perennial games are being played around the body with the notions of top and bottom, dressed and undressed, natural and artificial. (Here, of course, what is perceived as 'natural' is in fact artificial, being the un-retouched part of a carefully staged studio photograph.) In part, the model is the product of her own art (her make-up and clothes); in part of the photographer's art (his dextrously wielded airbrush and the air of synthetic smoothness this establishes). Titian's conception of the body as the last landscape left to us in its natural condition is compromised fairly comprehensively, but is not altogether expunged. It still lingers as an element in a puzzle that one cannot quite resolve.

Another of the image's oddities is that, despite its clear sub-division, it refuses to fall into top and bottom halves. The model's body remains entire. This coherence is achieved partly through the powerfully diagonal structure of the composition; and partly through two stylistically incongruous elements: a glimpse of breast which appears to have been airbrushed, and the part of a white blouse which shows through the glass table-top, yet appears not to have been rendered artificial in this way. But the props also contribute – the pen, ink-pot and ledger – and they do so ingeniously. They create suspense; the possibility of action that, both visually and psychologically, will integrate. They hint that the image's atmosphere of the enigmatic will be resolved once the model puts pen to paper; that, in the art of transferring thought to the written word, a visual riddle will be explained.

It is worth spelling out with a little care what this translation of thought to word implies. The girl is reflecting, obviously; but whether she will write remains unclear. It is on this doubt that the evocative power of the image turns. As spectators, we want to discover what paths her private ruminations are following, and are willing to use the clues supplied by Duffy and Jones in attempting a reconstruction. Once this shift of interpretative emphasis is grasped, pen, ink-pot and ledger cease to be 'Freudian' symbols, and are free to become Freudian in less stereotyped and predictable ways. There *is*, after all, something death-like about the inked or typed word; rosy sentiment trapped in black-and-white. There is even a violation implicit in the process whereby we cover clean paper with ill-conceived or inadequate characters: a dislocating shift from the potential to the literal. This is especially so if, as in this image of Duffy's, what we are invited to consider are not fine poetic phrases, but, as the ledger's feint lines suggest, a record of debit and credit. Put crudely, Duffy's girl may be someone who uses her body's hidden properties for cash on the nail. Less aggressively, she is any beautiful, intelligent woman, musing abstractedly on the conundrums of 'love's body'; on the business of being beautiful in other people's eyes, either professionally or more informally, and not just as an end in itself, but in order to pay the rent.[17]

All this may seem distant from the pin-up's function as a social device for affirming the masculinity of men in a male world.

Nevertheless, a pin-up of quality establishes the suspension of common sense that is essential to any art, visual or verbal. It recreates the formal conditions of the reverie. And, a point of interest to the psychologist, it does so by means of technical conventions, devices and tricks that provide the rudiments of a vocabulary with which to talk about states of mind that lie beyond common sense. The specific devices I have mentioned are the fragmentation of the body's image into parts; the impression of paradoxical movement; the isolation of preternaturally vivid likenesses against a plain background; and the introduction of incongruities of style or medium – the use here, for example, of the airbrush.[18] Taken together, they provide a kit with which we can begin to reconstruct what happens when our minds range beyond the matter of fact.

In the recent past, psychologists have relied almost exclusively on our verbal means of self-expression – sentence and paragraph, metaphor and metonymy – as a model for these half-hidden aspects of the mind's capability. The indications are, though, that this has been unwise. It is not just that we think in terms of visual images as well as words, but that the visual image, especially one that is carefully wrought, has a crucial advantage that most pages of print lack. It can present us with alternative systems of meaning, and do so not sequentially, but side by side. In looking at a Titian or a Pirelli pin-up, the tyranny of the movement across the page from left to right, and down the page from top to bottom, is abandoned. Likewise the strain of holding in store the messages that previous pages contained. As in the realm of what Freud called 'primary process', the visual image's meanings present themselves to the spectator simultaneously, and their reverberations and dissonances are ones that he is free to absorb to the limits of his patience and powers.[19]

Notes

1 *Olympia*'s pose was drawn, it seems, from Titian's *Venus of Urbino*, and, before that, from a female figure on the Parthenon (Mauner, 1975). Mauner suggests that the link with the Parthenon may help to explain the canvas's otherwise enigmatic title.

2 Sumptuous nudes gaze down on Princes Street in Edinburgh, from the upper storeys of Jenner's department store, a shop that epitomizes

the narrow-minded respectability of Edinburgh society. The nudes were put there in 1895, the architect being William Hamilton Beattie. If an architect were to place lifelike effigies of naked women on a public building today, he would be viewed as deranged.

3 *Le Bain Turc* was finished in its first state in 1852, when Ingres was already in his seventies. It was sold to Prince Napoleon, but returned. Ingres then added at least one figure, and gave the painting its circular format. Finally, in 1862, it was sold to Khalil Bey, the Turkish ambassador in Paris, a man with a lively interest in erotica. Khalil Bey also owned Courbet's mildly grotesque *Sleep*, in which two women, supposedly lesbians, slumber together. Sickert's comment is recorded by Baron (1976).

4 *La Source*, Clark (1960) says, was the most immediately popular of Ingres's nudes; the *Grande Odalisque* the most savagely criticized. Yet *La Source* is a frontal nude, while the *Grande Odalisque* presents the spectator with her back – and was criticized, in any case, on the grounds of her distortion (she was said to have two vertebrae too many). It is a blemish of Clark's exposition that he invokes the idea of Victorian prudery to account for the public's response to Manet, but does not explain at all satisfactorily why Ingres's brand of eroticism was exempt.

5 Courthion and Cailler (1960), p. 206.

6 In Victorine Meurend, it has been said, Manet had the ideal model: 'exact, patient, discreet and not given to chattering'. Her profile was 'rather severe', but her face was 'enlivened by her beautiful eyes and a fresh, smiling mouth'. She had a body 'delicate in every detail'. (Courthion and Cailler, p. 53.)

7 Courthion and Cailler, p. 225.

8 Courthion and Cailler, p. 54. The effect of artificiality is equally strong in Manet's remarkable *Déjeuner sur l'herbe*, similarly the focus of critical hostility. Both paintings were in fact the product of the year 1862, in which Manet first met Victorine Meurend.

9 Needham (1973). The care with which more traditional art critics step around the influence of the camera in discussing men like Manet and Degas is extraordinary to see. Effects patently attributable to the camera's influence have for generations been explained away as arising from the influence of the then popular Japanese prints. For reasons not examined, the Japanese print is seen as a legitimate source, the photograph as illegitimate. It is as if to identify a photograph as a source of inspiration in a great man's work is to accuse him of cheating.

10 Berger (1972), p. 63. Berger spoils a good argument by leaning too heavily on a single Marxist notion: the belief that the history of the nude can be organized around the desire of rich men to own beautiful women as chattels. None of the images I discuss seems to me susceptible to such a reading.

11 These instances are taken from an essay by Plumb (1969). Marcus's *The Other Victorians* (1966) is a valuable source. Obscene photographs were available to the Victorian male in great profusion. Jay (1971) records that on 31 March 1874, the police raided the Pimlico studio of a Mr Henry Hayler, and confiscated no fewer than 130,248 photographs deemed obscene. Yet many will have depicted models, some personable, others pathetically plain, in poses and settings made to look as much as possible like those of Salon paintings. Others, even more remarkable today, will have shown partly dressed women going about their ordinary lives – doing the ironing, say. Although considered improper at the time, the best of these now seem touching, and devoid of any prurience of detail that could condemn them. Victorian males were intrigued by them, one presumes, because they permitted a glimpse into a world of female domesticity that the middle-class Victorian man could never hope to enter at first hand.

12 On the evidence of his works, Manet was exceptionally conceptually adroit; but, like Turner, he suffered from advocates who misunderstood him. Zola announced in print that Manet 'never made the mistake ... of wishing to put ideas in his painting', being 'only guided in his choice of objects and figures by the desire to obtain beautiful colours, beautiful contrasts' (Mauner, p. 166). When Manet arranged an exhibition of his own work in 1867, Zola offered to sell there a book of his, flattering to Manet. Manet was forced tactfully to refuse, his own objectives being so totally at odds with Zola's reading of them.

13 Gombrich (1973) picks, appositely, on a magazine article for teen-agers, explaining how, by the use of eye make-up, the 'gentle look' is achieved. The conjunction of the ritually made-up eye and the undressed or partially dressed body seems to be an inexhaustibly potent evocative device.

14 A conjecture: we become capable of original thought when in the state of mind that Shinoyama's image depicts; genderless, defenceless, and in symbiotic contact with the 'other' who is also ourself. It is at such moments that 'seepage' occurs, elements of strangeness penetrating the armour of common sense.

15 It is interesting in this context to look at photographs of women taken by other women. Joyce Cohen's *In/Sights* is a collection of self-portraits restricted to women. Of the more than 4,000 photographs submitted, less than a half-dozen showed pregnant women or women with children; there were also very few pictures of women with men, or of women confronting the camera directly, face-on. Typical were 'pictures charged with intense emotion, usually focusing on one or two selected aspects of self-investigation' (1978, p. vii). To the male eye, most of these images by women are set apart from work of equivalent quality by men, not by being pretty (one at least is intentionally obscene), but by this introspectiveness of mood, and by the absence, often, of a dominant formal design. Plainly, though, such dissimilarities are hard to interpret. The photographers in Cohen's collection may well be working in a spirit of reaction to assumptions about image-making established by photographers who are men. The same might be said of the mistiness of focus that characterizes both the photographs of a Victorian pioneer like Julia Margaret Cameron and those of a modern fashion photographer like Sarah Moon. Consciously or unconsciously, such women may be seeking to set their work apart from imagery they see as typically male. On the other hand, the female nudes of Imogen Cunningham are sometimes almost indistinguishable from those of Edward Weston, in which sharpness of focus and strength of formal design both find extreme expression. These are early days, of course. My own guess is that, in questions of technique or style, the work of male and female photographers will soon be indistinguishable, but that their choice of subject-matter could nonetheless remain somewhat dissimilar. Where consistent differences in technique or style do arise, these are more likely to be correlates, I would have thought, not of biological maleness or femaleness, but of maleness or femaleness of gender identity, object-choice or presentation of self.

16 This classically Freudian distinction is now of keen interest both to brain physiologists (Pribram and Gill, 1976) and to those of us concerned with patterns of sleep and dream recall (Hudson, 1980).

17 The status of the artist's or photographer's intentions in the construction of an image is always a matter of doubt. It is possible that, between them, Jones and Duffy thought the whole chain of implication through. My guess is that they will have proceeded more intuitively; Jones launching a traditionally 'Freudian' theme, and Duffy modifying it, partly by instinct, partly by deliberation. The ledger, for example, could well have been the nearest prop to hand, and its financial connotation a happy accident. Whether the implications of such details are grasped explicitly at the time seems not to matter much. Image-making of this quality is

very much a matter of the sleepwalking of the prepared mind, just as good science is.

18 Airbrush technique is described by Curtis and Hunt (1980).

19 The division between the visual and the verbal is, of course, blurred. Many visual images are 'read' sequentially, and verbal metaphors, as Lakoff and Johnson (1980) demonstrate, are often visual images in thin disguise.

8 Artist and Model

Like fashion photography and pornography, with which they have become intimately connected, pin-ups foster the assumption that the relation of the painter or photographer to his model is at heart predatory: a cold, non-reciprocal exchange, in which the model's needs and capabilities are subjugated or ignored. Unquestionably, many relations of artist to model conform to this pattern. But rather than dwell on the sordid, I want to make explicit some of the more rewarding possibilities that this curious relationship presents. It need not be shallow; nor need the images of people that flow from it.

When pin-ups are set side by side with a work like Manet's *Olympia*, as they were in the last chapter, it is hard to avoid the impression of loss. A significant depersonalization has occurred. One might protest that unlikes are being compared; that popular art is being judged by the standards of high art, the ephemeral by the standards of the enduring. Nevertheless, the sense of loss persists. Many writers have blamed this pervasive inadequacy of the twentieth century's imagery on the industrial revolution, in which the camera has played a significant part. Thus Masud Khan, a psychoanalyst:

All serious thinkers – be they poets or psychologists or philosophers – in this century have been concerned about a distinct dehumanization of man's relation to himself. It is my contention that with the Industrial Revolution and the advent of scientific technology in European cultures man began to consider himself neither in the image of God nor of man, but in that of a machine which was his own invention.[1]

By any historical standard except perhaps that of the Middle Ages, the public art of our time is bleak. Images of the body, except in fashion photography, pin-ups and advertisements, are now used less and less as a vehicle for pleasure, and the antic, 'erotic' connotations of painting have given way to conceptual gymnastics that converge on the values and preoccupations of certain theoretically minded sociologists, a tendency that Manet could be accused of heralding, but of which he certainly would not have approved.[2]

In looking for signs that something of human worth can be rescued from this lunar wasteland, Degas, again, is as good a starting point as any. For while it is possible to construe his friend Manet's attitude to his models as that of a womanizer, Degas's was altogether more convoluted. Socially formidable, a skilled aphorist, correspondent and poet, Degas is often said to have been a misogynist. Although he evidently enjoyed women's company, that for instance of the American painter Mary Cassatt, he did not marry, and he seems to have kept all members of the opposite sex at arm's length. With them, he was gauche. On one occasion, sitting next to Berthe Morisot, Degas is said to have begun by paying her compliments, but ended with a sermon preached on the theme that women are the desolation of the just man. Manet once remarked to Morisot that Degas was 'incapable of loving a woman, even of telling her so'. Others report that he was 'prey to an adolescent shyness, a fear of refusal, a preliminary embarrassment and shame, that kept him from moving along the amorous way. His tentative questing, with his models, would be checked, then turned to jesting'. As a consequence 'Degas grew to be known not as a lover but as a prankster, and all the practical jokes of the bohemian quarter were attributed to him'.[3]

The intensity of Degas's commitment to the precedents set both by older painters like Ingres and Delacroix, and those long dead, was unswerving. He said of himself: 'What I do is the result of reflection and study of the great masters; of inspiration, spontaneity, temperament I know nothing.'[4] Yet Degas's imagery conveys a spontaneity and innovative daring that were as unmistakable in his own day as they are in ours. More than that, he painted women with an almost unprecedented sympathy, and was the first to do so in ways that did not presuppose the existence of a male audience:

'these women of mine are . . . unconcerned by any other interests than those of their physical condition'. They were, quite simply, women washing themselves, drying themselves, doing their hair. This sense of their physicality is one that his later pastels transmit with a clarity rarely matched. The poverty-stricken women he used as his models emerge from the surface of his works as if snatched from the air.

Dunlop concludes, correctly I think, that Degas's public persona was an expression of sustained irony, an attitude ideally suited to a man whose needs were categorically at odds with one another: who was attracted to women, yet frightened by them; who was in one sense a conservative but in another a revolutionary; who, in his own phrase, wanted at one and the same time to be both 'famous and unknown'. Even in his justly famed brothel scenes, there is an incompatibility between what we know of the man and what his images convey. He was one of the first modern painters to portray life inside a brothel, and remains one of the few to have done so with affection. There are grounds for believing that Degas rarely if ever visited a brothel for the usual sexual purposes, but when compared with the work of his approximate contemporaries, Constantin Guys, Toulouse-Lautrec and Forain, it is Degas's images that convey what whoring must actually have been like: its workaday stresses and fatigue, its camaraderie and vulgar humour. In one of his monotypes, Degas captures with precision what may well have been his own dilemma: it is called *Le Client Sérieux*, and it shows one of four naked prostitutes pulling a fully-dressed, middle-aged man by the hand, encouraging him to overcome some private fear or scruple (see Plate 21).[5]

The key to Degas's empathetic understanding of women is to be found, I think, in a performance he gave, late in his life, to Paul Valéry, in which he mimics a woman taking her seat in a tram:

> She ran her fingers over her dress to uncrease it, contrived to sit well back so that she fitted closely into the curve of the support, drew her gloves as tightly as possible over her hands, buttoned them carefully, ran her tongue along her lips which she had bitten gently, worked her body inside her clothes, so as to feel fresh and at ease in her warm underwear. Finally, after lightly pinching the end of her nose, she drew down her veil, rearranged a curl of hair with an alert finger, and then, not without a lightning survey of the contents of her bag, seemed

to put an end to this series of operations with the expression of one whose task is done. . . .

After fifty seconds or so, though, signs of dissatisfaction appear:

She drew herself up, worked her neck inside her collar, wrinkled her nose a little, rehearsed a frown; then recapitulated all her adjustments of attitude and dress – the gloves, the nose-pinching, the veil . . .

Valéry describes Degas as catching this performance to perfection: 'Degas, for his part, went through his pantomime again. He was charmed with it.' But as Valéry also remarks, there was 'an element of misogyny' in Degas's enjoyment. His was the mimicry of someone a shade fearful of the person he mimics. As he was to confess in a letter to an old friend written late in life: 'I was, or I seemed to be, hard with everyone, through a sort of passion for brutality, which came from my uncertainty and my bad humour. I felt myself so badly made, so badly equipped, so weak, whereas it seemed to me that my calculations on art were so right.'[6]

The idea that an artist might wish to keep hidden the source of his curiosity will come as a surprise to no one with the least interest in creative effort. Irony is one device; arbitrary inconsistency, theatricality, excessive reliance on convention, bohemianism, hostility, obscenity are others. All serve to keep prying minds at a distance. The point is made in John Fowles's story, *The Ebony Tower*, in which a critic and painter of civilized but limited gifts goes out to Brittany to interview the erratic, brutally irascible Henry Breasley, a painter of altogether more visionary powers. What he confronts is a way of life constructed like layers of barbed-wire defence: a mixture of outdated gallantry, dependence, prejudice, cruelty, drunken rage, ingratiation, and the sexually farouche. When Breasley drunkenly denounces his putative biographer, he *strafes*: 'You're afraid of the human body'; 'Don't hate, can't love. Can't love, can't paint'; 'Better the bloody bomb than Jackson Bollock.' And then, much later: 'Just paint. That's my advice. Leave the clever talk to the poor sods who can't.' At first meeting, he is a preposterous old blimp in retirement; in the end, something of a monster.

The psychologist's first impulse is to resolve the sorts of dissonance from which Henry Breasley's character is built: to demand internal consistency, and also juster treatment for the two young

women he has inveigled into his life and bed: the Mouse and Anne. Any such concern misses the point of Fowles's story. Our task, if we have one, is to describe the contradictions and absurdities of Breasley's character and ménage, and explain how they serve to protect his gifts.[7]

In their differing ways, Degas and Breasley could both be said to have made use of their models: women for whom they felt no lasting commitment. With Pierre Bonnard, a painter deeply influenced by Degas, the relation of artist to model was demonstrably more enduring. In Bonnard's nudes, the lessons of Degas's apparently accidental, snapshot-like compositions are fully assimilated, but the female body is no longer insistently physical; rather, it is enveloped in light. His greatest nudes seem all to have been of the same woman, Marthe de Méligny, whom Bonnard first met in the mid-1890s – she was working in a shop at the time, selling artificial flowers, and probably doing casual work as an artist's model. Although he did not marry her for another thirty years, he was devoted to her, and was her constant companion.

Bonnard's early nudes, like *L'Indolente*, painted when he was in his early thirties, were erotic in tone; but the later ones, the greatest coming when he was in his late fifties, sixties and early seventies, are not erotic in the least. In the majority, Marthe is in her bath, near her bath, or looking at herself in a dressing-room mirror. This choice of poses was influenced both by Degas's pastels and by Marthe's abiding preoccupation with cleanliness. As Fermigier describes her, she was a 'rather curious woman' who 'spent her life between bath tub and mirror'. 'Psychologically imbalanced' and 'capricious in temperament', she was afflicted, it seems, with a sense of persecution that led her to distrust Bonnard's best friends, obliging him to live largely in retirement. She was also pretentious, her real name being not the grand Marthe de Méligny but the more prosaic Marie Boursin. Despite these frailties, she was gifted enough to paint well in her own right, and to love her husband's work. Bonnard was in her debt both for her support and companionship, and for the sight, as she went about her washing, of a 'slender and charming body' that he depicted many times over with 'modesty but also with evident pleasure'.[8]

Marthe's preoccupation with washing also gave Bonnard the opportunity, you cannot help feeling, to ward off fears, both his

own and Marthe's; to rescue from the past some idealized fragment of a life once amorous but now given over to the need to be clean. Well into their sixties, he gives Marthe in his paintings the body of a young woman; but one, more and more, that dissolves in light.

In Bonnard's paintings though, as I mentioned earlier, there is an irony. Their iridescent luminosity collapses, when you step closer, into a paint surface of nervous, apparently indecisive marks. Rather than the masterful, abstract, cross-hatchings of a Degas pastel, Bonnard offers a mass of scribbles and dabs, lacking any coordinative principle or design. It is also a surface that is conspicuously dry. His luminosity is achieved not in a series of coherent gestures, nor by applying paint in luscious swathes, but as the cumulative outcome of months of approximations. In his images of Marthe, Bonnard takes away with one hand what he offers with the other. The luminosity of Marthe's body remains an illusion: a dream of effortless felicity, beyond anxiety or need, yet contradicted by the properties of the painted surface in which it is embedded. The effect is moving but disconcerting. Bonnard depicts a life of ease, yet this remains stubbornly out of reach; a thought that we are allowed to entertain only if we are also willing to accept that a process of graceless niggling is its prior condition. The superlative nudes of Bonnard's later years are the product of neurosis, then: not his own, but Marthe's – or, to make the same point more circumspectly, the product of an intimacy in which there were neurotic elements, and in which these came to rest not in him but in her. In the sphere of literature, Graham Greene claims that: 'Every creative writer worth our consideration, every writer who can be called in the wide eighteenth-century use of the term a poet, is a victim: a man given over to an obsession.' With Bonnard and Marthe, the obsession was superficially hers; more deeply, it was one that enveloped them both – a very fortunate fit of frailties indeed.[9]

A major conceptual advance of the last two decades is the realization that intimacies constitute systems in which the needs and actions of any one member are shaped by the needs and actions of the others. Laing and Esterson's *Sanity, Madness and the Family* remains the classical statement of this theme. Intimacies in which one participant possesses both a gift and the will to sustain it represent something of a special case. Here, it is the talent itself

which becomes the battleground: the focus of potentially destructive ambivalence. If the relationship is to survive and the gift find expression, it must evolve subplots, projects or routines which will absorb potentially destructive ambivalences, and will permit the main plot to succeed. Within Bonnard and Marthe's intimacy, the main plot was Bonnard's art; one of its subplots, Marthe's compulsion to wash. It is our great good fortune that, in this case, the interplay of plot and subplot was so benign.

While Bonnard was painting Marthe, the nude as traditionally conceived was disappearing as a subject of Western art. Picasso was imposing on the body all manner of ingenious distortions and fragmentations, and the surrealists were attacking it, stretching and squeezing it into obscene lumps, ostensibly on the grounds that this is how the body appears in dreams. A formative text like Herbert Read's *Art Now*, first published in 1933, shows this process of depersonalization in full swing. With only a few exceptions, the body is depicted there, if it is depicted at all, either as an element in a formal design or as a vehicle for the emotions of anxiety or disgust. The while, it was among photographers that the body was studied as an object of interest in its own right, and as a 'container' for emotions of a less depressing kind.

In the years after the First World War, under the influence of Alfred Stieglitz, a distinguished 'photo-puritan', Edward Weston, then in his mid-thirties, abandoned a lucrative trade as a studio photographer and began to take photographs as an art – pictures of steel mills, of natural forms like vegetables and rocks, and of nudes. He left his wife, his four children, and his studio in Glendale, and established himself in a state of bohemian poverty. Quite rapidly, he evolved the sharply focused, meticulously posed style by which he is now known (see Plate 23).

It is tempting to use Weston patronizingly, pointing to the personal frailties that fuelled his art. But although hints of the pathological attach themselves to his story, we are in no position to patronize. His work is memorable; it also serves a useful purpose, in that it introduces the model as a person – not a fetching object in the artist's field of gaze, but a discriminating individual, some of whose needs the photographer was able to satisfy.

Approximately speaking, the nude women Weston photographed were the women he slept with, sometimes two or three

concurrently. Just as Stieglitz's nudes of Georgia O'Keeffe were of a woman his equal, intellectually and artistically, so Weston found himself beset with women who were in a position to pick and choose. Some were writers, some photographers, some actresses and dancers, a talented and wilful array. Tina Modotti, for example, was both an actress and also, it seems, a courier for the Communist International.

Weston himself was a little baffled: 'Why this tide of women?' he asks himself at one point in his Daybook. Charis Wilson, his second wife, supplies her own answer: 'During photographic sessions, Edward made a model feel totally aware of herself. It was beyond exhibitionism or narcissism; it was more like a state of induced hypnosis, or of meditation ... he made her feel more completely *there* than she probably had ever felt in her life.'[10] While some models were doubtless drawn, as Weston realized, by his reputation as artist and bohemian, many – dancers, actresses – were urgently attracted, one suspects, to the notion of seeing themselves as an *object*. People who lived through the expressive capabilities of their own bodies, they were drawn to what only Weston could provide: sexual intercourse *and* images of their own bodies translated meticulously into every shade of silvery grey.

The excitement as well as the pretentiousness of these encounters is captured in Weston's exchanges with the dancer Bertha Wardell. Having seen an exhibition of Weston's work, she offered her services and danced before his camera once a week over a period of three months. Both were hyperbolic about the results: on 17 May 1927, Weston records: '... printed the first of the new set of dancing nudes: ... a kneeling figure cut at the shoulders, but kneeling does not mean it is passive – it is dancing quite as intensely as if she were on her toes! I am in love with this nude ...' Bertha, in her turn, writes to him: 'What you do awakens in me so strong a response that I must in all joy tell you your photographs are as definite an experience to the spirit as a whiplash to the body.'[11]

The images that Weston and Wardell produced between them are among the most potently physical that the visual arts have to offer, comparable in this respect to Degas's pastels; and the gratification they provided is easy to understand. As Irma Kurtz has observed: 'No matter how admired a woman is for her success, her personality, even her sexuality, at one time or another in her life

she longs to be worshipped as an object: a beautiful, soulless, mindless object enduring neither warmth nor compassion.'[12]

Unlike Degas's, Bonnard's or Titian's, however, Weston's nudes did not get better as he became old. After the remarkable images produced in the first years of his relation with Charis (he was in his late forties when this began, she twenty), their quality drops off quite sharply; and later images, the picture of her posing in a gas-mask, for instance, taken when he was in his mid-fifties, are in comparison banal. Arguably, the cause was ill health; he was to die some twenty years later of Parkinson's Disease. There may be a case, too, for believing that he was exhausted, aesthetically speaking, by talented women using him in quests of their own. There are signs, all the same, that those pearly images of Charis represented investments that lay beyond his psychological means. It seems that, despite his amatory vigour, his attitude to the women he photographed had earlier been one of suspicion and hostility; and while these emotions were in abeyance during the early years of his relationship with Charis, they could easily have reasserted themselves. The most remarkable of his portraits of her were certainly followed before too long by images dwelling on the themes of abandonment and death. In 1941, for example, he undertook to illustrate Whitman's *Leaves of Grass*, taking for this purpose a series of images of abandoned plantations in Louisiana and cemeteries in New Orleans.[13]

Whatever the intimate mechanics of her relationship with Weston, Charis Wilson was certainly blessed as a model. Although nagged by her mother for carrying one shoulder higher than the other, for walking with her toes turned in, and for having hips that were too big, and self-conscious, too, about a new appendix scar, she was quite unembarrassed to be naked. Like Marilyn Monroe, Charis was at ease in her skin. Looking back, she is free to speak of her relationship with Weston level-headedly, but also fondly, and without a trace of rancour.

In Monroe, on the other hand, the contradictions implicit in being looked at are starkly exposed. As her biographer, Norman Mailer stresses the difficulty she experienced in providing the performance her directors required; a difficulty that became progressively more extravagant with time. Away from the camera, away from a role, Monroe gave those around her the impression of

somnambulism, of living 'ten feet under water'. Naturally gifted as an actress and strongly driven to use those gifts, she nonetheless created a purgatory for those with whom she worked. Tony Curtis is said to have said that kissing her in front of the camera was like 'kissing Hitler'; Billy Wilder is said to have said, once filming was over, that he could eat again, sleep again, enjoy life, and look at his wife again without wanting to hit her simply because she was a woman.[14]

Beyond the contradictions of Monroe's nature, Mailer dwells instructively on two of the mysteries of an actor's life, and both, from the psychologist's point of view, are germane. He assumes that what a gifted actor or model offers to the camera is a buried and sometimes paradoxical part of him- or herself; a fragment turned into a whole. Also, that any such performance attracts to itself like a magnet half-truths, myths, 'factoids', lies. The two mysteries are related because an air of artifice penetrates to the heart of the performance itself, it being part of our need as spectators that this should happen. As Mailer says of Monroe: 'she is a sexual delight, but she is also the opposite of that, a particularly cool voice which seems to say, "Gentlemen: ask yourself what really I am, for I pretend to be sexual and that may be more interesting than sex itself." '[15]

Apart from its public attrition, there is a private cost, Mailer suggests, in any life made up of public performances: 'it is not a lack of grace that offers sexual problems when actors make love but the lack of an identity to give up to the act'.[16] There are comparable costs, likewise hidden, for the artist or photographer. These are explored with finesse in some drawings that Picasso did when he was in his seventies (see Plate 22). John Berger has written about them well:

In nearly every drawing there is a young woman. Not necessarily the same one. Usually she is naked. Always she is desirable. Sometimes she is being painted. But when this happens, one scarcely feels that she is posing. She is *there* - just as she is *there* in the other drawings; her function is to be ... Beside her Picasso is old, ugly, small, and - above all - absurd. She looks at him not unkindly, but with an effort - as though her concerns were so different from his that he is almost incredible to her. He struts around like a vaudeville comedian ... She waits for him to stop.

And again:

> It is no longer that an old man's desires are obscene and absurd despite himself: it is that to *paint* in front of such a young woman, to put marks on canvas and to peer at her proportions, instead of making love to her, is also absurd, and absurd in such a dry, pedantic way that it too becomes obscene.[17]

These drawings of Picasso's preserve his wit and his felicity of line. They make play with masks and monkeys, but are records, all the same, of confidence slipping from an old man's grasp. After a life's work dedicated to the wilful dismantling of the human form, he discovers that it is now too late to make amends. (Picasso once stood in front of a Bonnard and denounced it as 'piddling'.[18] Yet Bonnard's late nudes of Marthe represent a reconciliation with the lost powers of youth that, for all the fury of his attack, Picasso could not begin to rival.)

Both here and elsewhere in Picasso's drawings, there is sometimes a further member of his cast, a highly significant one: the spectator. It is in this shady figure that some of the special dangers of the relation between artist and model reside. On occasion, it is the artist himself who is reduced to the role of spectating, watching while his model plays with the monkey. Alternatively, an onlooker peers round a corner or over a shoulder at the old artist in his plight. The inclusion is important, because in various guises the spectator inhabits the imaginative lives of artist and model alike. Their activity in fact presupposes a third person: someone to whom what they do together in private can in principle be made public by means of an image. Were the spectator not there, at least as an idea, posing and painting would lose much of its point; the spectator, off-stage, creates an uneasy triangle; one laced, despite its consolations, with both illicit excitement and risk.[19]

The consolations, and what they imply about our knowledge of one another, demand the best part of a chapter to themselves; the risks, on the other hand, are fairly simply stated. If an artist like Degas makes public what he has done in the privacy of his studio with women he has hired by the hour, he does something which, to the layman, may seem a shade quirky; but it is not an action that need necessarily compromise the artist deeply. Curiosity may be excited about his motives: but this can be smothered in conven-

tional notions about the artist's role. For Bonnard and Marthe, the transposition from private to public must have been much trickier: Marthe was not only Bonnard's devoted wife, but a woman with a strongly developed sense of privacy. The transposition was possible, presumably, because, in his treatment of her body, he idealized and abstracted; and because they were jointly wedded to the cause of art. With Edward Weston and Charis Wilson, the manœuvre will almost certainly have been trickier still; for what Weston made public, and he was among the first members of his species to do this, were precisely detailed and sexually revealing portraits of a young wife whom, in some sense, he must have wanted to keep to himself.

Simple explanations are to hand, of course: that the model is an exhibitionist and the artist a braggart. She flaunts her body; he flaunts the fact that he has privileged access to it. The evidence of clinical inquiry suggests rather strongly, though, that the proffering of the model's naked body to the spectator meets more complex needs. Preeminently, it is a social device that enables the artist to explore and colonize his own feelings of possessiveness and sexual jealousy. By making images of his model public, he gives other men access to her; but an access that is only symbolic, and constrained by limits that he himself has set. The risk may well excite him, but like any other incipiently perverse game, it can bring disgust in its wake. The artist can discover that, in offering other men access to his model, what he is really seeking is intimacy with other men – an intimacy that may centre on questions of rivalry or competitiveness, but may equally prove to be erotic.

The model can face dangers of her own. It seems that it is a standard feature of female erotic fantasy to be watched by alien men.[20] In the shadows perhaps, the spectator is always there. To be the focus of intense professional skill, to be made beautiful and public, may help the model quiet her misgivings about her own body and its impermanence. But the risk is never far away, either that she will disgust herself, or that she will discover disgust in the person who is supposed to be turning her into art.

Artists and models who care for one another commit themselves, in short, to skate over ice even thinner than it looks. If they are to survive together, as some do, they must combine a taste for risk with an inbuilt sense of discretion. However stern their commit-

ment to a higher cause, few seem capable of proffering full exposure, either of themselves or of someone they love, without the sentiments of alienation or dismay rearing up arbitrarily within them.

Notes

1 Khan (1979), p. 226.

2 The menace as well as the humour of this development is implicit in the nation's recent purchase of 120 building bricks, the work of Carl Andre, an artist who speaks with the fastidiousness of a philosopher and who also deals in metal plates and bales of hay. Neatly deployed on the floor of the Tate Gallery, they have been the predictable focus of public irritation. Such a purchase carries with it, though, a Kafkaesque twist. By means of it, a coterie of well-connected artists, critics and purchasing committee officers are telling the citizenry that the use of public funds is now unaccountable. The more apparently vacuous the expenditure, the more eloquent such a gesture becomes. It seems at first sight subversive, but proves to be the celebration of arbitrary power by those who already possess it.

3 Dunlop (1979), p. 72, where he draws on Berthe Morisot's published letters, and p. 141. Dunlop concludes that Degas may have had no sexual experience of women, but repudiates the suggestion that he was either covertly or explicitly homosexual.

4 Reff (1976), p. 7. Reff convincingly refutes the belief, still widespread, that the talents of Degas and Manet were purely visual. Both, he demonstrates, were intensely sophisticated; both painted *ideas*.

5 Prostitution, as Dunlop reminds us, was a solidly constituted part of French life at the time. In the last thirty years of the century, Paris police arrested nearly three-quarters of a million women as suspected prostitutes. Visits to the brothel often began in a young man's schooldays, and eyewitnesses speak of the brothels swarming with schoolboys during holidays and half-days.

6 Dunlop, pp. 155 and 11. Little seems to be known about the psychology of mimicry: to those incapable of it, an incomprehensible accomplishment. Like practical joking, it seems to be fuelled, frequently, by fear or hostility. Degas's remarks about being 'badly made' and 'badly equipped' presumably refer to his character, but could conceivably allude

more distantly to a physical (and perhaps specifically genital) disability. This, in its turn, might explain his timidity with women. Another interesting detail of Degas's personal life that Valéry records was his 'dread of intestinal obstruction or inflammation. There was a faultless insipidity in the all-too-innocent veal and the macaroni cooked in plain water, served, very slowly, by old Zoé [Degas's maid].' Timid, shy and coolhearted, Degas was also a man given to periods of 'explosive rage'. (Dunlop, p. 55.)

7 Fowles (1974). This task is not straightforward. Contradictions can erode the talent they protect, as they have begun to in Breasley's case, and they can also protect a talent that is spurious. In science no less than art, a Breasley-like exterior can encase a talent that is puny, even nonexistent. There are reasons for believing, too, that relations like those of Breasley, Anne and the Mouse are sometimes more reciprocal than they seem. Whatever his deficiencies, Breasley was a source of meaning in Anne's life and the Mouse's; and his need for them, though exploitative, was almost fervent enough to pass muster as love.

8 Fermigier, pp. 108, 126.

9 Greene (1970), p. 108. Marthe died before Bonnard, in 1942, leaving him to face the rigours of the German occupation alone. He died five years later, aged nearly eighty. His friend Natanson claimed that Marthe's death was a blow from which Bonnard could not recover.

10 Wilson (1977), p. 11. Her memoir reveals a common sense and a grasp of syntax that Weston's writing conspicuously lacks. Although she is dismissive of the suggestion, there does seem to be a separation in Weston's *oeuvre* between those nudes which are portraits, showing body and face, and those simply of bodies. It also seems that it is the women he cared about most deeply – Tina Modotti and Charis Wilson – who have faces, while the others appear, with only occasional exceptions, as limbs and trunk.

11 Wilson, pp. 49, 10.

12 Jay (1971), p. 40.

13 As an additional item of evidence, it is perhaps worth mentioning Weston's older sister. Their mother died while he was still a child, and thereafter his relation with his sister was one that seems to have served both to burden and sustain him. In letters to Weston, she reveals herself as a formidable hysteric. If Weston saw intimacy as dangerous, he evidently had good cause.

14 Mailer (1973). Seen in some quarters as a doubtful enterprise, this text of Mailer's seems to me exceptionally fertile. As he says, the question of 'how reality may appear to a truly talented actor' is one that 'opens the entire problem of biography'. What he offers is a 'species of novel ready to play by the rules of biography'; one that respects 'the facts', in as much as they can be established, but subjects them to a novelist's scrutiny.

15 Mailer, p. 106.

16 Mailer, p. 49. Mailer distinguishes between the Coquelin and Method schools of acting, the one offering polished impersonation, the other encouraging the actor to reach inside for an echo of personal experience that will meet the requirements of a script. For Method actors especially, 'living with the wrong part is like living with the wrong mate and having to make love every night' (p. 108).

17 Berger (1965), pp. 186, 199.

18 Fermigier, p. 9.

19 Plainly, the relations of artist to model and of each to the spectator are ones that exploit ambiguities and nuances in the matter of what is public and what is private. Yet 'public' and 'private' are dangerously undifferentiated terms. We have:
(i) Privacy in the philosophers' sense: the relation of an individual to the stream of his own conscious thought;
(ii) The privacy we enjoy when we know we are alone and feel free, say, to pick our noses or talk to ourselves out loud;
(iii) The privacy of intimate relations (and also of some professional relations, like that of gynaecologist to patient or photographer to model) and the oases of familiarity that these create;
(iv) The limited publicness of a letter written in confidence, or a meeting to which access is restricted;
(v) The greater publicness of a letter between friends, or a picture hung casually, but where only members of the family will see it;
(vi) Publicness that is complete: that of a story in a newspaper, an image on a television screen, an open political meeting.

We tend to assume that all thought is private in the first of these six senses: a naïvety that psychoanalysis undermines. An analysand's 'true' thoughts are seen, these days, as a collaborative construction in which analysand and analyst are partners. More generally, there is only a restricted sense in which our thoughts about history, say, or psychology are private. In truth, they form a set of borrowings from a public stockpile, and ruminations on those borrowings that themselves follow fairly conventional paths.

20 Stoller (1979) and Khan are valuable sources. One of Khan's cases is
especially apposite. Although this young woman entered a perverse re-
lationship, one with a man she found repulsive and who was himself a
pervert, and although she had had fantasies of sex with several men at a
time, her lover's hold over her collapsed at the point where he insisted
that she have sexual relations with other men in his presence. In her, and
presumably in many men and women, this translation from fantasy about
action to action itself was of deep significance: a moment in which her
suspension of disbelief was suddenly cancelled, and a relationship that
had seemed compelling became a void.

9 *The Still Image*

Picturing is not exclusively an activity for professionals. Metaphorically, we all do it; envisaging, epitomizing the world around us and our relationship to it. To this extent, I want to suggest, the relations of artist to model, of both to the image, and of all three to the spectator, serve as a format for a sizeable proportion of the everyday thinking we all do.

As Titian's *Venus and the Organ Player* establishes, our knowledge of other people has layers. We can know others intimately and, by implication, sexually: the phrase 'carnal knowledge' acknowledges this. We can know them socially, as friends or acquaintances. We can know *about them*, either in the form of gossip, or, more diffusely, in the form of worldly wisdom. And we can know about them 'objectively', academically, collecting evidence and constructing theories about them in our capacities as psychologists, sociologists, psychiatrists, or what have you.

Ideally, perhaps, these various facets of our knowledge should knit together; but they do not. On the contrary, they generate confusion. We discover that we do not understand people until we are intimate with them; but we also discover that intimacy, especially sexual intimacy, like academic knowledge, can encapsulate; less a doorway to real understanding than a kingdom in its own right, replete with rituals, habits and obsessions. We learn respect, too, for the distinction between tacit, empathetic understanding and knowledge of facts. These drive one another out, and they do so no less in our dealings with the other's body than they do in our dealings with the other's mind. It is not easy, simultaneously, to know the body as a lover might and to know it as a surgeon has to.[1]

138

In other words, it is not just our needs that are ambivalent; the knowledge of people to which those needs lead us is itself fraught with ambiguities, paradoxes. Where people are concerned, what we know is rarely simple: the subject-matter of a discipline still in its infancy. My interest, here, focuses on a small but centrally placed part of that subject-matter; and, in particular, on a paradox that I have called the paradox of petrification.[2] To see it plainly, I would like to step back, for the last time, from the level of the particular to that of the schematic: to establish the grid of relationships between artist, model, image and spectator in formal terms, and, however cursorily, to hint at its psychological implications.

In examining this grid, there is a cautionary remark of William Gass's that we should bear in mind. He directs it to writers, but it applies equally to anyone attempting to translate people into symbols: the painter and photographer, and, by implication, the psychologist too.

> So to the wretched writer I should like to say that there's one body only whose request for your caresses is not vulgar, is not unchaste, untoward, or impolite: the body of your work itself; for you must remember that your attentions will not merely celebrate a beauty but create one; that yours is a love that brings its own birth with it, just as Plato has declared, and that you should therefore give up the blue things of this world in favour of the words which say them . . .[3]

For those who fashion containers, there is a species of choice, Gass warns, between devotion to the symbol and devotion to the life on which symbols draw. A certain ambivalence towards our subject-matter is not a pathological quirk, in other words, or evidence, even, of wear and tear, but of the cast of mind that leads us to fashion containers in the first place. The choice, among practitioners, is not between a relationship to our subject-matter that is whole and healthy and one which is riven with fissures, but between one pattern of fissures and another, some openly damaging in their effects, others, on balance, more benign.

The most basic of the grid's linkages is the one I have already dwelt on: that of artist to model. At present, the artist is often male, the model more often than not female. Typically, but by no means invariably, the artist is in charge of the relationship, while the the model, paid or unpaid, does what she is invited to do. And what happens between them is frequently exploitative; either tacitly,

in that the model's private needs and capabilities are ignored, or quite explicitly, in that she is treated expendably, as an object. As I hope I have made plain, though, exploitation is by no means necessary. Many memorable images arise from an abiding fascination, and reach the spectator as images spun from relationships between lovers or spouses that are of enduring significance to both alike.

Whether exploitative or more genuinely intimate, the relation of artist to model generates two triangular systems of perceived meaning: that between artist, model and image; and that between artist, image and spectator. When the two triangles are locked together along their common side, five relationships are specified, plus a new, sixth, one: that between model and spectator.

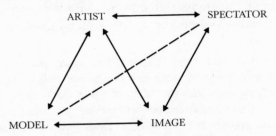

Figure 11 The six relationships implicit in an artist's representation of a model

It is from these six bonds that our repertoire of public imagery flows. None of them is quite what it seems:

1 *Artist: Model*

This relationship is in principle asymmetrical; the model offers herself to the artist as raw material. It is open to exploitation, but also to something more searching: it gives artist and model the chance to collude – and, within that collusion, to form images that epitomize something of their lives. Among the politically radical, it is sometimes assumed that this collusion of artist and model is inherently discreditable: that there is something morally offensive about the fact that some people find it gratifying to be looked at, while others find it gratifying to look. This prejudice, detectable, for example, in John Berger's writing,[4] rests on an assumption that is almost certainly false, namely that relationships must be

symmetrical (rather than reciprocal) before pleasure can properly be gained from them. For the reasons set out in my second chapter, it seems likely that mutually rewarding relationships will often prove to be reciprocal but asymmetric. Symmetrical relationships are the exception, and often, in any case, have about them an air of contrivance, as if designed to make a political point.

2 Artist: Image

Scrutinizing, adapting, the artist uses his image to discover the limits of his imaginative powers: his ability to turn inside out. But as it crystallizes, he also discovers his image's recalcitrance. It answers him back in the way that his characters answer back the novelist or playwright; or, more abstractly, that evidence answers back theory. The accumulated sequence of his own images constitutes the tangible, identifiable elements of the artist's biography. These have often become public property, in that they hang on someone else's wall; and, for that reason, cannot be reworked, as most biographical material is, in the light of present need. To that extent, the artist's biography is crystallized. All he can do, if he can get his hands on them, is destroy old images – as Weston is said to have destroyed his prize-winning plates, scraping them clean and using them to protect growing vegetables.

3 Model: Image

Like a mirror, the image confronts the model with him or herself as an object. More speculatively, it suggests to the individual what place he or she might occupy in another person's imagination – the imaginations, even, of thousands of others. There are complications, however. In our dealings with other people, we automatically use their outward appearance (facial features and expression, bodily shape and posture, clothes) as the format within which to lodge whatever we think or feel about them. In our dealings with ourselves, there is no such format. Hence, there is a profound difference between pictures of others and pictures of ourselves. With a likeness of someone else, we match, setting a particular photograph or painting against our format of that person, and deeming the likeness to be good or bad. With a likeness of ourselves, there is no format, so no such match can be made. The self which we perceive introspectively, a shifting system of fantasies,

appetites and fears, must somehow be compared with an objective image, as dispassionate a presence as a kettle or a shoe. It is perhaps for this reason that portraiture is so often seen as an existential threat.

4 Spectator: Image

The spectator is drawn into the image, guided by his own needs, but he subjects himself as he does so to the image's discipline. The image can be treated as a place of entertainment, but it can transform itself, too, into a hall of mirrors, replete with ill-lit corridors, dead-ends, trapdoors and dankly disconcerting basements. If he is lucky, the spectator will find his imaginative capabilities educated by what he looks at. In exceptional cases, like Ruskin's, a particular image may redirect his life, even encourage him to threaten his own sanity. There is no uniquely correct reading, though. What passes between spectator and image will in detail be idiosyncratic, and, in the fine grain, unique.

5 Artist: Spectator

Loosely, we assume that the artist speaks to his audience through his image; that he makes a species of broadcast. In practice, it is more often a case of take it or leave it. The artist completes his statement and walks away. The 'communication' between artist and spectator, the opening of one mind to another, is more often than not illusory, even when artist and spectator are contemporaries like Ruskin and Turner, and know each other quite well. The image intervenes, and does so gnomically. The artist addresses himself to his image; and, in its turn, the image speaks to the spectator. The artist's real audience, the one to which his efforts are actually addressed, is usually more spectral: a fantasied array of parents, mentors, rivals, lovers and friends, none of whom may in fact understand what he is doing, or even be aware that he is doing it. In those cases where the artist and spectator do genuinely communicate, it may well be at a level at which neither is consciously aware. What Ruskin and Turner shared, through an image like *The Slave Ship*, was not so much, I have claimed, the doctrine of truth to nature, but a horror that centred uncertainly on death, madness and disgust at the body; in Ruskin's case, particularly the mature female body. What passes between artist

and spectator is most potent when unacknowledged, and even unacknowledgeable, on both sides.

6 Spectator: Model

The strangest bond of the six: a meeting of a real person, the spectator, and another real person, the model, who has been turned into an object that turns back into a person in the mind's eye; a vision of flesh and blood that is both magically accessible and yet, in principle, beyond reach. For the spectator, the model is a recruit to that cast of actors and actresses who people his daydreams, reveries and sexual fantasies; for the model, the spectator is likewise a fantasy: a member of the audience that silently looks. Implausible though it seems, it is on this bond between two people who know nothing of one another that the whole enterprise of the figurative arts depends. Remove it, and we need never do more than stare at the creatures of flesh and blood that we find around us everyday.[5]

The humblest snapshot, the most fleetingly inarticulate response to pin-up or fashion plate, affirms our own positions within this web; and in as much as such images form the basis of our private ruminations, it is doubly affirmed. More generally, the kinds of picturing practised by the visual artist belong to a wider family of activities, in each of which human experience is conveyed. The poet, musician and dramatist are founder members of this family, of course; the novelist a member more recently joined. The psychologist belongs too. In each of these modes or genres, experience is epitomized, crystallized. And this feat is not peripheral to our culture, but lies at its heart. We may move, decade by decade, from paintings, say, to photographs, but this obsession with petrification remains. Why? Why are we so deeply committed to turning what we find desirable, or for that matter frightening, into paint on canvas, effigies in marble or stone, patterns on light-sensitive paper, printed word on the page?

The answer I have in mind is resolutely psychological in character; and a key to it is to be found in Roland Barthes's *A Lover's Discourse*. In this text, a collection of remarks set out, significantly, in alphabetical order rather than narrative form, Barthes points out that, at the centre of our lives, there lies an area of experience

where the dictates of common sense and the conventions of narrative, even the power of sensible-seeming utterance, collapse: the realm of amorous sentiment. In the amorous passages of our lives, we lose the purchase on our states of mind that the categories of everyday language exert. We experience intensely, yet find that the language on which we normally rely cannot be harnessed to lend this experience sense. We mean to utter great truths, but find banalities coming out of our mouths: 'it seems like a *dream*', 'where have you been all my life?'

This curiosity arises, Barthes claims, because amorous sentiment leaves us locked within an 'image repertoire' that is closed. The more vividly alive we feel, the less able we are to commit ourselves to words worthy of that feeling. Our language is craven; and we are craven too. So: 'In amorous life, the fabric of incidents is of an incredible futility, and this futility, allied with the highest seriousness, is literally unseemly. When I seriously envisage committing suicide because of a telephone call that doesn't come, an obscenity occurs which is as great as when, in Sade, the Pope sodomizes a turkey.'[6] It follows that, in Barthes's view, the amorous text is scarcely a text at all. It consists of 'little narcissisms, psychological paltrinesses'; a banal tune, a lock of hair or ribbon, certain scents, a bundle of letters perhaps. In effect, nothing.

Having diagnosed the illness with beady accuracy, however, Barthes then throws in his hand. Language, he implies, exists to express only those thoughts that are scarcely worth expressing; a conclusion which amounts to a capitulation. It is also a conclusion which assumes the primacy of language. Barthes seems to take it for granted that we experience futility because our language has collapsed. My own view is that language is in this respect secondary: that we are lost for words because we are lost, not the other way round. Whatever the reason, Barthes largely ignores all those states of the imagination that lie midway between the amorous and the everyday. Inexplicably, too, he ignores the arts: all those paintings, poems and bodies of music that serve as containers for precisely the sort of amorous consciousness that is his most immediate concern. Between the literal meanings of words and the inarticulacy of the lovelorn lie the wiles of the professional image-maker, and the conceptual functions that Gass correctly ascribes to them. It is not easy to construct images that will contain the erotic, but

it can be done; and although there will be moments when we are too lost in love to make use of them, they constitute a bridge.[7]

We seek to petrify all the more vividly evanescent aspects of our experience, then, because we would otherwise have no hold upon them. It is only through the medium of the artfully-wrought image that we can work back towards a discovery of what it is that, at such moments, we think and feel.

By the same token, there must be advantages for the psychologist in the scrutiny of such images and their attendant paradoxes. Instead of being trapped within reductive analyses of various sorts, the rhetoric of stimulus and response, for example, or the pursuit of analogies with the computer, he can start to talk about those signs, non-verbal as well as verbal, in terms of which ordinary lives are lived.

There are other advantages, too, less obvious. Among them is the new freedom it gives psychologists from the oversimplifications that have engaged us, for half a century or more, in the matter of verification or truth. We have sought the ratchet-like progress that the mathematician or physicist takes for granted; an accumulation of knowledge that is accepted as objective. And in attempting this ratchet-like movement, we have assumed that knowledge can be subdivided neatly into the subjective and the objective, the metaphorical and the literal, one a matter of whim, the other fully sanctioned by facts. Progress, it has seemed to us, must consist in the transfer of a topic from the first region to the second. But crude bifurcations of this sort ignore what stares us in the face: the criteria of truth that we employ as a matter of course in the arts. A good photographic likeness is 'objective' in any sense that one could sensibly wish for – but caricatures are likenesses too, true to life, even though they do high-handed violence to the facts of physiognomy. As Ruskin was aware, there is also the truth that lies beyond appearances, and that is not a matter of caricature. The best of Titian's portraits, or Degas's, are inherently 'truthful' in ways that a literal likeness, a caricature or a cheap imitation are not.

In psychology, we have burdened ourselves with the belief that to be judged by the standards of art is to admit defeat. Historically, though, the arts have always been disciplined and disciplining activities. The fashioning of containers of consciousness, in visual

art or any other, is not a matter for amateurs. It demands skill precisely because there can be no simple recipes or rules, no equivalent to painting-by-numbers that will carry us from where we are to where we want to be. To acknowledge a similarity between the arts and psychology is in no sense to commit ourselves to the free play of intuition, nor does it cut us off categorically from science. There, too, explanations are judged, as a matter of course, in terms of their 'elegance' or 'power', and are often accepted as ringing true, even though their truthfulness cannot be substantiated by immediate reference to facts. Both inside science and out, disciplined conjecture has always had an honoured place.[8]

Predictably, of course, there are awkwardnesses. Paradoxes like that of petrification rarely stand alone; difficulties, even mini-paradoxes, nest within the main paradox. The first of these concerns *technique*. It is this that intervenes between any two people who care for one another and the creation of a memorable image. They must accommodate between them the apparatus of image-making: in the old days, canvas and easel, now the camera. And in the case of the camera, not just the camera itself, nor even the intellectual distancing that the skilled use of a camera demands, but the ability of the model to stop in mid-sentence or stride: to hold it. Just as number-juggling among psychologists can become a substitute for thought, and the word-mongering of the poet an obstruction to experience, so photography can become a substitute for looking: a screen of technique that we place between ourselves and the emotional demands that people or places might otherwise make upon us. Posing, like impersonations and funny voices, can become, likewise, a device for distancing oneself from forms of self-exposure that are more committing. The pleasures of the medium can thus displace the pleasures of the person; and in the professional image-maker, whether artist or model, this displacement is to some extent unavoidable.

As survivors of a decade in which battles were fought and won in favour of four-letter words and pubic hair, it is tempting to be naïvely romantic about such hazards as these: to condemn the technology of image-making out of hand, and to assume that once this is removed, health and harmony will automatically be restored. Critics like John Berger and Susan Sontag sometimes speak as if the camera were an intrusion of the alien into lives that

would otherwise be spontaneous and free.⁹ But just as the needs underlying image-making are ambiguous, and the knowledge embedded in images is itself ambiguous, so too are the criteria whereby any particular instance of image-making is to be judged. The camera educates some at least of the eyes that use it; an education that is necessarily alienating only to the extent that all education is. And spontaneity is usually of more interest to us when the end-product of vast skill and infinite pains, as in Degas's late works, than when it appears as a naïve upwelling.

Behind the difficulties of technique and its attendant dissociations, there lurks the altogether more dismal possibility that image-making will be bent not to what artist and model can offer one another as individuals, but to aping whatever formats for the perception of people the culture happens at that moment to provide. Just as a tourist's snaps of the Grand Canal can seem real to him in as much as they look like the illustrations in his travel brochure, so lovers may value pictures of one another in as much as they make them look like denizens of advertisements for swimwear or aperitifs. The extent to which public imagery legitimates private experience is already disturbing. The real-life doctor (or painter or policeman) who behaves like a doctor on television now has a special claim to be real; or, more precisely perhaps, a real claim to be special.

The task of picturing ourselves and one another can collapse back without warning, in other words, into the rehearsal of whatever myths about personal attractiveness and social acceptability the advertising profession is currently seeing fit to promote. Within such a context, perceptions of what is real or true boil down to the recognition of soap opera clichés. As Norman Mailer puts it: 'The spirit of soap opera, like the spirit of American optimism, is renewal; God give us a new role each week to watch, but a role that fits the old one. Because that, Gawd, is how we learn!'¹⁰ The thoughts we exchange in our most candid moments will be those fed to us over the years by the directors of this programme or that. Our reveries will be stocked with a sad melange of interchangeable snippets; intimate recognition will occur when, as lovers, we breathe into one another's ears the jingles from the commercials with which we grew up.

Public imagery could well become more sophisticatedly bizarre,

and, beguiled, we may see ourselves as growing more sophisticated with it; but the messages reaching our imaginations may nonetheless take on increasingly stereotypical forms. As Mailer proposes, our personal lives could be lived increasingly in terms of the movement from one cliché to the next. All knowledge will have become public knowledge, and psychology – the discipline that maps the relation of outer knowledge to inner – will have become otiose.

My hope is that this degradation of our experience does not occur; that the central mysteries will retain their potency. The ambivalences of sex and gender, desire and disgust, separation and engulfment, need not disappear because we now live in the age of the camera and television set. Accordingly, there should remain an element of excavation in any form of art worth contributing to, just as there is in any relationship worth living within. This preoccupation with the past, and with the alarming contradictions buried in it, is not the antithesis of change. On the contrary, changes are worth making because, through them, we can hope to cast ancient contradictions in a new light.

Degas, then, is the cautious, backward-looking kind of revolutionary we need; a man who saw in the technical innovation of the camera the opportunity to exert a fresh purchase on perennial perplexities. If we follow that path, we will discover that petrified images can still function for us as they have functioned continuously for two thousand years at least: as a means of articulating to ourselves emotions that are of cardinal significance, but on which we can otherwise impose none but the slipperiest of grips.

It is by means of such images that sentiments inaccessible to common sense become a currency in our everyday lives. They are also our guarantee against loss: the loss of people themselves, and the loss of the felicity they had seemed to promise. In place of emotion, fluid to the point of illusion, our images constitute our own small stakes in eternity, semi-permanent and still.

Notes

1 The surgeon: in an alarming phrase of Mailer's, the man 'who goes into cutting because he likes to discover the route by which meat falls away before the knife'; Mailer (1973), p. 124.

2 Hudson (1975). There are helpful essays in Benthall and Polhemus (1975), the best in the present context being that by MacRae, 'The Body and Social Metaphor'. Two remarks are particularly apposite: 'the theme of the female nude in art is never only erotic ... but a metaphor of the world conceived – as our physics and astronomy lead us to forget – primarily as a human place'. Also the reminder that 'as a source of social metaphors' the influence of the body 'is on the whole conservative'. The tendency of my own text, certainly, has been to restore, recover· and recreate rather than to build from scratch.

3 Gass, p. 89.

4 Berger (1972). Societies in a state of revolutionary fervour – Russia, China, Cuba – do seem consistent in their hostility to the kinds of personal intimacy I have sought to discuss. Aspiring revolutionaries in a relatively stable society like our own usually denounce such refinements as bourgeois. All is not yet dead on the left, however: witness Fuller's recent *Art and Psychoanalysis*, which reintroduces into the discussion of art, and more specifically the nude, the psychoanalytic notions of the British 'object relations' school (Melanie Klein, Marion Milner, Winnicott and Charles Rycroft in place of Lévi-Strauss, Lacan and Althusser).

5 There is a special oddity about seeing for the first time in person someone you know well from art. At a lecture in Cambridge, I once saw Victor Pasmore's wife: she was fully dressed, and I had previously seen her only in her husband's paintings, usually in the nude.

6 Barthes (1979), p. 178.

7 Curiously, the poetic language that Gass dwells upon is insistently *visual*: it is pictures that spring, one after another, into the mind's eye. He is explicit about this: 'fiction becomes visual by becoming verbal'; and does so, he suggests, in ways that the camera cannot match (p. 87). The camera *is* a disconcertingly literal instrument. Perhaps for this reason, while good photographers are as rare as good poets, bad photographers outnumber bad poets many thousands of times to one.

8 In his article 'Blurred Genres', Clifford Geertz (1980) seems to suggest a clear distinction between two strategies open to the psychologist, the scientific and the hermeneutic: one a matter of laws-and-instances, the other of cases-and-interpretations. In fact, the explanatory strategies of the psychologist would seem to form a continuum, with law-based science at one extreme and case-based hermeneutics at the other. The policy I have followed here falls somewhere in the middle: hermeneutic rather than in any genuine sense scientific, it nonetheless lays more emphasis

on interpretative categories than the phrase 'cases-and-interpretations' implies. It affords these categories the status of heuristic devices rather than of descriptions or laws, and seeks to hold category and case, the schematic and the particular, carefully in balance. In such activity, one is vitally concerned to penetrate systems of meaning that are unfamiliar. Each foray into the unfamiliar leaves a trace in the form of a text.

9 Berger (1972), Sontag (1979). Beneath the moral scrupulousness of the one and the bristling sophistication of the other, the thought of both these critics seems to me to betray legacies of Rousseau left insufficiently disturbed. A more generous, less crabbed, view of the part that the camera can play in our imaginative lives should emerge from Roland Barthes's *Camera Lucida*, now in press.

10 Mailer, p. 95.

References

Apter, M., *The Experience of Motivation* (London: Academic Press, in press)

Baron, W., *Camden Town Recalled*: Catalogue (London: Fine Art Society, 1976)

Barthes, R., *A Lover's Discourse* (London: Cape, 1979)

Barthes, R., *Camera Lucida* (London: Cape, in press)

Benthall, J., and Polhemus, T. (eds.), *The Body as a Medium of Expression* (London: Allen Lane, 1975)

Berger, J., *The Success and Failure of Picasso* (Harmondsworth: Penguin, 1965)

Berger, J., *Ways of Seeing* (Harmondsworth: Penguin, and BBC, 1972)

Brown, N.O., *Love's Body* (New York: Random House, 1966)

Butlin, M., *Turner's Watercolours* (London: Barrie and Rockliff, 1962)

Clark, K., *The Nude* (Harmondsworth: Penguin, 1960)

Cohen, J.T. (compiled and with introduction by), *In/Sights* (Boston: Godine, 1978)

Cook, E.T., and Wedderburn, A. (eds.), *The Works of John Ruskin*, 39 volumes (London: George Allen, 1903-12)

Courthion, P., and Cailler, P., *Portrait of Manet* (London: Cassell, 1960)

Curtis, S.T., and Hunt, C., *The Airbrush Book* (New York: Orbis, 1980)

D'Andrade, R.G., 'Sex differences and cultural institutions', in *The Development of Sex Differences*, ed. E.E. Maccoby (Stanford: Stanford University Press, 1967)

Delen, A.J.J., *Flemish Master Drawings of the Seventeenth Century* (New York: Harper, 1950)

Douglas, M., *Purity and Danger* (Harmondsworth: Penguin, 1970)

Dunlop, I., *Degas* (London: Thames and Hudson, 1979)

Ehrenzweig, A., *The Hidden Order of Art* (London: Paladin, 1970)

Erikson, E., *Childhood and Society* (New York: Norton, 1963)

Faiman, C., and White, J.S.D., 'Gonadotropins and sex hormone patterns in puberty', in *Control of the Onset of Puberty*, ed. M.M. Grumbach, *et al.* (New York: Wiley, 1974)

Farwell, B., 'Courbet's "Baigneuses" and the rhetorical feminine image', in *Woman as Sex Object*, ed. T.B. Hess and L. Nochlin (London: Allen Lane, 1973)

Fermigier, A., *Bonnard* (London: Thames and Hudson, 1970)

Finberg, A.J., *The Life of J.M.W. Turner, R.A.*, 2nd ed. (Oxford: Oxford University Press, 1961)

Fowles, J., *The Ebony Tower* (London: Cape, 1974)

Freud, S., *Leonardo* (Harmondsworth: Penguin, 1963)

Fuller, P., *Art and Psychoanalysis* (London: Writers and Readers Publishing Co-operative, 1980)

Gage, J., *Colour in Turner* (London: Studio Vista, 1969)

Gass, W., *On Being Blue* (Boston: Godine, no date)

Geertz, C., 'Blurred genres', *American Scholar*, 49 (1980), pp. 165-79

Gilot, F., and Lake, C., *Life with Picasso* (Harmondsworth: Penguin, 1966)

Goffman, E., *The Presentation of Self in Everyday Life* (New York: Doubleday, 1959)

Gombrich, E.H., 'Illusion and Art', in *Illusion in Nature and Art*, ed. R.L. Gregory and E.H. Gombrich (London: Duckworth, 1973)

Greene, G., *Collected Essays* (Harmondsworth: Penguin, 1970)

Gregory, R.L., and Gombrich, E.H. (eds.), *Illusion in Nature and Art* (London: Duckworth, 1973)

Hartnett, O., *et al.*, *Sex-Role Stereotyping* (London: Tavistock, 1979)

Hewison, R., *John Ruskin* (London: Thames and Hudson, 1976)

Hibbard, H., *Masterpieces of Western Sculpture* (New Jersey: Chartwell, no date)

Hobson, J.A., 'Film and the physiology of dreaming sleep', *Dreamworks*, 1 (1980), pp. 9-25

Hudson, L., *Frames of Mind* (London: Methuen, 1968)

Hudson, L., *The Cult of the Fact* (London: Cape, 1972)

Hudson, L., *Human Beings* (London: Cape and Triad, 1975)

Hudson, L., 'The flesh made word', *Times Literary Supplement*, 22 April 1977

Hudson, L., 'Flexibility as a frame of mind', in *The Exercise of Intelligence*, ed. E. Sunderland and M.T. Smith (New York: Garland STPM, 1980)

Hudson, L., *Containers of Consciousness, an Exploration of the No Man's*

Land between Psychology and Photography (exhibition catalogue, Library Gallery, Brunel University, 11–13 July 1981)

Hudson, L., 'The Role of Metaphor in Psychological Research' (paper given at London University Institute of Education, 12 November 1981: to be published)

Jaques, E., 'Death and the mid-life crisis', *International Journal of Psychoanalysis*, 46 (1965), p. 502

Jay, B., *Views on Nudes* (London and New York: Focal, 1971)

Kelly, J. (ed.), *Nude: Theory* (New York: Lustrum, 1979)

Keynes, J.M., *Essays in Biography* (New York: Norton, 1963)

Khan, M., *Alienation in Perversions* (London: Hogarth, 1979)

Kinder, M., 'The adaptation of cinematic dreams', *Dreamworks*, 1 (1980), p. 54

Kinsey, A.C., *et al.*, *Sexual Behaviour in the Human Female* (Philadelphia: Saunders, 1953)

Klein, V., 'The demand for professional womanpower', *British Journal of Sociology*, 17 (1966), p. 183

Laing, R.D., *The Divided Self* (London: Tavistock, 1960)

Laing, R.D., *Self and Others* (London: Tavistock, 1961)

Laing, R.D., and Esterson, A., *Sanity, Madness and the Family* (London: Tavistock, 1964)

Lakoff, G., and Johnson, M., *Metaphors We Live By* (Chicago: Chicago University Press, 1980)

Licht, F., *Sculpture 19th and 20th Centuries* (London: M. Joseph, 1967)

Lindsay, J., *J.M.W. Turner* (London: Cory, Adams and MacKay, 1966)

Lombardo, T., article in *The Institute* (news supplement to the *Institute of Electrical and Electronic Engineers Spectrum*), 3 (August 1979), p. 4

Lucie-Smith, E., *Eroticism in Western Art* (London: Thames and Hudson, 1972)

Lutyens, M., *Effie in Venice* (London: John Murray, 1965)

Lutyens, M., *Millais and the Ruskins* (London: John Murray, 1967)

Lutyens, M., *The Ruskins and the Grays* (London: John Murray, 1972)

McClelland, D.C., 'The calculated risk', in *Scientific Creativity*, ed. C.W. Taylor and F. Barron (New York, London: Wiley, 1963)

Mackinnon, D.W., 'Personality and the realisation of creative potential', *American Psychologist*, 20 (1965), p. 273

Mailer, N., *Marilyn* (New York: Grosset and Dunlap, 1973)

Marcus, S., *The Other Victorians* (London: Weidenfeld and Nicolson, 1966)

Mauner, G., *Manet, Peintre-Philosophe* (University Park: Pennsylvania State University Press, 1975)

Money, J., and Ehrhardt, A.A., *Man and Woman, Boy and Girl*
(Baltimore: Johns Hopkins University Press, 1972)

Needham, G., 'Manet, "Olympia" and pornographic photography', in
Woman as Sex Object, ed. T.B. Hess and L. Nochlin (London: Allen
Lane, 1973)

von der Osten, G., and Vey, H., *Painting and Sculpture in Germany and
the Netherlands 1500-1600* (Harmondsworth: Penguin, 1969)

Plumb, J.H., 'The Victorians unbuttoned', *Horizon* (Autumn 1969)

Pollack, P., *The Picture History of Photography* (London: Thames and
Hudson, 1977)

Pribram, K.H., and Gill, M.M., *Freud's 'Project' Re-assessed* (London:
Hutchinson, 1976)

Proust, M., *Swann's Way*, Part One (London: Chatto and Windus, 1966)

Read, H., *Art Now* (London: Faber and Faber, 1933)

Reff, T., *Degas: The Artist's Mind* (London: Thames and Hudson,
1976)

Rorimer, A., *Drawings by William Mulready* (London: Victoria and
Albert Museum, 1972)

Rorty, A.O. (ed.), *Explaining Emotions* (Berkeley: University of
California Press, 1980)

Rosenberg, J.D., *The Darkening Glass* (London: Routledge and Kegan
Paul, 1963)

Rothenstein, J., and Butlin, M., *Turner* (London: Heinemann, 1964)

Scharf, A., *Art and Photography* (London: Allen Lane, 1968)

Shaw, J.B., *Old Master Drawings from Chatsworth* (London: Victoria
and Albert Museum, 1973)

Shuttle, P., and Redgrove, P., *The Wise Wound* (Harmondsworth:
Penguin, 1980)

Sontag, S., *On Photography* (Harmondsworth: Penguin, 1979)

Spacks, P.M., 'Self as subject: a female language', in *In/Sights*,
compiled and with an introduction by J.T. Cohen (Boston: Godine,
1978)

Stenger, E., *The March of Photography* (London and New York: Focal,
1958)

Stokes, A., *Painting and the Inner World* (London: Tavistock, 1963)

Stokes, A., *Reflections on the Nude* (London: Tavistock, 1967)

Stoller, R.J., *Sex and Gender* (London: Hogarth, 1968)

Stoller, R.J., *The Transsexual Experiment* (London: Hogarth, 1975)

Stoller, R.J., *Perversion* (London: Harvester Press, 1976)

Stoller, R.J., *Sexual Excitement* (New York: Pantheon, 1979)

Storr, A., *The Dynamics of Creation* (London: Secker and Warburg,
1972)

Summerson, J., *Georgian London* (London: Penguin, 1962)

Tanner, J.M., *Foetus into Man* (London: Open Books, 1978)

Turner 1775-1851: Tate Gallery catalogue, 1974

Vaizey, M., 'Art language', in *The State of the Language*, ed. by L. Michaels and C. Ricks (Berkeley: University of California Press, 1980)

Vonnegut, K., *Breakfast of Champions* (London: Cape, 1973)

Weinreich-Haste, H., 'What sex is science?', in *Sex-Role Stereotyping*, ed. O. Hartnett, *et al.* (London: Tavistock, 1979)

Werner, A., *Degas Pastels* (New York: Watson-Guptill, 1977)

Wethey, H.E., *Titian* (London: Phaidon, 1975)

Wilkinson, G., *Turner Sketches 1789-1820* (London: Barrie and Jenkins, 1977)

Williams, R.J., *Biochemical Individuality* (New York: Wiley, 1963)

Wilson, C., *Edward Weston Nudes* (New York: Aperture, 1977)

Wisdom, J.O., *The Unconscious Origin of Berkeley's Philosophy* (London: Hogarth, 1953)

Wollheim, R., *Freud* (London: Fontana, 1971)

Young, W., *Eros Denied* (London: Weidenfeld and Nicolson, 1965)

Index

attitude to the body, 13–15;
childhood sexual awareness,
15–16; and the fascination of
violence, 18; photography of
women by, 120; pregnancy, 17;
psychological differences from
men, 13–14; puberty, 16–17,
24; sexual perversions, 19;
sexual potency, 17–18; *see also*
femininity

Wordsworth, William, 71, 72
works of art, as cause of outrage,
102; integrity of, 45; as public
property, 46, 132–3

Young, W., 68

Zola, Emile, 119